MURDERS &
MISDEMEANOURS
in
Gloucestershire
1820-29

MURDERS & MISDEMEANOURS

in

Gloucestershire
1820-29

Malcolm Hall

AMBERLEY

First published 2008

Amberley Publishing Plc
Cirencester Road, Chalford,
Stroud, Gloucestershire, GL6 8PE

www.amberley-books.com

British Library Cataloguing in Publication Data.
A catalogue record for this book is available from the British Library.

ISBN 978 1 84868 046 3
Typesetting and Origination byAmberley Publishing
Printed in Great Britain

CONTENTS

ACKNOWLEDGEMENTS

The author would like to record his indebtedness to that invaluable institution, the Gloucestershire Archives, together with its staff, but for whom this book would never have seen the light of day.

I should also like to express my gatitude to Alan Sutton, for allowing me to delve into his extensive library of photos and sketches, from which the illustrations for this book have been drawn.

INTRODUCTION

Crime and Punishment in the county of Gloucestershire nearly two centuries ago, in the shape of the cases heard in the Courts of the County Assize, and as recounted at the time in the local newspaper, form the complementary themes of the following pages, where the reader will find a variety of examples of the sins and sinners of those days, together with the fates suffered by the latter, as determined by the Courts' decisions. From time to time, to provide him with some relief from man's darker side, he will also find the milder disputations represented by some of the civil cases which were also brought to the Assize Courts.

So far as the criminal trials are concerned, it will perhaps be agreed that these reports show that the capacity for naughtiness, forever lodged in the bosom of mankind, differed little then from that which we find today. In those far-off days, not a few innocent people were fated to end their days as the victims of murderers, as sadly they still do, with the murderer sometimes acting by design and for personal gain, or in other cases driven by emotions which he or she is unable to master. As for that most common of sins, theft, this was never absent from the Calendar of crimes which the Assize Courts were called upon to consider. Sadly, we must take it that there was never then, as now, any shortage of misguided individuals who regarded other peoples' property as there to be purloined for their own purposes.

If the crimes seem to have altered little during the last two centuries, the punishments which were then at the judges' disposal certainly have, including as they did some which are now denied to their modern counterparts. Capital punishment by hanging lay at the top of the punishment tariff and would continue so for rather more than another hundred years, while there was some time still to pass before it ceased to be performed in public, a spectacle which, it has to be said, never failed to provide a popular and enthralling entertainment, free of charge, for

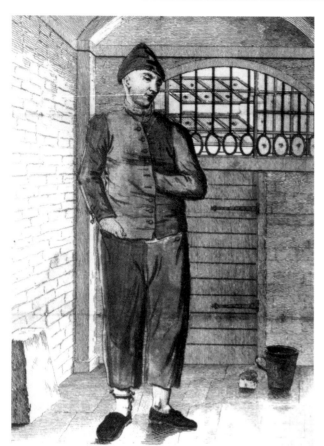

Left: *A prisoner in his cell.*
Below: *A public execution in the early 1800s.*

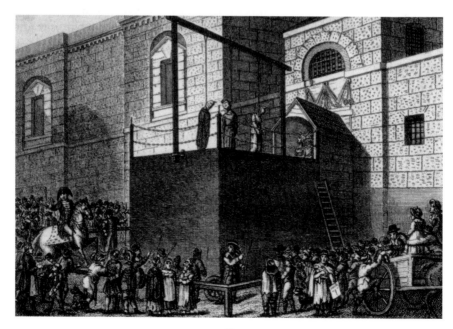

thousands of people. In not a few cases, however – and more frequently in fact than might be supposed – mercy intervened to moderate the sentence of the court and the condemned man was reprieved. In such cases, the next punishment available down the scale was the widely-used one of transportation. With the prisons tending to be full (another parallel with today!), the wide open spaces of the then sparsely colonised continent of Australia made a convenient and far-off dustbin in which to dispose of society's unwanted embarrassments. Prisoners in this category would first find themselves incarcerated in the 'hulks' – vessels which, no longer seaworthy, were anchored at convenient spots and which served to hold the 'transports' while they waited for a ship to take them to exile on the other side of the world.

For those judged to be deserving of less heavy punishment, there remained imprisonment at home, with or without 'hard labour', and to which might frequently be added flogging – or 'whipping' – which could be administered either in private or in public. Some of this class of convict also found themselves in the hulks, not to await transportation, but simply because, with the prisons full, it was the only space available.

For reform of the nation's prisons was sorely needed; not only did they lack capacity, they were also poorly maintained and unhealthy places, the abode of despair and disease. It was towards the end of the eighteenth century that serious action was belatedly taken in this respect. The moving spirit was the reformer John Howard, and under his leadership an extensive programme of new prison building was successfully pursued.

In Gloucestershire, the situation was no different from the rest of the country: conditions in Gloucester Gaol, housed in the ruins of the city's castle by the river, were so bad that outbreaks of typhus and smallpox were not infrequent, while the county's other jails and lockups were no better. The motor for the Howard reforms in this part of the country was Sir George Onesephorous Paul, of Rodborough, near Stroud, and in 1791 his efforts culminated in the opening of a new County Gaol in Gloucester, while around the same time five new Houses of Correction, as they were officially – and expressively – called, were established. One was incorporated in Gloucester Gaol itself, and the other four were located at Horsley, near Nailsworth; at Lawford's Gate, in Bristol; at Littledean, in the Forest of Dean; and at Northleach, on the wolds to the east of Cheltenham. They replaced outdated Bridewells, to give them their other name, which had been located at Winchcombe, St Briavels, Cirencester, Berkeley and Gloucester.

The old Watchman: a sight not exactly calculated to raise terror in the heart of a footpad.

However, if the new prisons were to be of use, their inhabitants had first of course to be caught and brought to justice. Here, too, the arrangements differed markedly from those of today, and were not as extensive as they might have been. It would be 1829 before Sir Robert Peel, then at the Home Office, introduced his Bill which resulted in the formation of London's Metropolitan Police Force. In due course the provinces followed suit, but not before some more years had gone by. Gloucestershire was amongst the leaders in this respect, but even there a police force was not created until 1839. Throughout the twenties, in order to keep the peace, or to arrest those who did not, the County continued to rely on the tried and trusted Parish Constable, complemented in the towns by the Watch.

* * * * * * * * * *

The Courts of Assize, to which all cases too serious to be tried by the local magistrates were taken and in which they reached their settlement, found their beginnings in the thirteenth century, when the confrontation between King John and his barons culminated in the great conclave on Runnymede and the signing of the Magna Carta. For it was one of the latter's provisions which first allowed the principle that certain causes might be heard in the county where they had originated, rather than in the King's Court at Westminster, as hitherto. In later reigns, the advantages of dispensing the King's justice in the country at large and not just in London, thus sparing the actors involved the long, wearisome and sometimes hazardous journey to the capital, saw this notion evolve, until in due course the County Assize had become an essential and time-honoured element of English justice, enduring in modulated forms through centuries of change, until it was abolished towards the end of the last century.

Once established, the Assizes were held twice each year at the different County Towns, presided over by two judges who travelled to each town in turn, each pair moving around one of a number of 'Circuits', which covered different parts of the country. By 1820, when the decade covered by this book begins, the Assizes consisted of two separate courts, the lesser cases being considered in the Crown Court, while the more important ones came before the court which went by its Latin name of *Nisi Prius* – meaning 'unless before'. The term echoed the earlier justification for the establishment of these provincial courts, based on the concept that the major cases concerned would normally be heard in the capital, *unless* the Assize judge was on hand *before*, to try them locally, as it was tacitly assumed he would be and as was now always the case.

Gloucester itself lay on the Oxford Circuit, the opening of its Assizes taking its turn after those in other towns such as Worcester and Monmouth, which the two appointed judges had already visited. Twice each year, usually in early April and again in late August, they would complete their duties in Monmouth and set off by carriage along the turnpike road which took them through Ross and ended at the city's limits at the Over Bridge. There they were met, with due punctilio, by the High Sheriff and from thence conducted to the Shire Hall to begin their duties.

The county in which they were to administer justice still lingered in an earlier time, far from London's grime and from the smoking chimneys and gaunt factories which were now disfiguring parts of the industrial north.

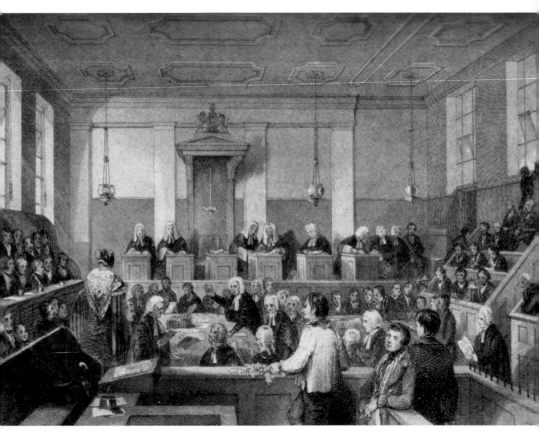

The courtrooms in Gloucester's Shire Hall were probably not dissimilar to that in the Sessions House at Newgate, illustrated here.

Its broad acres and rolling downland were largely devoted to farming and hunting, detached from the capital by a full day's jolting coach journey, for it would be nearly the end of the thirties before the region acquired its first railway, when Brunel laid the line joining London with Bristol.

In 1821, of its population of nearly 300,000 – leaving aside the port of Bristol – only about 20,000 lived in the two major municipalities of Gloucester and Cheltenham (although the latter, then in the full flood of its rise to the status of a fashionable watering-place, was growing apace). The remainder could have been found scattered among the small towns and villages, many scraping a living on the land, while others worked as miners, either in the coalfield lying beneath the southern part of the county, or beyond the Severn in the Forest of Dean. In the Cotswold uplands a sizeable number were engaged in Gloucestershire's major manufacturing activity – the weaving of cloth, based on the wool

gathered from the flocks which grazed the nearby hills.

Many knew only poverty: unemployment was high and agricultural wages were low, while the Corn Laws, which had been enacted to protect the arable farmers from the competition set by cheap foreign wheat, also kept the cost of bread high, making even the price of a loaf sometimes difficult to find. There was always a certain number – some through circumstance rather than their own fault – who were able to subsist only with the help of the inadequate Poor Laws or the harsh conditions of the Workhouse.

In the cloth industry the workers had their own peculiar problems. It was in the later years of the previous century that Progress had begun to bring in the new machines which, powered at first by the region's fast-flowing streams and later on by the even newer steam engine, proved more efficient than the outmoded handlooms, which the weavers, working in their own cottages, had operated for generations. This circumstance had encouraged entrepreneurs, more sharp-witted than the rest, to build multi-storey workshops, or 'mills', along the region's valleys, to house the usurpers. Some of these clothiers, as the mill-owners were called, prospered and earned the reward for their enterprise by climbing into the ranks of the county's gentry. The less-fortunate weavers, obliged by penury to exchange their erstwhile independence for ill-paid employment and long hours in the new factories, became another well of discontent.

Except when goaded to protest, as we shall see, these unfortunates were usually too busy trying to scratch a living to be found among the cast of characters who appeared at the bar of a criminal court to answer for their alleged sins, although the latter were ever a motley collection, driven by a variety of motives. If it be possible to both generalise and divide them into two categories, it might be said that the majority of the murderers and thieves owed their melancholy fate (as well as that of their victims) to the very limited degree of education to which they had access, along with the malign influence of the ale-house, while the other offenders, such as the forgers and embezzlers, were more likely to be found from among the next level of society, perhaps clerks and other town-workers. The crimes of the first group were all too frequently the result of spontaneous and reckless impulses, while those of the others were more likely to have been planned with a certain amount of forethought.

As well as the criminal cases, the Assize also dealt with civil actions. If, in the great majority of the former, the prisoners who appeared at the bar were members of the labouring classes, the latter were largely

the preserve of the gentry, who alone could afford the luxury of the cost of complaining in a court of law and claiming redress, in the form of damages, for the actions of another. From time to time, a courtroom crowded with idle and fashionable members of local society would bear witness to the keen interest which a particular case of this kind had excited. Some of the latter might invoke the laws pertaining to slander or libel, while others concerned more delicate and emotional infractions such as breach of promise or the alienation of a wife's affections.

The verdicts in these cases, in favour of the plaintiff or the defendant, together with the amount of any damages awarded, were of course, like those in the criminal cases, in the hands of the appointed Jury. The qualifications which defined those who might be called upon to serve on these bodies were much more restrictive than they are today. The full definition is rather complex, but, simplified, it amounted to all men (no women of course!) between the ages of 21 and 60 who had, in their own name, an income of at least £10 per annum from 'lands or tenements', either 'freehold or copyhold', or, alternatively, £20 per annum leasehold. Possession of a house with at least 15 windows formed another qualification. Juries were thus always and exclusively composed of male members of the more comfortably off.

In the following pages are presented the words, acts and opinions of all concerned – prisoners, witnesses, counsel and, of course, the august judges – reported and interpreted, at rather greater length than we might expect today, by the *Gloucester Journal's* courtroom reporter. If the style is sometimes archaic and the language extravagant, it is also vivid, while employing some of the more stately phraseology available in the English language, which today has passed out of fashion.

The individuals involved in the different cases tend to be divided, with greater exactitude than is possible today, into the two classes, workers and persons of leisure (although it was perfectly possible for one of the former, such as Joseph Pitt of Cheltenham, who began by holding horses' heads for pennies, to climb up into the latter). A useful, frequently-used word, applicable across the class division, to indicate approval of a person's apparent worth to society was the adjective 'respectable'.

1820

By the year eighteen twenty, five years had passed since Waterloo's narrow margin had finally banished the tyrant Buonaparte to his island prison in the South Atlantic. The same year also saw the end of the period known to history as the Regency, with the death of George III, whose long reign had included the wars which that battle finally brought to an end. He was replaced on the throne by yet another George, who thus assumed in his own right the royal powers which, as Regent for his late father, when the latter lost his wits, he had been exercising for the previous eight years.

The capture of the Cato Street Conspirators.

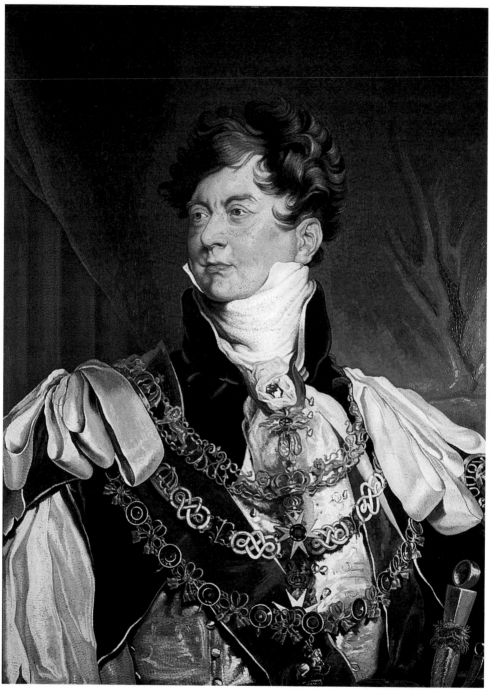

George IV.

Although the country was now enjoying a time of peace which, with the exception of a short period of ten months in 1802-03, it had not known for over twenty years, it was far from at peace with itself. Radical forces were afoot, which, dissatisfied with the old ways, looked for changes. Their discontent was focussed both on corruption in the political system, exemplified by the scandal of the 'rotten borough', and on the poverty in which many of the working class were obliged to exist. To the country's rulers, the revolutionary ideas which were aired under these banners and the actions proposed to implement them often seemed dismayingly reminiscent of the ideology which had brought in the bloody tumult in France – an upheaval which had taken place within the adult lifetime of most of them.

The new reign was not a month old when their worst fears seemed to be realised, as they found themselves confronted with a group of malcontents known as the Cato Street Conspirators, whose purpose was nothing less than the assassination of the entire Cabinet. Although they were soon arrested and tried and the ringleaders executed, dissatisfaction with the established order continued, albeit following more lawful means.

For some time, however, these political disputes were overlaid and supplanted by a quite different and – to the general public – altogether more absorbing affair which had been lying in the background for some years, only waiting for the accession to make it of immediate and urgent concern – the matter of the new Queen. It was to both convulse and divide the nation for more than a year, whilst the airing of details of the unsavoury allegations involved would have the effect of casting an unseemly aura around the throne.

It was in 1795 that the arranged marriage had taken place between Caroline, Princess of Brunswick, and her cousin George, then Prince of Wales. It was not a success, the couple had long been estranged and Caroline had spent the Regency years living on the Continent. Now, however, her husband had ascended the throne as George IV and Caroline should, of course, have taken her place alongside him as his consort, in a natural and normally unremarkable manifestation of the constitutional arrangements. Unfortunately, the circumstances were not normal and certainly far from unremarkable.

The Princess, who could be said to possess a rather ebullient nature, had, in the course of her travels and sojourns in Europe, acquired a rather notorious renown, informed by tales of adventures and involvements of a dubious nature with members of the opposite sex – and often rather lowly

ones at that – while other reports told of unchaste and lewd behaviour in public. In short, although a daughter of a European noble house, she had, in the eyes of the Government and, most particularly, the King, behaved with the vulgarity of a common person, and was quite unfitted to be the consort of His Majesty the King of Great Britain and Ireland. The government might have been prepared to overlook these stories (which were, after all, unproven), albeit with a certain distaste, but the King was adamant: on no account would he accept Caroline as his Queen and his ministers were obliged to seek a way round this constitutional imbroglio. Their dilemma was not eased by the fact that a large proportion of the nation took a completely opposite view, prepared simply to believe that the tales were slanderously untrue and siding enthusiastically with Caroline in her quarrel with an monarch who was in any case deeply unpopular and who moreover could hardly claim that his own behaviour down the years had enhanced the dignity of the Crown.

The King, however, was immovable: some means must be found. The government, headed by Lord Liverpool, therefore produced a device, in the form of a 'Bill of Pains and Penalties', which was introduced in the House of Lords and which in effect placed the Queen on trial to answer a charge of adultery.

If Gloucestershire was remote from the capital, its population was far from ignorant of events in the wider world. Newspapers, whether national or provincial, were now widely read and the weekly *Gloucester Journal* was no exception. Nor did it confine itself to local news, but devoted a considerable part of its four pages not only to happenings in London and other parts of the kingdom, but frequently to 'intelligence' about political and military events in other nations.

Thus, when, encouraged by widespread manifestations of support from a sizeable proportion of the population, Caroline landed at Dover on 6 June, her arrival received full coverage in the *Journal*. From Dover, determined somehow to assert her rightful place in the kingdom, Caroline set off for London. Her route took her through Canterbury and Chatham and over Blackheath, while ever larger crowds lined the roads and repeated cries of 'God Save the Queen' rang out. Once arrived in the capital, she set up residence at Brandenburgh House in Hammersmith, the street outside being continuously thronged with crowds of well-wishers, while at all hours written expressions of support, in the form of 'Loyal Addresses' arrived from every corner of the kingdom.

In Gloucestershire, the way was naturally led by the county town, when

a public meeting, held in Shire Hall on 7 August under the chairmanship of the Mayor, unanimously resolved to send an Address to the Queen, in which it presented its congratulations to Her Majesty on her safe return to this country, as well as, more pertinently, expressing its 'astonishment and indignation' at the proceedings against her now being adopted. Similar meetings were held across the county, those at Stroud (18 September) and Wotton-under-Edge (6 October) being two of many.

The Bill of Pains and Penalties was introduced into the House of Lords in August and continued to occupy the Peers for nearly three months, while numerous witnesses were produced by the 'prosecution', with unsavoury allegations – including much circumstantial detail – about Caroline's conduct. On 10 November, the Bill was passed and the washing of the last shreds of dirty linen came to an end. Its majority, however, was of the slimmest: only nine votes in a total of some 207. Faced with such exiguous support from the Upper House, together with the likelihood of its defeat in the Lower House, not to mention the threat of a popular backlash in the country as a whole, the government backed down. The Bill was withdrawn, to leave Caroline, in the eyes of her many supporters, triumphant and vindicated, albeit with a reputation which to some now seemed rather more tarnished by the unseemly revelations at Westminster than they had previously thought. Nevertheless, her supporters were still both numerous and strident, Gloucestershire being no exception. The *Gloucester Journal*, which each week had carried extensive reports of the 'trial', was as pro-Caroline as any, while across the county, when news of the abandonment of the Bill became known, there was not a community of any size which failed to celebrate the fact in one way or another. In Stroud, the citizens assembled at the Cross, where a whole ox and four sheep were roasted and the result, together with 'four hogsheads of strong beer' was distributed amongst the poor. Similarly, at Painswick, five sheep were roasted, for the benefit of the parish's needy. Everywhere, the church bells were rung and all the houses were lit up.

Despite these rumbustious events at the heart of the nation, normal life went on, including the ever-present need to deal with the law-breakers; on 3 April, while the Queen still lingered on the other side of the Channel and the Caroline affair was yet to reach its full intensity, the judges arrived in Gloucester to open the Spring Assizes, to which we may now turn our attention.

Gloucester Spring Assizes

From the Gloucester Journal, 3 April 1820:

Soon after four o'clock on Wednesday afternoon, Mr. Justice Holroyd arrived in this city, escorted by the High Sheriff, Sir Edwin Baynton Sandys, Bart. and the usual cavalcade, and immediately proceeded to the Shire Hall, where the Commission was opened. On the following morning, his Lordship attended Divine Service at the Cathedral, where an excellent sermon was preached by the Rev. H. Morgan, of Winstone, chaplain to the High Sheriff. Mr. Justice Richardson, who had been detained by the business at Monmouth, did not arrive here till Thursday forenoon. At one o'clock, their Lordships went into Court, Mr. Justice Richardson presiding at the Crown Bar, and Mr. Justice Holroyd at Nisi Prius.

From the Gloucester Journal, 10 April 1820:

REX versus BRADLEY AND MARTIN

This was an indictment charging the prisoner *Henry Bradley* with having, in company with Thomas Fletcher and Wm. Jones, (not yet taken) in the house of Messrs. Wilson and Fisher, tea-dealers of this city, and stealing therefrom two chests of tea, their property, on the 20th of October last; and the prisoner *George Martin* was tried under the same indictment, for having feloniously received the said tea, knowing it to have been stolen. The following was the evidence.

John Wilson is a tea-dealer residing in the parish of St. Michael, in this city. His partner, John Fisher, resided in London. The shop forms part of the dwelling-house, the door opening into the Eastgate-street. The New Inn passage passes by the side of the house and shop, the door of which also opens into the Eastgate-street. On the 20th Oct., witness went to bed between ten and eleven o'clock, and locked up the shop door before he retired. The wall between the shop and New Inn passage was quite safe. Had three chests of black tea unpacked in the shop, the lid of one of which he had taken off that night. Each chest contained from 81 to 84 lb, and they were worth at the least upwards of 25*l*.[1] each. Witness was called up some time after four o'clock next morning. It was quite dark and he was obliged to light a candle. Found the front door open and a hole in the wall large enough for a small man to get through. The door of the New

Inn passage was also open, the lock of which had been forced by some instrument. Missed two chests of tea, one unpacked and the one of which he had taken off the lid the night before. Found a pair of nippers inside the shop. A pair of scales were taken from the shop, which were brought back the same morning; they were in the shop on the night before. Searched the house of the prisoner in company with Mr. White, Marsh and Cooke, on the Thursday or Friday of the week following. Martin was not at home, but witness had seen him the morning before. Found one of the chests, with part of the tea taken out, in a small room adjoining the shop; knew the chest to be one of those lost by the number. The lot mark also; the ship mark was on the chest, and in every respect corresponded with one of those witness had lost; the tea was of the same sort and quality. Found fragments of another chest in the cellar which he thinks from appearance formed part of the other chest that was stolen from him.

Cross-examined by Mr. Campbell, Counsel for Bradley – Witness had kept the shop upwards of twelve months; and had lived in Gloucester more than five years. Had no other partner than Fisher. The business was carried on in their joint names. There was an outer door backwards; cannot swear that he saw it bolted the night before, but it was bolted when witness came down in the morning. It was after four o'clock when witness came down. His sister lived in the house, but there was no servant that night. He has no relation who is a tea-hawker.

Cross-examined by Mr. Twiss for Martin – It was commonly called Congou tea. About 15 or 20 lbs appeared to have been taken out of the chest. The number was scribe-marked. The number might sometimes become obliterated. Six or nine chests in a lot commonly sold by East India Company. Every chest has the same lot mark upon it. Found other fragments of a tea-chest in the cellar.

Thos. Randall said he was servant to owner Witmore. Going to the stable early to feed his horses, on 21st Oct. he called up Mr. Wilson about a quarter past four, having seen a quantity of tea, scales, and a chisel, lying near his door. Gave them to Mr. Brown. It was not day-light.

Samuel Apperley lived at Gloucester in October, he knew Henry Bradley, Thomas Fletcher, and William Jones. Had seen these three before the night of the burglary (18th Oct.) at the Upper George, and heard Fletcher and Jones ask Bradley if he would go with them to break open Mr. Wilson's shop. Bradley said he would. The morning after the robbery, saw the three together at the Mason's Arms between ten and eleven.

Cross-examined by Mr. Campbell – Said he was a shoemaker, and

lodged for six weeks at Mrs. Connor's, Maidenhead Entry, where he did jobs for himself in mending but not making shoes. He had been at Hereford, but never was in gaol any where. Bought small quantities of leather of a person opposite the Entry, and dealt with him twice. Cannot tell the names of any persons for whom he mended shoes. Heard there was a reward offered about two days after the robbery was committed. Mentioned the conversation, before he heard of the reward, to John Clissold. Witness slept two or three times on the lime-kilns near Gloucester, as he could not get any thing to do. Declined to say how he got his living at that time. Fletcher and Jones asked him to go with them but he said he would have nothing to do with such a job. They asked him on Constitution Walk, and he went to the George with them but did not keep in their company. Had two pints of beer by himself, for which he paid. Slept the same night at the lime-kiln.

Re-examined – Told Clissold before the reward was offered. Had known Fletcher and Bradley about half a year. Told Clissold on the Saturday, after breakfast, in the Mason's Arms back court, where he was fetching water for them from the River. Clissold, who persuaded him to tell of it, went for Marsh, and witness accompanied them to Wilson's Office and the Mayor's.

Thos. Wren is brewer at the Upper George. On the Monday before the robbery saw Wm. Jones, Henry Bradley, and the last witness, with several others, together; amongst them was the lad who ran away with Jones. Witness was funning his beer, and, in going backwards and forwards, saw them frequently. On the morning after the robbery saw the same persons, Bradley, Apperley, Jones, and the other man, at the Upper George, about ten o'clock. They were very busy dancing in the kitchen, and he heard some of them say, as he was passing, "damme, here goes the tea-money!"

Cross-examined by Mr. Campbell – Apperley was with them both on the Thursday and Monday. They were all sitting, drinking, and talking together, on the Monday.

John Clissold lived at the Mason's Arms. Apperley was employed to carry water for him on Friday the 22nd Oct. Apperley made him a communication, in consequence of which he went to Marsh on Saturday, who met Apperley in the meadow. The morning after the robbery, saw Fletcher, Jones, Bradley, and others, at the Mason's Arms. They were very noisy and pressed witness to drink. Some appeared to have drunk a good deal. They asked him if he would give change and he saw that some of

them had money in bills.

John Marsh said he was a police-officer. On the Saturday after the robbery he went before the Mayor, accompanied by a boy named Jones, and Apperley, and then received a warrant to apprehend Bradley, Jones, and Fletcher. Witness made diligent search after them till two o'clock the following morning, but could not find them. Took Bradley into custody the latter end of January in London. On his apprehension, Bradley observed that "a silent tongue made a wise head, and he would have nothing to say!" About seven o'clock in the morning after robbery, saw Bradley, Jones, and Fletcher at the Coopers' Arms, drinking together.

Cross-examined by Mr. Campbell – Said that hand-bills were distributed on the Friday, offering a reward of 10*l.* to any person who would give information, or apprehend the offenders.

John Phillpots, Esq., Mayor of Gloucester, said that Apperley laid an information on the Saturday, in consequence of which he granted a warrant. He had seen the hand-bills before Apperley came to him.

Margaret Connor said she lived in the Maidenhead Passage. Apperley lodged with her about the time of the robbery. He mended one pair of shoes to her knowledge, whilst in her house, where, however, he only remained three or four days.

Joseph Jones said on the night of the robbery he slept under Mr. Page's hayricks in the Island; George Hayward, who was very drunk, was with him. Bradley, Fletcher, and Wm. Jones came at twelve o'clock, and laid down for about ten minutes. Heard Bradley say, "Now is the time to go and crack that *kenn*." Fletcher asked, "What *kenn*" Bradley answered, "The tea shop in Eastgate-street." Wm. Jones said he had got the tools he had from Nelmes, but they were not produced. Witness saw them before, the same evening, at the Upper George; there were a pair of nippers and a chisel; Wm. Jones had them. Marsh afterwards shewed him a chisel and nippers, which he knew to be the same, the nippers having a notch in them, and the chisel being without a handle. Bradley, Fletcher, and Jones then went away; and Bradley returned in about three-quarters of an hour, and asked Hayward to lend him his smock-frock; but Hayward refused. Soon after, Fletcher and Jones came back, and the former said to Bradley, "Come along, we have got the bricks out, and it's all ready." They then went away together, and returned again between two and three o'clock. Fletcher asked if witness was asleep; Wm. Jones said he was. Bradley said, "damme, never mind, we've done it very well." They then laid down under the rick. Saw Fletcher and Jones go into Martin's shop next

morning about nine o'clock; they had left the rick about six. The same morning saw Fletcher, Jones, and Bradley together, at the Upper George; they were drinking, and had plenty of money. Saw them afterwards at the Masons' Arms, where Fletcher asked for change for a 5l. note.

Cross-examined by Mr. Campbell – Said he never slept under a hay-rick before or since that night; has been constantly along with a trow since that time, in the employ of Owner Bowers. Slept under the rick because a little boy had lost the key of the cabin, and he could not get in. Had 2s. in his pocket. Slept one night in prison, where he was taken by Lewis, a police-officer, but did not know upon what charge, and was liberated the next morning.

Edmond Kirk saw Martin in Dockham, about half-past twelve o'clock at noon, on the morning of the robbery, in conversation with Nelmes, Fletcher, and Jones. About an hour after, saw Jones, Fletcher, Bradley, and others go into the Masons' Arms.

Richard Nelmes lent Wm. Jones, about the 7 Oct., a carpenter's chisel; it was an old one, and has never been returned, but he has seen it in Marsh's possession since. About nine o'clock on the morning after the robbery, saw Wm. Jones go into Martin's shop. The same evening, Martin sent witness, Jones, and Fletcher down to Dockham, where he came to meet them. Jones and Fletcher asked for the money for the tea. Martin asked what he was to give for the two chests. They said 20l., Martin said he would not give any such money. If he was to give so much as that, he would wash his hands clean of them, and have nothing more to do with them. They said if he did not choose to pay them for it, they would have the tea away. Martin then said he supposed he must give them the money, and accordingly gave them four 1/- bills and 1l. in silver, saying the 1l. they had had in the morning would make 6l.; that day three weeks he would give them 6l. more; in a fortnight after, 6l. more, and any time after they might call for the other 2l. Two or three nights after, Martin called him into his passage, and asked witness if he had seen these chaps since? Witness said he had not. Martin said he had better try if he could see them any where, and come back to him, and he would advance some money for them to be off with. Half an hour after, he gave witness six 1l. bills, telling him to give them to Fletcher, Bradley, or Jones, if either of them called. Neither of them came. This was on the Saturday.

Cross-examined by Mr. Twiss – Has worn his present clothes about a week. Has been in the Forest of Dean lately, but not in Littledean prison. Does not know Eliz. Collier; never told her he was imprisoned

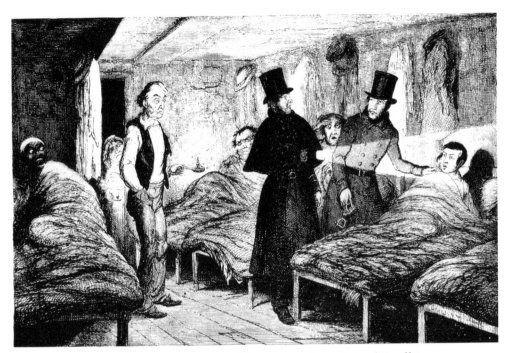

Like this suspect, the fleeing Martin was unable to escape the pursuing law officers.

there for stealing fowls within the last four months. He has lodged with Mary Bower, but never said he had stolen sheep in the Forest. Had no concern with breaking open the house. A few days before, Martin had asked witness to fetch a chest of tea from Wilson's in the middle of the day, and he would give him 5*l*. for doing it. He had no concern with this transaction, and did not know of the business till he was in Dockham. Was not to have any of the money. They said they would give him 5*s*. each if he would have it, which he refused. He gave the 6*l*. to the Magistrates at the Tolsey. Never saw the tea till it was brought to the Tolsey.

Re-examined – Martin has known him five or six years. Was offered the 5*s*. each, not to say anything about the chisel. (The chisel was here produced, and proved).

John Marsh searched Martin's house the Friday week after the robbery; Mr. Wilson was with him and Geo. Cooke, a police officer. Martin was not there. Found a chest of tea in a small parlour behind the shop; some was gone. Apprehended Martin on 2nd Nov., at Liverpool. Martin asked what witness wanted. Witness said he wanted him. Martin said, "For God Almighty's sake let me go!" Said he would give witness 50*l*. to let him go; that he would go to South America, and never be seen again. He said he would give the whole of the money he had got if witness would let him

go. Witness said he would not, if he would give ten times as much. Martin asked who searched his house, and what was found. Witness said one chest of tea in the parlour, and another chest broken to pieces in the cellar. Martin said he had but one chest of the tea. Witness asked who had the other. He said he would not tell; he had got into a mess himself, and he would not involve any other person. Martin said if witness had met him on the road, he would not have known him; that he had bought an old hat and smock frock; he had not gone by the coach to avoid being taken; and if witness persisted in taking him to Gloucester he should be a dead man. He said he had taken his passage to South America, and lodged with one of the mates of a ship going out.

Wm. Brown saw Randall give his father a chisel, who sent witness with it to Wilson, by whom it was afterwards given to Marsh.

Randell proved the chisel to be the same he found.

John Wilson offered a reward the morning after the robbery was committed. Had bills printed and distributed over the town, and published an advertisement in the papers. (The tea chest produced, and proved).

Rd. Nelmes knows Nanny Collier; but never said he was used in the Forest to steal sheep, and take them home to his family.

Elizabeth Collier lives in the Leather-bottle-lane. Knows Martin and Nelmes. Heard Nelmes say that when he was in the Forest, he was used to steal sheep, and take them home for the rest of the family. Heard him say that he was at Mr. Wilson's door when the robbery was committed, but he did not go in.

Cross-examined by Mr. Ludlow – Is not particularly intimate with Nelmes.

John Welch is a shoemaker; had known Bradley from a child, and never heard any thing amiss in his character.

John Williams, master cordwainer. Bradley worked for him three years, and was always punctual and honest.

Adn. Collier said that Nelmes told her he was the support of his mother's family; that he stole the sheep, killed them, and the family partook of them. He also told her that he stood at Wilson's door at the time of the robbery; that he took the tea from them, but that he did not go into the house!

For the prisoner *Martin*, John Phillpotts, Esq., Mr. Alderman Jones, and thirteen other most respectable inhabitants of this city and neighbourhood, were called up and examined, who all concurred in giving the prisoner a most excellent character up to the period of this unfortunate transaction.

The evidence having now been gone through, the learned Judge (Mr. Justice Holroyd) proceeded to sum up, a duty which occupied his lordship upwards of two hours, and in the course of which he commented in the ablest and most impartial manner upon the various testimony which had been adduced. It was a case of the utmost importance to the prisoners at the bar; and as, from the degree of interest which it had excited in this city, no doubt it had given rise to much conversation out of Court, he felt it incumbent upon him to remind the jury that it was their bounden duty to discard from their minds all prejudice either on one side or the other, and to be guided in their decision solely by the evidence they had that day heard.

The jury, after about a quarter of an hour's consideration, acquitted Bradley of the burglary, but found him *Guilty of stealing above the value of 40s. in a dwelling-house*; and returned a verdict of *Guilty* against Martin; at the same time strongly recommending them to mercy.

Henry Bradley was condemned to death, for stealing two chests of tea from the dwelling-house of Mr. Wilson, Eastgate-street, later reprieved.

George Martin was sentenced to fourteen years' transportation, for feloniously receiving two chests of tea, knowing them to have been stolen.

On 14 August, with the uproar in the country over the 'Queen's Business' in full spate, Gloucester's second Assizes of the year began its business. Three days later, the Bill of Pains and Penalties got under way in the Lords.

Gloucester Summer Assizes

From the Gloucester Journal, 21 August 1820:

TRIAL FOR MURDER

On Monday morning, at eight o'clock, came on the trial of Rebecca Worlock, charged with the wilful murder of her husband, Thomas Worlock, butcher, of Oldham Common, in this county, by mixing arsenic with beer, on the 17th of April last. Mr. Osborne having opened the case, Mr. Ludlow briefly stated the facts, which were afterwards proved in evidence, and immediately proceeded to call the witnesses, the first of whom was:

Mary Ann Worlock, aged 10 years (daughter of the prisoner). On the 17th of April, witness was sent to the public-house to purchase some beer for her father; on her return home she met her mother in the passage, who took the jug from her, and desired her to go and look after her brother and sister. Having brought them home and seen them to bed, she returned into the kitchen; her father having drank the beer, observed there was something at the bottom of the cup, and then said to her mother, "you have done for me", and having expressed a wish that somebody should see it, witness went to fetch a neighbour; on her return, her mother had got the cup, and took it out of the kitchen into the cellar adjoining, where she saw her empty it into a bucket of water and then swill out the cup. Her father and mother both went out for assistance, and soon after Geo. Hook and another man came, who examined the stuff in the bucket. Her father came home at night and continued ill until he died; he had complained of his stomach being bad before he drank the beer.

On her cross-examination by Mr. Twiss, witness said that some stuff from the mouth of the cup fell on the table, which her father took up on a bit of paper, and carried it to Mr. Edwards.

Sarah Butler, the person who returned with the child, said when they went in the prisoner seemed to be in a great fright. Deceased observed to witness he had swallowed something which had burnt his mouth very much; there was some white powder laying on the table. Deceased asked the prisoner what mess she had put into the cup; she said none, unless the children had. Deceased said he had pulled her back two or three times, but that she would wash the cup; upon which prisoner asked how he could say he pulled her back, when he knew he did not. Prisoner said, "she did not know what it could be, unless it was the stuff she had from Dr. Watts". Deceased said, "you know that was rank poison, why did you put it in the way of the children?" Prisoner said she had put the stuff between two books, and she supposed the children had taken it for paper to curl their hair. Witness saw the stuff in the bucket; it looked whiter than that on the table.

Mary Hook lives at the Chequers, at Bitton. Worlock's little girl came there for some beer, which witness drew from the barrel into a pewter pint, and then put it into the cup. She did not observe anything in the cup. In a few minutes after witness went to Worlock's house, when the deceased asked what was in the cup; he said there was almost a teacup-full of white stuff in it. He told witness to go into the backhouse, where she saw the bottom of the bucket covered with white stuff; there was some

also on the table, which she touched; it was very rough and looked like salt. Deceased said he had caught hold of the prisoner two or three times to prevent her swilling the cup, but that she would do it. Prisoner and deceased went together to look for a doctor, and witness left the house at the same time.

George Hook (father of the last witness) went to Worlock's when his daughter returned; the prisoner and deceased were then from home. Witness looked into the bucket and saw the white powder; it was very rough and of a glistening nature; scraped some of it with his nail, and put it on a penny-piece on a shelf at home, in an inner room, for the purpose of shewing it somebody; witness's wife took the penny-piece away, not knowing there was any thing on it. Dr. Wingrove shewed witness some powder like it, but that in the bucket was of a rougher nature. Wm. Short tasted it in witness's presence.

Wm. Short went with Hook to Worlock's. The deceased's daughter shewed witness the bucket, the bottom and edges of which were covered with white stuff about an inch thick. Witness took some out of the bucket and tasted it; it had an unpleasant rough taste, which he did not lose for half an hour.

Rd. Jenkins stated that the deceased, in his wife's presence, told him there was something unpleasant in the beer he had drank, which the prisoner at first said was flour, but afterwards thought it must be some stuff she had from Dr. Watts. Deceased said he wanted to call some neighbour to look at it, but his wife threw it away, and he had hard work to save enough to shew Mr. Edwards. Deceased was uncommonly sick, and appeared to have something burning in his throat. Witness went with them to Mr. Edwards, and tasted the stuff. On their return, deceased complained much of his throat, and had a glass of gin, but retched more after that. Witness had seen deceased the preceding day; he did not complain of any illness.

Roger Edwards, surgeon, of Keynsham, deposed that the parties came to his house between nine and ten o'clock. The deceased appeared as he had always done, a poor sickly fellow; he did not vomit in his presence; he shewed witness a powder, and said he had been drinking and had something in his mouth like a hop. Deceased came to ascertain if the powder was poison. Saw him by accident two days after; he complained of sickness and pain in his stomach, and was in a high state of fever, and said he could retain nothing on his stomach. Witness ordered something for him; he was in a state of inflammation and in great danger. The powder was a vegetable powder, not powder of hop; could not tell what it was. Witness took an eighth part of the quantity into his mouth, it was free

from roughness and had the appearance of jalap[2]. An ounce of jalap might produce so much sickness as to occasion inflammation of the stomach. It was possible that death might be occasioned by taking an ounce of jalap, but witness never saw such a case. Jalap does not produce a burning heat; nor is it a white, glossy substance.

The Rev. Mr. Ellicombe, Curate of Bitton, was with Worlock on the 21st; he was sensible of his approaching death. A person came to make the deceased's will, which was read over in witness's presence. The deceased approved it, but wished his wife to enjoy the interest during her lifetime and till the children came of age. Witness afterwards administered the sacrament to the deceased and, at Mr. Edwards's suggestion, examined him as to what he knew of the affair. Deceased said his eldest girl was sent for some beer, that her mother met her in the passage, took the cup from her and sent her to look for the other children; that his wife set the beer before him, and being very thirsty, he had finished it at two or three draughts. He saw nothing floating at the top of the beer, but, in drinking it he found it foggy, and thought there was a hop in it; that he put his fingers in and took out some stuff which he put in a paper to carry to Mr. Edwards; that his wife snatched the cup from him, took it into the back place, and swilled it out in a bucket of water. He complained of internal pains, as if a fire was within him, and was very anxious about his children. The prisoner was not present during this examination. After the Coroner's inquest witness told her what had passed, and she was afterwards taken into custody. Witness said there was strong evidence of her having brought poison some weeks before, which she denied; she always said she loved her husband too well to do such a deed. Deceased had no delirium when he gave this information. Other persons put questions to him.

Samuel Watts, surgeon, of Bitton, was present when the body was opened by Mr. Edwards. The Coroner was not present at that time. On opening the stomach, there were found from four to six ounces of a brown fluid, which was put into a bottle by Edwards and his pupil for the purpose of being analysed; several livid spots were on the internal coat of the stomach, of a corrosive appearance, as though lunar caustic had been applied to it; the liver appeared tolerably healthy; the lungs were in a putrid state, but not particularly diseased; witness did not perceive that the fluid was flaky, nor did the intestines exhibit the same appearance as the stomach.

Mr. Edwards re-examined. On opening the stomach, it appeared that the inflammatory action had existed; several spots seen, apparently caused by

corrosive sublimate. On examining the stomach, the appearance did not seem consistent with that of a body poisoned; the contents appeared to be animal matter, but were not so; they looked like pus.

Sarah Jenkins, who lives at Bitton, met the prisoner on the road a few weeks before the inquest was held. Prisoner asked where she could purchase somewhat to put any body to sleep; witness told her at Mrs. Stephen's, a druggist's shop, at Kingswood; she said she did not want Godfrey's Cordial, but something to poison rats. They went to the shop together, where she was served with 2d. worth of arsenic; the person in the shop told her to be cautious where she put it if she had children, to which the prisoner replied she had no children. Prisoner afterwards said she "did not want it for poisoning rats, but she had a hell of a man that she wanted to put to sleep, and that if she could see an opportunity she would do it". She told witness not to expose her, and they soon after parted.

Elizabeth Amey, who lives with Mrs. Stephens at Kingswood, corroborated the statement of the former witness, as to the sale of the arsenic to the prisoner.

On the part of the prisoner several witnesses were called as to character, and to prove that the deceased had been complaining of illness for sometime previous to his death.

The Learned Judge then summed up the evidence in a very clear and impartial manner; and the Jury, after a few minutes deliberation, returned a verdict of *guilty*. His Lordship then, in a most impressive address, recommended the unhappy prisoner to employ the short period allotted to her in this world in imploring forgiveness of her offended Maker; and concluded by pronouncing the awful sentence of the law, which was carried into execution on Wednesday, on the new drop in front of the County Gaol; and her body, after hanging the usual time, was cut down and given to the Surgeons for dissection. We understand that she made a full confession of her guilt, previous to her execution. This trial excited very considerable interest, and lasted nearly eight hours, during which time the Court was excessively crowded.

1821

While the nation – and in particular the House of Lords – had, for the better part of the previous year, been preoccupied with the matter of the Queen, any idea of the King's Coronation had perforce been laid aside. However, with the withdrawal of the Bill of Pains and Penalties, some of the heat in the affair had been dissipated and, although it was no nearer resolution, it became possible to put in hand arrangements for the ceremony to take place. Nevertheless, the Queen was not to be invited to attend and to take her place at George's side, as convention – indeed, the Constitution – would normally have demanded.

It was on 19 July that, amid scenes of great splendour, George entered Westminster Abbey, minus Queen, but gorgeously attired, for a protracted and impressive ceremony. Outside, Caroline, ever prone to wilful but unwise excess, arrived demanding entrance, which was, of course, denied her, with further damage to royal dignity.

Three weeks later, on 6 August, most unexpectedly, and in the simplest, though saddest way possible, the apparently insoluble problem was solved. As the newly-crowned King was sailing into Holyhead Bay, on the way to make a regal visit to his other realm across the Irish Sea, Caroline suddenly died, to George's unfeigned relief.

Only two days earlier a Captain Crokat, of the 20th Regiment of Foot, had arrived on these shores after a lengthy voyage from the southern hemisphere. With the nation scarcely emerged from its preoccupation with its royal domestic squabble, the news he brought – that the old enemy, the great Napoleon, had died two months earlier on St Helena – came almost as a footnote.

Gloucester Spring Assizes

From the Gloucester Journal, 9 April 1821:

The Commission was opened here, about four o'clock on Wednesday afternoon, by Mr. Baron Garrow, Mr. Justice Parke not having arrived from Monmouth till the evening. On Thursday morning, their lordships attended divine service at the Cathedral, where an excellent sermon was preached by the Rev. Jos. Mayo, Chaplain to the High Sheriff, after which the business was opened in both Courts. Mr. Baron Garrow, who presided at the Crown Bar, in a forcible and perspicuous Charge to the Grand Jury, adverted with great earnestness to several points, which he felt particularly anxious to submit, as well to their consideration, as to that of the Magistrates at large.

After complimenting the Gentlemen whom he had now the honour to address, for the zeal and judgment they had uniformly manifested in the discharge of an important public duty, his Lordship expressed a wish that, amongst those who were summoned to attend upon these occasions, even the meanest individual should not be compelled to leave his humble dwelling oftener than he ought in justice to be called upon to serve his country. He felt it proper to make this remark, because, in the progress of the present Circuit, complaints had been made in other counties, of the unequal and partial manner in which the lists of Freeholders liable to serve as Jurors were made out, by which many parties were repeatedly called upon to serve in that capacity in the course of a few months, whilst they who were equally liable, had been totally exempted. His Lordship was not aware that such was the case in this county; but it would tend much to the equal distribution of these public duties, if a regular system were adopted, emanating from the Petty Constables of parishes, by means of which correct lists might be kept, that would shew at one view, as well those who had, as those who had not served as Jurors. The increase of crime doubtless rendered these labours more frequent and burthensome and he particularly cautioned those with whom the selection rested, to be careful that they evinced no partiality, either from favour or reward, as the discovery of any dereliction of duty in this respect would inevitably bring down the most exemplary punishment upon the offenders.

The next object to which he would beg their notice, was the extreme irregularity and inattention in supplying, for the information of the Judge, the depositions taken before the Magistrates on the commitment

of prisoners, which, whilst it seriously retarded the business of the Court, prevented the Bench from rendering that assistance to the Jury, so frequently necessary for their guidance. His Lordship added, that he had himself, since his arrival here, experienced the inconvenience and evil of such conduct in an important degree. At the time of opening the Commission, a few depositions were handed to him; at the hour of his retiring to rest, came some more; and next morning, when he was preparing for a more important duty, being summoned to attend the Cathedral, a further remnant was brought! But even the whole that were thus supplied bore no proportion to the number of cases likely to occupy the attention of the Court; and, instead of being put in possession of their several merits, by a careful and patient perusal of these scanty documents, he was shut out from a channel of material information, and cramped in the discharge of his official duty. His Lordship illustrated these observations by alluding to the case of a notorious burglar, who was convicted at a bar where he presided; but there being a capital charge against him in an adjoining county, his Lordship considered it his duty to send him there for trial, where he was sentenced to death, but respited, in consequence of offering to divulge important particulars respecting two mysterious murders. With so much plausibility was his statement made, that he would in all probability have received a pardon, and thus have been again turned loose upon society, had not the depositions been sent to London, in time for his Lordship to make enquiries, when the whole turned out to be a fabrication! The fellow was in consequence sent out of the country. His Lordship strongly urged the attention of the Magistrates to this subject; and suggested the propriety of sending their depositions to the Clerk of Assize, even before the commencement of the Circuit, which would enable the Judges deliberately to peruse their contents at intervals of leisure and convenience, and thus ultimately, in no small degree, expedite the public business.

The total number of prisoners was 103 for the county, and eight for the city; and the following are the sentences of those who have been tried:

CONDEMNED – *Wm. Newman*, for stealing a mare, the property of T. Matthews, of Stroud, *John Buck* and *Rd. Daniels*, for stealing woollen cloth, from the premises of Messrs. Harris, Stephens and Co. of Kinstanley; and *Saml.* and *Thos. Williams* (father and son), aged 43 and 18, for housebreaking at Stapleton.

SEVEN YEARS' TRANSPORTATION – *Jos. Pullen*, for stealing a silver spoon in the house of T. Newman, of Marshfield.

IMPRISONED – Eighteen Months and once publicly whipped: *Samuel Caines*, for stealing fowls at Oldland, the property of T. Waters – One Year: *John Dory* and *Danl. Sullivan*, for stealing wearing apparel at Cheltenham; *Thos. Papps*, for a like offence at Stroud; *Rd. Lewis* and *Edw. Richings*, for stealing geese at Cirencester; and *Jos. Jenkins* (an accomplice with S. Caines), for stealing poultry, the four latter to be whipped – Nine Months: *Wm. Brain*, for stealing pigs, the property of W. Phipps – Six Months: *Wm.* and *John Skarrett*, for stealing hay at Sevenhampton – Six Weeks: *Jos. Wyman*, for stealing woollen cloth, the property of Messrs. Austin and Co.; and *Thos. Barrett* and *Thos. Symons*, for stealing poultry at St. George's, the property of D. Donovan – One Month: *Wm. Archer*, for stealing hay at Sevenhampton; *John Cox*, for stealing a wool sheet, the property of Edw. Taylor, of Minchinhampton; and *Francis Caines* alias *Bush*, for stealing poultry at Oldland, the latter to be once whipped – Seven Days: *Amelia Poole*, for stealing milk at North Nibley.

ACQUITTED – Elisha Goram, Wm. Lake, Benjamin Roberts, Thos. and John Done, Jas. Curnock, Danl. Window, Jos. White, Benj. Matthews, John Brain, Stephen Chew, Edw. Hyatt, Edw. Robins, Caleb Mayor, J. Danvers, E. Willis and Sarah Baldwin.

NO BILLS – Jas. Screen, James Davis, Benj. Winyard, John Cox, Saml. Homeyard, Peter Johnson, Geo. Scott, Geo. Savage, Geo. Rudder, Thos. Jones, Thos. Blackwell, Rd. alias Robt. Webb, Wm. Hobbs, Geo. Britton, alias Headford, David Ridgway, Rebecca Hunting and Christopher Jones.

DISCHARGED BY PROCLAMATION – *Samuel Wozencroft*.

ADMITTED KING'S EVIDENCE – *Daniel Hall*.

William Berkeley was born in 1786, the eldest son of the fifth Earl of Berkeley and his Countess, *née* Mary Cole, the daughter of a Gloucester butcher. The Earl and his wife were joined in a marriage ceremony which took place in Berkeley church on 30 March 1785, but under such questionable circumstances that it was subsequently declared invalid. Although the couple's union was later regularised by a second ceremony in 1796, that could not, of course, alter the illegitimacy of William and other offspring who were born before that date. This fact thus debarred William from succeeding to the title, although he did inherit Berkeley Castle itself.

In 1831 he was created Lord Segrave, and later Earl Fitzhardinge, but in 1821 when the following civil case came to the Assize he was plain

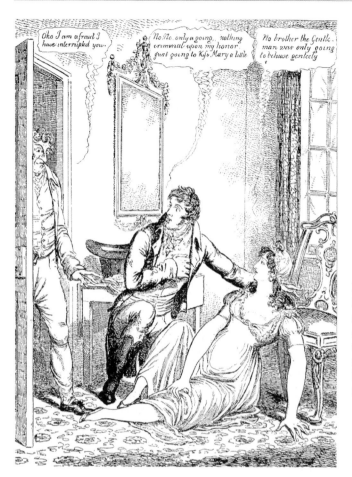

Left: 'The Berkeley Slip'. William Berkeley's adventures with the fair sex gave the cartoonists of the day full scope for their rather ponderous humour. Below: Berkeley Castle: the Inner Courtyard.

Colonel Berkeley of the Militia. He was nevertheless the wealthy owner of broad estates in the county and of properties elsewhere, allowing him to divide his time between enjoying the pursuits of a country gentleman in Gloucestershire and sampling the more sophisticated pleasures of London. He rode to hounds both with the Berkeley Hunt and at Cheltenham, where he kept a second pack. In the latter city he was also wont to indulge his passion for the stage, frequently acting alongside professional performers as famous as Mrs Siddons, whose fees he was well able to afford. To these colourful activities was added a reputation for adventures with the fair sex. It was probably in this connection that, on at least one occasion, he indulged in the useful practice, now fallen into disuse, of horse-whipping a newspaper editor whose actions had displeased him. He was, in short, as good a template as any for the archetypal Regency buck. Such notoriety, which the trial featured below will have done nothing to mitigate, would not have endeared him to the more sober and responsible members of the county's Society.

He had, for all that, a less frivolous side, involving himself fully in the political life of the county and adding his considerable weight to ensuring, in those corrupt times, that the Berkeley family sent its representatives to Parliament, in the shape of one or other of his brothers. All in all, one must admire young Waterhouse's temerity in bringing his action against such a powerful opponent. At all events, it represented an absorbing entertainment for those who were able to find seats in the Courtroom, as well as for those who were obliged to make do with the accounts which appeared in their newspapers.

From the Gloucester Journal, 9 April 1821:

CRIM. CON. – WATERHOUSE versus BERKELEY

The trial of this cause, which has excited a very extraordinary degree of interest throughout this county, came on about two o'clock on Saturday last, before Mr. Justice Parke, and a most respectable Special Jury, of which H. Burgh, Esq. was foreman. At one time during the day, owing to the indisposition of a very important witness, it was expected that the trial would of necessity have been postponed; to the great disappointment of numberless persons who had been drawn here from a distance on the occasion; but he soon so far recovered as to enable the case to be entered into. The trial was not concluded till after eleven o'clock, and during the whole of the time the Court was crowded to excess; in fact, it was

overflowing from an early hour in the morning, and the heat was so oppressive that one gentleman fainted away and was obliged to be carried out. We lament very much that the late period at which this cause was decided has prevented our reserving so much room in our present number as we could wish, in order by a full report of it to gratify the curiosity of our readers, as the near approach of our publication only leaves us space enough to give a brief narrative of the facts as proved in evidence. Damages laid at 20,000*l.*

The plaintiff, John Waterhouse, Esq. is the son of the late Benj. Waterhouse, Esq. of Kingston, Jamaica, who was connected with the House of Willis and Co., bankers in London; and, in the year 1810, whilst on a visit to the Isle of Man, became acquainted with Miss Jane Lascelles Blake, eldest daughter of Captain Blake R.N. who was for several years a resident of this city, and is well known to many of our readers. The lady was attractive, amiable, and highly accomplished; and the parties being about the same age, an attachment sprung up between them which eventually led to their union, and on the 5th September, 1812, they were married under the sanction of the lady's parents. After remaining about three months in the Isle of Man, they visited London, whence they proceeded to Scarborough, where they lived in retirement for three years; and the happiness arising from their union was crowned by the birth of three children. In 1817 they removed to Charlton Kings, near Cheltenham, in which village Lady Wraxall, aunt to Mrs. Waterhouse on the maternal side, resided.

Despite the lamentations it expressed above concerning the limited space available, the *Gloucester Journal* managed that week to pen quite a long report. However, the following, rather more detailed account it was able to publish in its next issue will have given greater satisfaction to its readers:

From the Gloucester Journal, 16 April 1821:

CRIM. CON. – WATERHOUSE Esq. versus COL. BERKELEY.
Mr. WEST opened the declaration, which stated the nature of the action. The damages were laid at 20,000*l.*

Mr. JERVIS addressed the Jury on behalf of the plaintiff; but the concise statement of the case given in our last will preclude the necessity of repeating the introductory particulars this week.

The Learned Counsel said that, when the parties were married, the plaintiff was about 20, and the lady a little younger. Soon after their union, from pecuniary circumstances, they retired to Scarborough; and in the course of the three following years they were blessed with three children, two girls and a boy. In the year 1817, from the state of the health of Mrs. Waterhouse, they removed to Cheltenham; and after a short stay in that town, they settled at Charlton Kings, about a mile from thence, where an aunt of Mrs. Waterhouse, the Lady of Sir W. Wraxall, then resided. In the winter of 1818, Mrs. Probyn, who had been an early friend of Mrs. Waterhouse, arrived at Cheltenham; their intimacy was of course renewed; and, thro' the medium of this lady, the defendant, Col. Berkeley, was introduced to the plaintiff and his wife in March, 1819. No particular intercourse followed between the gentlemen, further than an exchange of cards. On the 16th April, Mr. Waterhouse went to London to see his brother, who was ill, and continued absent till the 10th of May. It had been proposed to Mr. Waterhouse, in consequence of the increasing state of his family, having had a fourth child born at Charlton, to proceed to Jamaica, to endeavour to obtain a situation, by which he might be enabled the better to consult the comforts and happiness of those whom he so tenderly loved; for up to this time he did not entertain a doubt that he was in full possession of the warmest affections of his lady. At the commencement of the year 1820, he therefore resolved to prosecute that design; and on 18th Jan. in that year, he set off for Bristol, with a view of embarking for Jamaica. On thus again leaving his wife, Mr. Waterhouse left her under the protection of her aunt, as on two former occasions, with an ample provision for her maintenance during his absence. From Jamaica, Mr. Waterhouse returned in July, and knowing that he had had no intercourse with his wife from the 18th Jan. preceding, the Jury might better imagine than he was capable of describing, the agonized situation in which he was thrown on being informed of the course which she had adopted, and of her being then far advanced in pregnancy. He went to Cheltenham, but took the precaution of avoiding the abode of his wife. He remained there three days after the communication of the painful intelligence, and then left the place, determined never to see her again. His suspicions, which were, unhappily, but too well founded, were confirmed by an intercepted letter – the contents of which, as it had come from Mrs. Waterhouse, he was not at liberty to state. It was addressed to the present defendant, in language calculated to excite sensations which he would not venture to express.

He (Mr. Jarvis) was in possession of 24 letters and eight notes, written by the defendant to Mrs. Waterhouse, which were obtained from that lady on 12th Dec. in consequence of Mr. Waterhouse, with his solicitor, having gone to her lodging and obtained them by means which, under the circumstances, were not to be reprobated. The Learned Counsel then proceeded to read the letters in question, which, he contended, contained allusions which could leave little doubt as to the nature of the intimacy that had subsisted. At length the defendant evinced the waywardness of illicit love, and in his last short and hasty notes proved that his once ardent attachment had altogether subsided. The Learned Counsel then went on to state the oral testimony with which he was provided as to the occasional visits of the defendant to Mrs. Waterhouse – their private interviews and the subsequent disordered appearance of the lady's dress – and finally made an animated and eloquent appeal to the Jury, to compensate, as much as damages could compensate, the plaintiff for the injuries which he and his helpless infant family had sustained.

The Court then proceeded to the examination of witnesses, the first of whom, the *Rev. C. B. Maitland*, proved the marriage of plaintiff to Mrs. Waterhouse, at the Isle of Man in September 1812.

Lady Wraxall, aunt to Mrs. Waterhouse, deposed to their having resided in her neighbourhood, at Charlton Kings, from 1817 to 1820, when the plaintiff went to Jamaica. Witness had very frequent opportunities of seeing them; the conduct of the plaintiff was most exemplary of a good husband; he was the best of fathers; and witness never saw anything to the contrary of their living happily together as man and wife. On her cross-examination, Lady Wraxall stated that Mrs. Waterhouse quitted her residence at Charlton, and took a house at Cheltenham the day after plaintiff had left her to proceed to Jamaica. When plaintiff was at Cheltenham in December last, she understood that he would not see his wife at all. On witness representing to him the impropriety of his suffering Mrs. W. to go to live at Cheltenham, he assured her that he knew nothing of her change of residence. On the plaintiff's return from Jersey, in August 1819, he was much distressed about some reports which had been spread abroad to his wife's prejudice, so much that the ladies of the village had withdrawn their acquaintance from her; but upon being spoken to, Mrs. W. had given an explanation which was satisfactory to plaintiff and witness, and they continued to live together as before.

Mrs. Probyn, widow of Governor Probyn, had been acquainted with Mrs. Waterhouse for many years, and on witness's arrival at Cheltenham,

from the West Indies, about two years ago, their intimacy was renewed, and she then became acquainted with the plaintiff. They had visited her on two different occasions for a month at a time. Plaintiff was one of the best husbands she ever saw in her life, most exemplary as a father, and they lived perfectly happy together. Witness introduced the defendant to Mr. and Mrs. Waterhouse, at her own house, in March 1819. Cross-examined, said the introduction took place the day before witness left Cheltenham. About three weeks before, witness, at Mrs. W.'s request, had procured tickets for the Berkeley Hunt Ball; and the day after the Ball, Mrs. W. asked witness if Colonel Berkeley or Mr. Edwards had admired her dress; to which witness had replied in the negative. She did not recollect Mrs. W. asking to be introduced to the defendant, and never heard her express her admiration of the defendant's person, except in the most playful and innocent manner. On one occasion, Mrs. W., leaning on her husband's arm, was standing with witness at the window, when they saw defendant in the street. Witness remarked that he looked very well; and Mrs. W. observed "that if she ever intrigued with anyone, it would be with Colonel Berkeley." She considered them the happiest couple she had ever met with, and the observation alluded to was made in the most playful manner.

The Upper Nurse-maid to Mrs. Waterhouse said she recollected the defendant calling one day, about April 1819, when her master was from home. Her mistress had dined and slept out the night before, and returned home about eleven o'clock. Witness was desired to shew defendant into the drawing-room; there was a sofa there, and the bed-room communicated with it by a passage. There was no one in the room but her mistress and the defendant, who stayed about half an hour. Two months afterwards, the defendant called again, about nine in the evening. Before he came, a note was brought by a young woman. Her mistress was dining at Mr. Hall's, about half a mile distant; but the note was forwarded to her there, and she returned home as soon as she could. When Mrs. W. came home, she changed her dress, as if she was going to a ball. Tea was ordered, and the best plate got in readiness, but the tea was not to be brought in unless the bell rang. This was before the defendant came, he stayed about an hour.

Mary Wait, another of Mrs. W.'s domestics, swore that the defendant had visited several times in the course of last year. She had ordered her [illegible] occasions to enter the room till after he was gone [illegible] had heard the footsteps of one person from the drawing-room [illegible] to the bed-room. Once saw the frill round her mistress's neck, and her hair, very

much tumbled and disordered, Could not go from one room to the other without passing the public landing-place.

Anne Tree deposed to Mrs. W.'s generally being full-dressed when defendant called.

Dinah Breakspear, landlady of Sherborne Cottage, where Mrs. Waterhouse resided, was applied to by her to put up a muslin curtain against the drawing-room window. The sofa was opposite the window. Has known Mrs. W. deny herself to ladies, and afterwards admit defendant. She likewise spoke of hearing the footsteps of one person from the drawing-room to the bed-room.

Mr. R. Hughes, attorney, proved the circumstances under which the defendant's letters were found in Mrs. Waterhouse's possession by the plaintiff.

Mr. H. Davies, of the house of Willis and Co. in London, proved that the plaintiff had provided the means for his wife's subsistence during his absence in Jamaica, and that she had drawn 200*l* during the six months he was away.

Mr. W. Wood, surgeon, attended Mrs. Waterhouse during her confinement in November last. It appeared to be a full-grown nine months female child.

The defendant's letters were then put in, and their authenticity being admitted, were read to the Court. Their extreme length precludes us from giving them in detail. Like all epistles of a similar nature, expressions of rapture, admiration and attachment pervaded them; but tho' there was nothing contained in either of them which went positively to prove that the act of adultery had been consummated by the parties, yet the Learned Counsel for the plaintiff contended that the general import of some of them was such as to render it impossible not to draw an inference, that such a criminal connexion had taken place.

The case for the plaintiff being now closed, Mr. TAUNTON addressed the Jury in a very able speech on behalf of the defendant. He contended that the plaintiff had failed in making out his case, as there was not one tittle of evidence to establish that fact, upon which alone an action of this nature could be founded, namely, the fact of adultery having been committed. If that was not established to the satisfaction of the Jury, the case was no longer tenable, and they were bound to return a verdict for the defendant. He then entered into a minute examination of the evidence adduced, and the letters that had been put in, asserting that there was not in either any satisfactory proof of the plaintiff's having suffered the injury which was

set forth in the declaration. But, he said, supposing for a moment the Jury to be of a different opinion upon this point, they would then have to consider what compensation should be made for the loss the plaintiff had sustained; and the Learned Counsel argued that he had evidence to produce which would convince the Jury that the services and society of such a wife could not be estimated at more than nominal damages, and that the defendant was not the seducer but the seduced. Painful as it was to him, it was still more painful to his client, to have recourse to such a proceeding, but a sense of what was due to himself, in [illegible] from the imputations which had been thrown upon it, imperiously demanded of him to shew that they had not been justly bestowed. Unpleasant as was the task, yet he was now called upon to produce letters which would be proved beyond doubt to be in the handwriting of Mrs. Waterhouse, and which would establish the fact that she was the first to declare to the defendant that she had long secretly nourished a passion for him!

The Learned Counsel then read the four letters alluded to, and they were proved by Mr. Cossens to be in Mrs. W.'s handwriting. The two first were in a disguised hand, and were dated on 20th March and 10th April, 1819. The first declared, in the most unequivocal language, that the writer had for two years past cherished in her bosom a guilty passion, and now added to her guilt by confessing it, and spoke of the struggles she had had during that time with "an infatuation *violent as unaccountable*". It likewise described the efforts of the writer to avoid being in defendant's society, and declared her resolution to remain undiscovered. The last letter was dated 9th May 1819, and one of the defendant's letters, which was read in the progress of the plaintiff's case, was evidently an answer to it. The whole of these letters were couched in the most passionate language, and exhibited a painful picture of the mind of a woman who had fallen from that purity and virtue which constitute the greatest ornament of her sex.

Mr. JERVIS made a most animated reply to Mr. TAUNTON, in which he recapitulated some of his former arguments, and commented with great severity upon the course which the defendant had adopted, insinuating an opinion that some of the letters just produced were fictitious. In conclusion, he made a forcible appeal to the Jury, calling upon them to give such damages as the justice of the case demanded, and asserting that if they should return a verdict for the whole amount laid in the declaration, 20,000*l.*, it would not be a compensation for the loss and injury which his client had sustained.

Mr. JUSTICE PARKE now commenced a most able and impartial summing up. His Lordship said the first question for the consideration

of the Jury was whether adultery had been committed or not; and then, if they were of opinion that adultery had been committed, they were to consider what damages the plaintiff was entitled to. As to the proof of adultery, express evidence was not necessary, but they were to judge from the peculiar circumstances of the case. They would observe that the first introduction of the parties took place in the very end of March, and the first visit of the defendant occurred in April; the letters commenced at the same time. The parole evidence that had been adduced was insufficient to constitute the offence; but it was their duty to consider it as connected with the defendant's letters. They must read the letters as men of the world, and see what construction they could put upon them, and whether they did not satisfy them that an adulterous intercourse had taken place. His Lordship then read over the letters, and commented on them at great length. Another circumstance which called for their attention was the birth of the child. It was proved in evidence that the plaintiff left his wife in January, last year, and that she was confined on the 11th November following; thus it was completely out of the course of nature that it could be the plaintiff's child. Assuming that the fact of the adultery was proved, they now came to the second point for consideration – what amount of damages was the plaintiff entitled to. One of the Learned Counsel had made some observations upon the policy of making adultery a penal offence; whatever might be the expediency of such a measure, they had nothing to do with it, but they must be guided by the laws as they now exist. As a Jury of the country, his Lordship thought they had no right to inflict punishment upon the defendant, but they were in duty bound to consider fairly, what satisfaction the plaintiff is entitled to for the injury he has sustained. This was certainly a case unattended by those aggravated circumstances which marked most others of a similar nature. There was no friendship broken through, no hospitality violated. The plaintiff and the defendant did not appear to have walked to the house of God, and taken "sweet counsel together." They next came to the consideration of Mrs. Waterhouse's letters, which certainly were very material upon the question, what has the plaintiff lost? and presented a great circumstance of extenuation in favour of the defendant. In taking a review of these letters, his Lordship observed that the plaintiff's Counsel had called them fictitious, and had said that he was not satisfied with Cossens's evidence; for his part, he saw no reason to doubt their genuineness; and the defendant could not be said to have robbed the plaintiff of his wife's affections, as it would appear by those letters that they were gone before. His Lordship concluded by leaving the

case to the decision of the Jury, confident that they would return such a verdict as would, under all the circumstances, be satisfactory.

Verdict for the plaintiff – Damages *One Thousand Pounds*.

The following episode, whilst it could have had a serious, even tragic outcome, was more prank than crime, though foolishly conceived and the product of over-long visits to the alehouse.

From the Gloucester Journal, 7 May 1821:

OBSTRUCTING A MAIL COACH

The King v. Dove and others. Mr. Shepherd opened the indictment in this case, which stated that the defendants, Thomas and John Dove, Thomas Roberts, and William Lake, intending to impede a certain coach, called the Birmingham Mail, did place five gates, called field gates, in the highway, whereby the said common highway was greatly obstructed, and the said mail was in danger of being overthrown. There were other counts stating the offence differently.

Mr. Jervis stated the circumstances under which the indictment had been preferred. The prosecution, he said, had been instituted at the instance of his Majesty's Post-Master-General against the defendants, for a malicious and mischievous course of conduct, which might have been attended with fatal consequences to some of his Majesty's subjects. The two first mentioned defendants were in the habit of travelling about the country with a threshing machine; and the other two were labouring men. It would be proved that they, in company with an accomplice of theirs, of the name of Freemantle, did, on the night of the 24th of September last, whether with the intent of committing a highway robbery or not, the jury would be enabled to judge from the facts, sally forth from the town of Tewkesbury, between the hours of eleven and twelve o'clock, and after unhanging several gates, and pulling up the posts, did place them in the center of the public road, along which the mail coach, on its way from Gloucester, was then momentarily expected. Those gates they placed at the distance of about fifteen yards from each other, and then maliciously waited to witness the effect of their diabolical plan. Fortunately, from the accidental circumstance of a post-chaise being on its return to Gloucester, their principal object was defeated. Still, however, the mail was greatly impeded, and it was with the utmost difficulty that the coachman was enabled to prevent its being overthrown. It was needless to say how

necessary it was to bring the defendants to justice for such conduct, and by not permitting them to escape with impunity, to prevent the repetition of similar outrages.

Mr. Mayo, a bookkeeper, residing in the city of Worcester, was then called. He deposed that on the night of the 24th of September, as he was returning from Gloucester towards Tewkesbury in a gig, he met a post-chaise, the driver of which informed him that the road was obstructed at a short distance before him, and that he was apprehensive some mischief was intended. In consequence of this caution he proceeded with care, and at length came to several hurdles, gates, and posts which were placed across the road; he alighted from his gig to remove them, in order that he might pass; and having again mounted, he was about to drive on, when two men rushed from behind a hedge towards him, one of whom seized his horse by the head, and the other jumped up behind him. He threatened to blow out the brains of the man who held his horse, and who he believed to be Lake, although he could not swear to him, if he did not let him pass; and added that, as the mail was close at hand, he would have them both taken into custody. At this moment he heard the guard of the mail blow his horn, upon which the man behind him said, "Near as the mail was he would upset him". The mail then actually did come up, and the men escaped across the field.

The coachman of the mail was next called; he described the impediments which had been placed in the road. His horses were frightened, and he lost nearly twenty minutes in his journey.

Wm. Freemantle, the accomplice, was next called; he deposed that on the night in question he and the defendant had been drinking at several houses in Tewkesbury. They left the Wheatsheaf about half-past eleven, and proceeded towards Gloucester. Knew the two Doves for about 12 months. They travelled about with a thrashing machine. When they got a small distance from Tewkesbury, one of them broke a lamp and on getting a little further William Lake and Benjamin Roberts unhung a field gate, which they carried for a considerable way, and then broke it and threw it away. Witness then pulled up two hurdles and put them in the coach road. William Lake helped him. They afterwards pulled up several other hurdles and gates, which they threw down. They were all in liquor.

This being the whole of the evidence against the prisoners, Mr. Justice Park was of opinion that however mischievous and unjustifiable the conduct of the defendants had been, yet there had not been enough proved to sustain the indictment, which was framed under a particular act of

parliament. Under these circumstances, his Lordship directed the Jury to acquit the prisoners.

His Lordship then addressed the prisoners, pointed out to them the folly and witlessness of the [illegible] amusement in which they had indulged, and at the same time expressed a hope that the escape which they had had would operate so as to produce a wholesome effect on their conduct hereafter.

The Prisoners expressed their contrition for what had passed, and were discharged.

Gloucester Summer Assizes

From the Gloucester Journal, 20 August 1821:

The business in both Courts commenced on Monday morning, the Lord Chief Justice presiding at the *Nisi Prius* and Mr. Baron Garrow at the Crown Bar. The latter in addressing the Grand Jury of the County, offered his sincere congratulations on the diminution of prisoners in the calendar, exhibiting a presumptive proof of improvement in the state of the public morals. Several concurring causes doubtless operated towards this great benefit, and it might not be too much to hope that it will ultimately promote a still more general amendment. The great extension of schools for the National Education must have advanced in no small degree the morals of the poor; and another cause, strongly operating to so desirable a result, would assuredly be found in the great reform which had been so generally effected in Prison Discipline, though no where in a more eminent degree than in this county, where the Magistrates so zealously and beneficially employed themselves for the public good. Before this happy achievement, our Prisons were extremely bad schools, where those who were immured for trivial offences were too frequently made adepts in crime when they came to be enlarged. Another circumstance which operated powerfully towards the improvement of the lower orders was the watchful attention bestowed by Magistrates to the conduct of those to whom they granted alehouse-licences. Great benefit must be derived from the orderly conduct of publicans in the management and decorum of their houses, the irregularities in which were the grand source of the accumulated evils of nocturnal depredations. An instance had come within his knowledge, wherein four paupers assembled at one

of these receptacles of vice, in order to plan an attack on the property of some person in the neighbourhood; and altho' one of them got so drunk as to be incapable of accompanying his associates, yet the gang considered him duly entitled to a share of the booty, which he absolutely received! It was worthy of remark that there were more sheep stolen between Saturday night and Monday morning than during the remaining part of the week; and could farmers but devise some means of security in that short interval, they might very easily be protected from the heavy losses hitherto sustained.

To guard against depredators, who made the public-house as well the place of their rendezvous, as the scene for perfecting their schemes of plunder and exciting their courage, Constables ought to second the efforts of the Magistrates, by enforcing orderly conduct and a rigid attention to early hours. By due vigilance in this respect, whilst great good would result to the publican, the effort would be magical to his customers, and we should no longer hear of those inroads upon the property of honest individuals which were at present a disgrace to the police of the country.

CONDEMNED – *Joseph Ford*, for stealing a horse, the property of J. Copeland, of Abingdon; also convicted upon a second indictment for horse-stealing; *Jas Westwood*, for stealing a lamb, the property of Mr. Beech, of Quedgley; *Samuel Brinkworth*, for maliciously cutting and maiming T. Cordy and J. Pitt, constables of Horsley; *Thos. Marklove* and *Isaac Bennett*, for burglariously breaking open the dwelling-house of R. Groves, of Tewkesbury, with intent to commit some felony therein; these were the two prisoners who broke out of Tewkesbury Gaol in June last, as detailed in a former paper; *John Baker*, aged 16, for breaking open the dwelling-house of Sarah Allsop, of Farmington, in the day time, and stealing thereout thirteen handkerchiefs, a shirt, and various other articles of wearing apparel, &c, her property; *Francis Rice*, for a burglary in the house of J. Coulstone, of Elmstone Hardwick, and stealing thereout a quantity of cheese and other articles; *John Badcock, Edward Downing*, and *Wm. Westwood*, for stealing a horse, the property of J. Arkell, sen. at Sezincott; also convicted of another offence of a similar nature; *James Roberts*, for a burglary in the house of C. Swaine, at Painswick, and stealing thereout a quantity of wearing apparel, &c; *Robt. Whiteway*, for breaking open the dwelling-house of J. Pool, at Welford, and stealing thereout a quantity of wearing apparel; and *Samuel Cooper* and *Edward Child*, for breaking open the wash-

house of Mr. T. Hulls, at Corse, and stealing thereout a quantity of linen, his property. All the above capital convicts were reprieved, except *Jas. Ford*, *John Badcock*, and *John Baker*, who are left for execution, and it is expected will suffer on Saturday next.

A prisoner wearing leg irons. What with hard labour, flogging and the treadwheel, life for condemned felons was far from comfortable.

1822

In London, Lord Liverpool had been rearranging his Cabinet. The Home Secretary, Lord Sidmouth, thought at 64 to be somewhat past it, was succeeded by Robert Peel, then on the threshold of his distinguished ministerial career. He immediately began the much-needed task of updating and strengthening society's ability to defend itself against the criminal elements which it always harboured. Over the next few years, Peel disposed of a number of obsolete statutes and brought in new ones to make the criminal law more effective. At the same time, he began the reform of the forces of law and order which he believed was necessary to enable that law to be effectively enforced. Central to this was his concept of an organised police force, to replace the present inadequate system. In this, however, he was to meet considerable resistance, born of the fear that such a move would be inimical to personal liberty, and it would be some time before his ideas had any effect, not only in the capital, but, for an even longer time, outside it.

Gloucester Spring Assizes

From the Gloucester Journal, 8 April 1822:

On Wednesday afternoon, the Commission was opened at the Shire-Hall, in this city, before Mr. Baron Garrow, and in the course of the evening, Mr. Justice Richardson also arrived. On Thursday morning, their lordships, attended by the High Sheriff, S. J. W. Fletcher Welch, Esquire, went in procession to the Cathedral, where an excellent and appropriate Sermon was preached by the Rev. T. B. Newell, the Sheriff's Chaplain, from Peter ii 17: "Love the Brotherhood. Fear God. Honour the King." Their Lordships

Robert Peel.

afterwards proceeded to the Shire-Hall, when the business of the Assize commenced, Mr. Justice Richardson presiding in the Crown Court, and Mr. Baron Garrow at *Nisi Prius*. The Grand Juries for the county and city having been sworn in, Mr. Justice Richardson addressed them nearly as follows:

"*Gentlemen of the Grand Jury for the County of Gloucester*, I have great satisfaction at meeting so full an attendance of Magistrates, evincing as it does, on this as on every other occasion, the attention constantly paid to your public duties. This county, I believe, had the honour to take the lead in the internal administration and construction, as well as discipline, of Gaols; and I am happy to observe the public attention still engaged in this interesting subject, that enlarged improvements are now going on, and others under consideration. One most important point has been effected in nearly all the prisons in the kingdom, by rendering them free from infection; so that instead of being subject to the propagation of disease, our gaols are now, perhaps, the most healthy of all our numerous populous establishments. Though much has been done in the system of classification, more still remains to be done in populous counties, where the offenders are numerous. You have also adopted in your Penitentiary, a principle, with respect to persons confined after conviction, which, I believe, has not been initiated in any other institution of the kind – I allude to solitary confinement. By this, the law does not mean that a person should be excluded from all communication with his friends, but merely that he should be left to himself during a considerable portion of the time for which he shall be so sentenced. On the subject of hard labour, I must observe that the law is not carried into execution unless the prisoners have hard labour provided for them in the gaol, which is intended to be more an object of punishment and example to other offenders, than of profit to the proprietors. The Calendar, I am sorry to say, is as numerous as usual at this season; but I am not aware that there are many cases which require any observations from me.

The first case we meet at this year's Assizes is a civil one and once more concerns, not any criminal activity, but the tangled consequences of a love affair which was destined to perish on the rocks. It might easily have formed the plot of a popular novel of the day, containing as it does certain familiar elements of the genre: the dashing young officer paying court to an attractive young lady; the love affair threatened by the disapproval of the young man's family, she being rather below his station in life; the girl's father, as

the courtship becomes somewhat prolonged, demanding to be told if the young man's intentions are honourable; the lady, when her hopes are dashed, swooning away – not once, but twice . . . Can it be true? Read on.

From the Gloucester Journal, 8 April 1822:

BREACH OF PROMISE OF MARRIAGE

King versus *Chance* – This was a Special Jury case, which came on before a crowded Court, on Saturday, about one o'clock. Mr. Ludlow opened the pleadings; after which, Mr. Jervis stated the case for the plaintiff, which was one, he observed, that called upon the jury to compensate, as far as pecuniary damages could compensate, for one of the most cruel injuries which could be inflicted on the female sex. The plaintiff in this case, Miss Mary King, was the only child of the manager of a very extensive and respectable manufactory, at Dursley, in this county, and was now about 32 years of age; but at the commencement of the courtship whence the present action originated, was only 26; and the defendant, Mr. Daniel Gardiner Chance, was a gentleman of considerable fortune, of accomplished manners, and had served some time as a Lieutenant in the South Gloucester Militia. Before the year 1815, he had met with the plaintiff, a young lady of great personal charms, and, attracted by her beauty, was induced to visit her at the house of her father. She was certainly inferior to him in point of situation, and followed the business of fancy-dress maker, her father's salary amounting to only 80*l.* a year. In the month of April 1815, the defendant, after visiting at the house of the plaintiff's father, invited him to the Old Bell, at Dursley, to take some refreshment. After some conversation, Mr. King, with laudable and natural anxiety for the welfare and credit of his daughter, asked the defendant what was the object of his visits? The defendant, with the open honesty and candour of a soldier, replied, "What more can I say, or what can I do more to convince you of the honour of my intentions? May my right arm drop off, and may my tongue cleave to the roof of my mouth, if I ever deceive you or your daughter; there is no one shall ever call me husband but she, and I'll make her my wife". Mr. King then remonstrated with him, observing that, as he was a gentleman of fortune, he supposed he expected some fortune, to which defendant replied that he wished for no fortune, but the person of his daughter. After some further conversation, the defendant observed that he was old enough to be his own master, and to chuse for himself. The Learned Counsel would not enter into a minute detail of the

circumstances, as they would be elucidated by many letters which he had to read. Mr. Jervis here read extracts from a number of letters addressed by the defendant to the plaintiff, commencing in the year 1815, couched in terms of the warmest and most honourable attachment, and breathing sentiments of the most tender description. The Learned Counsel dwelt at some length upon the contents of these letters, which, in several instances, alluded most explicitly to his intention of marrying the plaintiff. On the 4th of February 1819, however, a letter was addressed to the plaintiff, in which it was evident that his affections had begun to cool; but, to the honour of the defendant, Mr. J. observed, it bore testimony, in the most precise terms, to the exemplary virtue and propriety of conduct of the plaintiff. In the month of May 1820, the defendant visited the plaintiff at her father's house; and, without any previous announcement of a change of sentiment, abruptly stated his attachment to another lady, and asked the plaintiff's consent to his marrying her, at the same time demanding that all letters which had passed between plaintiff and himself might be destroyed. At this unexpected communication she fainted away, and whilst in this state her father entered the room. On demanding of the defendant what was the matter, he referred him to his daughter, who, when she was a little recovered, exclaimed, "Oh! God, this will be the death of me!" and again fainted. On recovering a second time, she explained to her father, as well as she was able, the cause of her distress; when Mr. King reminded the defendant of their conversation at the Old Bell, and upbraided him for his conduct. After some further conversation, the defendant referred Mr. King to his mother, at Uley, wither he went; but during his absence, the defendant renewed his demand for the letters, and threatened to break open the doors and locks of the house to procure them! On Mr. King's return, he found the defendant still at his house, and informed him that he had seen his mother, who had declared to him that he (her son) had been engaged to Miss Maria Evans for the last twelve months, which the defendant flatly contradicted. A few days afterwards, the defendant wrote to the plaintiff, pressing her to give up or destroy the letters. In the month of March 1821, the defendant's mother, upon whom he was wholly dependant, and who had uniformly opposed the connection, died, and he in consequence came into possession of a landed estate to the amount of 500l. a year; and, on the 21st of Jan. 1822, the defendant was married to the lady above alluded to.

Upon that statement of fact, Mr. Jervis observed. The Jury had now to decide. The defendant had made promises, and he had broken them; and

the only question now to be considered was the amount of the damages, for in rendering to the plaintiff such justice as was now attainable by the law of the land, pecuniary damages constituted the only balm which could be poured into the wounds she had sustained. He would venture to assert that no evidence would be adduced on the part of the defendant, no letters would be read, or if they were, there was nothing which required concealment. There was no disparity of ages; the courtship had been continued six years, and the defendant was quite old enough to judge for himself. To the plaintiff, the loss of six years was not to be retrieved; her beauty faded, and her eyes,

"White and azure, laced with heaven's own tint,"

were dimmed under the pangs of disappointment! Let it not be forgotten, likewise, that, although the defendant himself had borne testimony to the vitruous propriety of the conduct of the plaintiff, the censorious were ever ready to throw out insinuations; and her peculiar situation might render her, in spite of her unimpeachable correctness, an object of illiberal reproach. The same circumstances would operate against her forming another connection. It was for the jury, therefore, to estimate the loss which the plaintiff had sustained. That the defendant was her superior in rank was a great aggravation. To be allied to a man of honour was the great object of female ambition; and he was not ashamed to say, in the presence of the ladies who surrounded him, that that was one reason why the sex were generally so partial to gentlemen of the army, as they were equally distinguished for their honour and gallantry. He did not know what his Learned Friend's eloquence might adduce in mitigation of damages; but the only topic he could conceive was that the defendant's affection having experienced a change, he was no longer worthy of the plaintiff's regards! in answer to this he would say, that even supposing his affections not to be within his own control, the very moment the change commenced, and that the passion of love departed from his breast, humanity ought to have stepped in. The life of the plaintiff had nearly been the sacrifice of the cruel treatment she had experienced, and the only remuneration the law could now afford her was in the shape of pecuniary damages. He therefore concluded by calling upon the jury to give a very large and liberal compensation for the injury inflicted.

Mr. Jarvis having concluded an animated and impressive address, to which we lament that our limited space will not allow us to do justice, the Counsel for the plaintiff proceeded to the examination of witnesses,

the first of whom was *Mr. John King*, the plaintiff's father, who distinctly proved the conversation between the defendant and himself, at the Old Bell, in April 1815, as recited by Mr. Jervis; and also confirmed the statement of the circumstances which took place in 1820, when the defendant first announced the change which had taken place in his sentiments and intentions. The defendant had frequently repeated his promise to marry his daughter, but could not say when. His daughter was in a large way of business, as she worked for most of the ladies in the neighbourhood. After the interview in May 1820, the plaintiff continued in fits all that evening and nearly the whole of the following day; and, since that period, her health had suffered so materially in consequence of the disappointment, that she could not attend to her business, which had therefore fallen off. The plaintiff's mother died a short time before May 1820.

Jane Wood, an apprentice to the plaintiff, and *Eliz. Harris*, likewise in her employ, deposed to the frequent visits of the defendant, and the bad state of health of the plaintiff since the interview in May 1820.

Hester King, cousin to the plaintiff, proved the defendant's handwriting in the letters. Documents were then adduced, proving the date of the death of the mother of the defendant, his age, and lastly his marriage with Miss Maria Evans, on the 21st Jan. 1822.

The letters commented on by Mr. Jervis were then put in and read; after which *John Morgan, Esq.* was sworn, who proved that he rents mills of the defendant to the amount of 400*l.* a year. Being cross-examined by Mr. Campbell, this gentleman stated that the defendant, after the disbanding of the Militia, went to live with, and was entirely dependent upon, his mother. The defendant was certainly not a man of affluence.

The evidence on the part of the plaintiff having been brought to a close, Mr. Puller, for the defendant, proceeded to address the jury in mitigation of damages. He commenced by stating that he should confine himself to the plain and simple language which had been promised by his learned friend, but which he had, somehow or other, totally forgotten in the course of his address; for whether he had become inflamed by his subject, or excited by his powers of oratory, he had indulged them with both pathos and poetry. A principal point which the jury had to consider was, who are the parties and what are their situations in life? The defendant undoubtedly moved in a higher sphere and had superior connections to the plaintiff; and the latter, in a comparatively humble situation, endeavoured to gain a livelihood by honest and virtuous industry. His client would be the last to say a word either against her honour or her virtue; and if, as his learned friend had

set forth in aggravation, the censorious would render her situation the subject of unmerited reproach, it was the greatest satisfaction to him, in the name and as the representative of the defendant, to offer, in the most public manner, his testimony to the unimpeachable propriety and strictly virtuous conduct of the plaintiff. In reviewing the whole circumstances of this case, the disparity in point of situation of the parties could not fail to strike the minds of the jury. They were both young, and, under the influence of a mutual attachment, it was not much to be wondered if they should be blind to the course which prudence would point out. But it should be borne in mind that, from the commencement, the friends of Mr. Chance, upon whom he was entirely dependent, were totally averse to the connection. Of this fact, the plaintiff's father was perfectly aware, as appeared by the first conversation between him and the defendant; and yet they had heard of no interview between the former and the connections of the latter. Here the Learned Counsel argued at some length that, in such a state of affairs, it was the duty of Mr. King, as a parent, not to encourage the visits of the defendant to his daughter, knowing them to be unsanctioned by his relatives; and, had he placed himself for a moment in their situation, his conduct would have been very different. He (Mr. Puller) thought that it was the relatives of the plaintiff, rather than she herself, who were now seeking for redress in a Court of Justice. His Learned Friend had contended that the only balm which could now be administered to the plaintiff, would be by awarding her heavy damages; but if she feels as she was represented to do, damages would afford no consolation; and, in his opinion, the best balm would be what had been that day voluntarily offered – the most public acknowledgement of her virtue and propriety of conduct. After some remarks upon what the plaintiff might be supposed to have lost, Mr. Puller proceeded to argue that if the lady's father had acted a prudent part he would, instead of encouraging an intimacy, have represented to her that she was endeavouring to place herself in a situation where her affections would be continually wounded, by the neglect and want of countenance of the defendant's friends. That a real regard had existed between the parties, could not be doubted. This was not the case of a person lightly and frivolously securing the affections of a female; for the whole tenour of the letters shewed that he had felt a strong and sincere attachment, but which was eventually borne down by the continued difficulties he had to encounter, and the unceasing opposition of his friends, whose relative situation gave them a paramount claim upon him. in conclusion, Mr. Puller said that he knew a verdict must be given for the

plaintiff; but he entreated the jury not to be led away by their feelings, or by the impassioned eloquence of his Learned Friend, but coolly to weigh the circumstances of the case; and as it was proved that his client was not in the affluent circumstances which had been represented, he conjured them not to be instrumental to his ruin, by awarding excessive damages.

No witnesses being called for the defendant, Mr. Baron Garrow proceeded to sum up the evidence, and addressed the jury in a remarkably forcible and perspicuous manner. In recapitulating the circumstances of the case, his Lordship animadverted in strong language upon the abrupt communication of the defendant, at the interview in May 1820; which his Lordship characterized as unfeeling and inhuman. By the law of the land, the plaintiff had certainly a right to be recompensed for the outrage her affections had sustained; her fortune broken, her health materially impaired, and her future prospects blighted, she asked for such compensation as the law could give, but in making the estimate of that compensation, the jury were to consider the circumstances of the defendant, and not by giving vindictive damages, to bear too heavily upon the innocent partner of his fortunes, but to return such an amount as the justice and merits of the case under all its various bearings seemed to them to demand.

The jury, after a few minutes consultation, returned a verdict for the plaintiff, EIGHT HUNDRED POUNDS damages. The trial occupied the attention of the Court till nearly six o'clock.

Counsel for the plaintiff, Messrs. Jervis, Taunton, and Ludlow; Attorney, Mr. Stone, of Tetbury. Counsel for the defendant. Messrs. Puller and Campbell; Attorney, Mr. Croome, Cainscross.

From the Gloucester Journal, 15 April 1822:

Our Assizes were brought to a close on Tuesday afternoon; and the following were the sentences of the prisoners:

CONDEMNED – *Rachael Davies, Edward Haynes* and *Henry Baker*, for a highway robbery at St. Philip and Jacob; *Jos. Surrage*, for breaking open the house of Rd. Wright, of Westerleigh; *Jos. Holder* (pleaded guilty), for breaking open the house of E. Close, of Rodborough; *Fras. Jefferies*, for a burglary in the house of G. Packer, of Siston; *John Wilmer*, alias *Smith*, for stealing a quantity of plate from the dwelling-house of J. Ranger, of Cheltenham; *Saml. Fry, jun.* and *Wm. Fry*, for stealing money in the house of F. Hicks, of St.

George; *John Stone*, for stealing seven sheep, the property of G. Taghill, of Wick; and *Benj. Burlow*, for stealing one ewe lamb at Dymock, the property of R. Chinp. The above were all reprieved before the Judges left this city.

They therefore joined the 'transports', presumably in their cases, for life. Among others who were transported, for the lesser term of seven years, were, notably, William Corbett (alias Hughes), for stealing two cheeses and a coat; and William Hughes, for stealing 'a counterpane from a hedge in Barton Street' – both of which offences would appear to us really quite minor to have attracted the severe punishment of banishment from their native land. Of the other offenders, two reflected the strict morals of the day (the official ones at any rate): Hannah Bishop and Hannah Pegler were sentenced to six months and one month respectively, 'for endeavouring to conceal the birth of her bastard child', while Edward Lewis got one month, 'for stealing a piece of coal, from the coal-heap of D. Oldland, at Ham'.

Gloucester Summer Assizes

From the Gloucester Journal, 19 August 1822:

Soon after five o'clock on Wednesday evening, the Judges, Sir John Bayley, and Sir Wm. Garrow, arrived in this city, escorted with the customary formalities, by our High Sheriff, S. J. W. Fletcher Welsh, Esq., and immediately proceeded to the County Hall, where the Commission was opened. On the following morning, their Lordships attended Divine Service, at the Cathedral, where the Rev. Mr. Newall, the Sheriff's Chaplain, delivered an excellent Sermon from Micah, vi, 8 *"He hath shewed thee, O man, what is good; and what doth the Lord require of thee, but to do justly, and to love mercy, and to walk humbly with thy God."* On reaching the Shire Hall, Sir John Bayley took his seat in the *Nisi Prius* Court, whilst Sir W. Garrow presided at the Crown Bar.

The calendar for the county contained the names of 36 prisoners, whose cases were gone through by four o'clock, on Saturday afternoon; and the following were the sentences:

CONDEMNED – *Samuel Barrett*, for stealing three geldings, the property

of Mr. Richard Hooper, of the parish of St. George; *Moses Sweet*, for breaking into the dwelling-house of James Ball, of Olveston, and stealing thereout a quantity of wearing apparel and other articles; *John Lloyd*, for breaking into the dwelling-house of G. Phillips, of Stoke Gifford, and stealing thereout a pair of sheets, and other articles; *Wm. Gordon*, alias *George Long*, for burglariously breaking into the dwelling-house of F. Pickard, of Stroud, with intent to commit a felony therein; and *Edw. Jones*, for breaking into the house of G. Hurcom, of Tidenham, and stealing therefrom a quantity of money in silver, and two gold rings.

TRANSPORTATION – *Thomas Howman*, for stealing a watch, a guinea, and half-a-crown, from the person of Benj. Kitchen, at Cheltenham, to be transported for life; *Thos. Phipps* and *Thos. Pitt*, for stealing a quantity of rope, the property of W. Pugh, at Stroud, for fourteen years; and *Wm. Hobbs*, for stealing a quantity of wheat from the barn of J. Pendock, of Winterbourn; *Lewis Morgan*, for stealing a drab coat, the property of J. Cooke, sen., of Cheltenham; and *Elisha Millett*, for stealing three lamb-skins, from the stable of J. Hawkins, of Mangotsfield, for seven years.

From the Gloucester Journal, 2 September 1822:

EXECUTION – On Saturday last was executed, on the lodge of our County Gaol, *Samuel Barrett*, aged 31, convicted at our late Assizes of stealing three horses, the property of Mr. Richard Hooper, of St. George's. Since his condemnation, it is satisfactory to be enabled to state that his behaviour was very proper and becoming his awful situation. He received every attention from the Rev. Chaplain, and by the penitence he evinced, shewed that he had made a due use of those consolations which religion held out to him. On Saturday, after receiving the Holy Sacrament, he was conducted to the scaffold, about twelve o'clock, and having briefly exhorted the people to take warning by his disgraceful fate, was launched into eternity, in the presence of an immense concourse of spectators. We would fain hope that his warning may take effect upon his guilty companions, but that he afforded in his own person a melancholy proof of the insufficiency of those dreadful examples of the law to deter the hardened offender from the repeated commission of crimes denounced as capital by our existing code. The subject of this notice was from the neighbourhood of St. George's, where we fear there are many more of equal depravity. About seven years ago he was sentenced to be transported for stealing two donkeys, from Bradbury, Wilts, and having served five

years and three months on board the hulks, the remainder of his term was remitted, and he was discharged in January, 1820. He was immediately returned to his old companions, and was in close connection with a most notorious set of horse-stealers and house-breakers, of whose proceedings he has given an accurate account. Since the period of his discharge, it appears that he has been actually a party in stealing no less than thirty-five horses from various parts of the country, which were disposed of at Smithfield, Brighton, Bristol, and other places; and he was one of the persons concerned in the robbery of Mr. Godfrey's house, at Bitton, a few months ago. Some of the property has been recovered, in consequence of his confession, and we would give a more minute detail of his nefarious transactions, but that we might thereby defeat the ends of justice with regard to his equally guilty associates.

From the Gloucester Journal, 19 August 1822:

The city calendar contained the names of only two prisoners, *Saml. Pantell* and *Henry Travell*, who were convicted of stealing a silver pint and two spoons, the property of Mr. John Aston, and sentenced to seven years' transportation.

Although the Summer Assizes of 1822, like those previously in the Spring, yielded less than the usual amount of crime, there were happily some members of the gentry ready to come forward in their stead, not with any infraction of the penal code, but seeking settlement of a quarrel which had proved intractable of resolution, save in the Courts.

From the Gloucester Journal, 19 August 1822:

There was but little business to do in the *Nisi Prius* Court, the list containing only 14 causes. The following, which was tried on Friday, excited great interest, and having caused much conversation at Cheltenham, the court was crowded at an early hour by fashionables from that town, anxious to hear the proceedings.

DEFAMATION – *The Rev. Jas. Stovin, D. D. and Eleanor his Wife,* versus *Lady Shuckburgh.* This case was appointed to be heard by a Special Jury, but only four of the gentlemen summoned thereon appeared; four others were fined *5l.* each, the absence of the remaining sixteen being accounted for they were excused, and Mr. Puller prayed a tales[3].

Mr. Cross opened the pleadings, and Mr Puller in laying the case before the jury, stated that considering who the Plaintiffs and Defendant were, and the place from whence the case came, he was not surprised that it had excited considerable interest. There was no one, he observed, not even Lady Shuckburgh herself, who appeared before them this day with greater regret than Dr. Stovin and his wife; and glad would they have been if by any possibility they could have avoided coming into a Court of Justice in order to vindicate their character. The jury must all be aware how valuable life was with, and how utterly valueless it was without, character, and he thought that before he had proceeded far in stating the circumstances of this case, they would be of opinion that if this recourse had not been had, Dr. Stovin and those nearly and dearly connected with him must have passed the remainder of their lives under the imputation of a crime that would banish them from Society; and though happy in the other blessings of life, those would have been worth nothing when the family were stripped of their character. Juries were generally assembled in such cases to consider what damages some individual had sustained by another imputing to him want of skill in his profession, but they seldom were called on in cases stripped of all those circumstances, and where the injury the plaintiff had to complain of was simply and purely of this kind – where the defendant could do the plaintiff no harm in any of the advantages of life he possessed, except by rendering all those advantages wholly barren and useless to him with the imputation that rests on his family from the charges thus made. He must be a man of extraordinary philosophy of mind who could be content to go about (as Dr. Stovin was obliged to do on account of ill-health) into places where such a report would be particularly likely to injure him. He was a gentleman in possession of a large fortune, and Rector of Rossington, in the county of York, and had been a Magistrate of that county for many years, but from being subject to the gout he was obliged to be very often at Bath and other watering places. Mr. Puller then detailed the circumstances which gave rise to the slander charged against Lady Shuckburgh, as detailed in the evidence of Mrs. Marshall; and that with respect to the assertion that Mrs. Hunt had refused to dine with Capt. and Mrs. Inglefield, because she would not meet the Stovins, the Learned Counsel observed that Capt. Inglefield, understanding that such assertion had been made by the defendant, called upon Mrs. H. upon the subject; that Mrs. Hunt at the request of Capt. I. waited upon the defendant and demanded her authority for the assertion; that the defendant at first denied having used such language,

but being reminded by a gentleman present that she had stated the same fact to him, the defendant then said that she must have heard it from some body else. To rebut this the Learned Counsel stated that he should call Mrs. Hunt, who was then in attendance, and who would prove that so far from having ever given grounds for such a statement, she had never been invited either by Captain or Mrs. Inglefield to meet the Stovins. Mr. Puller then enumerated other instances of the circulation of the slander by the defendant, and concluded a very eloquent address by stating that the plaintiffs had denied on oath the imputation against them, by affidavits made with a view to an application to the Court of King's Bench for a criminal information, and he called upon the Jury to give such damages as would mark the sense they entertained of so serious an imputation cast on the characters of his clients.

Mrs. Eliza Lucas Marshall, the lady of the Master of the Ceremonies at Cheltenham, was examined by Mr. Campbell, and stated that in the month of January last, Dr. and Mrs. Stovin, and their three daughters, came to Cheltenham, and introduced themselves to her by making use of the name of a family to whom she was under obligations for many civilities, and she called upon the ladies in consequence. The witness and Mrs. Stovin and two of the Miss Stovins were present at a ball given by the Master of the Ceremonies, at Cheltenham, on the 21st of January last. At the conclusion of the Ball, the Miss Stovins went home, and Mrs. Stovin came up to the witness taking her arm till the servant returned; they walked up and down the ballroom several times, and then going into the card-room Mrs. S. took her leave. The witness immediately took a vacant chair at the loo table. Lady Shuckburgh, Mrs. D'Arcy, Mrs. Curwen, Mrs. Macleod, and Captain Nicholson were at the table. Lady Shuckburgh said, "Pray Mrs. Marshall who was the lady that was walking with you with the scarlet tippet?" I replied, "a Mrs. Stovin." She immediately exclaimed, "Good God! what brings her here?" "I believe for the benefit of her daughter's health". Lady S. replied, "I am astonished at her assurance in coming here so near the neighbourhood of Bath". The witness replied that it was the wife of a Dr. Stovin, of Yorkshire, conceiving Lady S. must have mistaken the lady. Lady S. said, "I know very well who she is. Did you never hear of her shocking infamous conduct at Bath?" upon which the witness immediately rose from the table, considering that an improper place for any explanation of such a delicate nature. The next day she waited on Lady S. at her house in Berkeley-Place, and was introduced into the drawing-room. One of her ladyship's daughters was there, who was in a

very delicate state of health, and was reclining on a couch. Mr. Curwen was in the room. Witness said, "Upon my introduction I apologised to her Ladyship for calling upon her at such an early hour, but that I was induced to do so in consequence of the words that she had made use of at the card table the night before. Upon which she immediately said, "Mrs. Marshall, did you never hear of anonymous letters which were written at Bath seven months ago?" I stated that I could not then be there for I was on the Continent, upon which Lady Shuckburgh said, "Mrs. Marshall, that family have written anonymous letters of an infamous nature, destroying the character of two ladies, the Miss Amratts, particular friends of mine; these letters were dropped in the ball room at Bath, one of which was picked up by a gentleman, and after reading it he presented it to one of the Miss Stovins, saying we are now at no loss for the author of these letters". Lady S. further said, "that the matter was very generally known in Bath, and to several in Cheltenham; amongst the number, Mrs. Hunt and Col. Burke, that Mrs. Hunt had refused to dine with Captain and Mrs. Inglefield, because she would not meet the Stovins, and that they were very dangerous characters". The witness then observed to Lady Shuckburgh that she extremely regretted that her Ladyship had taken such an extremely public manner of alluding to it, for had she called her aside and mentioned it in confidence, she would have felt bound in honour not to have repeated it, and would have gradually declined the acquaintance with the Stovins without any communication on the subject, as they were strangers to her; upon which her Ladyship replied that she was one of those that never destroyed or killed character in the dark; what she had said she was neither ashamed nor afraid to avow: that she wished it to be known; upon which the witness made a remark that she thought it a pity that Capt. and Mrs. Inglefield, such highly respectable people, who seemed so intimately acquainted with family, should not be made acquainted with the circumstance; upon which her Ladyship replied, "that I was perfectly at liberty to repeat it to whom and to as many as I pleased". I wished her Ladyship good morning and withdrew.

Mr. Jervis cross-examined this witness, but nothing was extracted from her inconsistent with her examination in chief; and Mr. Marshall being called as the second witness.

Mr. Justice Bayley – Will this enquiry do any good to either party? *Mr. Jervis* – I think not my lord. *Mr. Justice Bayley* – Cannot you arrange it between you? *Mr. Jervis* – Yes my lord. *Mr. Justice Bayley* – And there had been a suspicion? *Mr. Jervis* – There then the justification is proved

to a certain extent. *Mr. Justice Bayley* – The justification is bad in law I think. *Mr. Jervis* – Not worse than any count in the declaration. *Mr. Justice Bayley* – That is all matter of law. *Mr. Jervis* – For the words admitted to have been spoken by Lady Shuckburgh on the record, she is perfectly ready to apologise. *Mr. Justice Bayley* – I think she would be wise not to limit her apology. *Mr. Jervis* – She is a Lady of very high rank and great respectability, and it cannot be admitted that she is guilty to the full extent charged. *Mr. Justice Bayley* – If I have said so, I am sorry for it. *Mr. Jervis* – She is sorry to have given offence to these parties; and if it can afford satisfaction to the minds of Dr. Stovin and his respectable family (for such I must admit they are), what they have sworn I will admit to be true. I will go further: I am speaking my sentiments and I believe I am authorised to speak the sentiments of my client; I have no doubt she believes those affidavits to be true, and I think with that and an apology for the words she admits having spoken, the plaintiff ought to be satisfied. *Mr. Justice Bayley* – I think there must be a verdict against you. *Mr. Jervis* – Then that must be taken with all its consequences in point of law, and I apprehend they will not get much by that verdict. *Mr. Justice Bayley* – Perhaps the plaintiffs were driven to the necessity of bringing an action in order to challenge an enquiry. *Mr. Sergeant Peake* – I feel authorised by my brief, and what I have seen elsewhere, to say that Lady Shuckburgh only spoke of suspicions; and her Ladyship has come here merely to answer to those suspicions that she entertains. *Mr. Justice Bayley* – I think this enquiry will satisfy persons there was no foundation for the suspicion. *Mr. Puller* – If my Learned Friend says that on her Ladyship's part, I will be satisfied. *Mr. Jervis* – That is too much; there were such suspicions, and they continued in the mind of Lady Shuckburgh up to the time that she spoke these words. It stands as a fact on the statement of my Learned Friend, and that must be taken as strong as if proved (which it is not in this case) that Dr. Stovin and his wife cleared themselves by their affidavits. Whether that fact was known to Lady S. at the time of those words, I do not know.

Mr. Justice Bayley – I think Lady Shuckburgh may say, with propriety, at the time I believed the words well founded; subsequent facts have led me to believe there was no foundation. If you mean this, which I think it comes to, that at the time you spoke the words you believed every thing you stated to be true, but that you are now satisfied, from subsequent investigation, that there was no foundation for the charge, that will do.

Mr. Puller – Dr. Stovin does not come here willingly. *Mr. Campbell* – And with less than your Lordship has proposed, we cannot be satisfied.

Mr. Jervis – Lady Shuckburgh is here for the purpose of a personal communication with me, if necessary.

Mr. Justice Bayley suggested the propriety of Mr. Jervis seeing Lady Shuckburgh, and he withdrew accordingly for the purpose. Upon his return, the Learned Gentleman said, "My Lord, I have waited on Lady Shuckburgh, and read to her Ladyship part of the affidavit of Dr. and Mrs. Stovin, which I will now read to your Lordship". (The passage was read by Mr. Jarvis, denying all connexion with the authorship or circulation of the anonymous letters at Bath). "I further informed her Ladyship that this was not a voluntary affidavit, but an affidavit made with a view of moving the Court of King's Bench for a criminal information. Her Ladyship then authorised me to state what I am now about to read to your Lordship, and which she wrote, because I knew it would be desirable that it should be her voluntary statement, and one that would not rest on the frail memory of any individual; and therefore, my Lord, in her presence, and in the presence of her respectable Solicitor, I wrote these words:

"Mr. Jervis having read to me that part of the affidavit of Dr. and Mrs. Stovin, in which each of them have deposed that they or either of them were not nor was, directly or indirectly, concerned in or privy to the writing or circulating the said anonymous letters therein referred to, and that they or either of them had not at the time, when the investigation therein mentioned took place, nor have they or either of them at this present time the slightest knowledge either of the authors or distributors of the said letters.

I do hereby voluntarily declare that I believe the said affidavit to be true; that the said affidavit has completely removed from my mind the suspicions which I entertained that the said Dr. or Mrs. Stovin, or some of their family, had either written or circulated the said letters; and I declare myself sorry for having published those suspicions. (Signed) C. C. SHUCKBURGH"

Mr. Puller – I beg to thank your Lordship for your kind interposition. Dr. Stovin came here for redress, as the only place open to him; for he was advised it would not be proper to apply for a criminal information. He came here to vindicate the fair fame of himself and his family, and in order to convince the world that damages were not the object, and how little he regards pounds, shillings and pence, in the present question, he consents to the intimation of your Lordship, that a Juror should be withdrawn.

Mr. Justice Bayley – It seems to that the explicit manner in which Lady Shuckburgh has expressed herself does her the greatest degree of credit;

and that Mr. Puller behaves most properly, for he has narrowed what I had originally proposed, namely, that he should take a verdict. He consents to the apology, and I shall be extremely happy if the investigation of today shall remove every suspicion as far as relates to Dr. Stovin's family; and as far as I may express myself of Lady Shuckburgh, I am sure it will raise her very much in my estimation. I think I may say from the part Mrs. Marshall has taken, she does not appear to me to have taken the part of a busy body on the subject; but unfortunately that which never can be kept secret got wind. *Mr. Jervis* – I agree in that sentiment. Mrs. Marshall has acted in a manner which does her great credit.

The apology was accepted, and a juror was withdrawn.

The Counsel for the plaintiffs were Messrs. Puller, Campbell, and Cross; Attorney, Mr. John Phillpotts. The Counsel for the defendant, Mr. Jervis, Mr. Serjeant Peake, and Mr. Maule; Attorney, Mr. Maul, of Bath.

Mr Sergeant Ludlow, a leading member of the Bar who frequently appeared in both criminal and civil cases.

1823

The start of the year saw the loss of one of the County's most eminent sons, with the sudden death on 26 January at his Berkeley home, the Chantry, of Dr Edward Jenner, in his seventy-fourth year. Although he had chosen to spend his working life as a general practitioner in that same town where he had been born, his true life's work was devoted to the larger goal of the eradication nationally of the smallpox disease, then widespread.

In his daily occupation, he found himself caring for many affected with that malady while, as a country doctor making his rural rounds, he was also made aware of many cases of the bovine disorder of cowpox. The latter was often passed on to humans, though, unlike smallpox, without fatal results. Jenner perceived not only that there might be a connection between the two, but also that the link might prove the key to finding a defence against the greater disease. By dint of many years of experimentation, perforce on patients under his care – and even on his own son – he succeeded in proving the truth of his contention that vaccination of human beings with the milder complaint of cowpox would render them immune from the other, more deadly scourge.

Gloucester Spring Assizes

From the Gloucester Journal, 14 April, 1823:

Daniel Pennington, aged 21, a young man of respectable appearance, was indicted for forging a bill of exchange for 100*l*.

R. Morris, Esq., examined by Mr. Ludlow – I am a banker in this city, and John and Thos. Turner are my only partners. On 28th Sept. last, the

Dr Edward Jenner.

prisoner came to our Bank, and offered a bill to be discounted. (Witness here handed the bill to the Counsel.) Prisoner said he received it from his father. Being a stranger I asked him if he knew any body in Gloucester. He said he did not; that he came from Oxford; that his father was an accountant at No. 10, Charles-square, Hoxton, and that his name was Osborne. I said it was quite unusual to discount bills for strangers; however from his respectable appearance, and the appearance of the bill, I discounted it. I gave him 99*l*. 3*s*. 6*d*. the remainder, 16*s*. 6*d*. was deducted for interest. I told him to indorse it, and he wrote upon it, "D. Osborne, for G. Osborne, 10, Charles-square, Hoxton." He said he was staying at the Bell. The bill was sent to London, and was returned. I went in consequence to London; and, from information, on the 18th October I found the prisoner asleep at the Wellington Inn, Highgate. On awaking him, I asked if he knew me. He said he had seen me at Gloucester, at our Bank, where he came to have a bill discounted, and that I had discounted it for him. I said, if you knew it was not forged, why did you not give me your own address. He said he had heard the bill was bad that morning, and was going to his friends in Cumberland to get the money, to send it to Gloucester. He then protested he did not know the bill was forged; he said he had never seen it until his father gave it him to bring down to Gloucester. I again asked him why he assumed a false name, and gave a false address. He said his father told him to do so. He was in great agitation, burst into tears, and begged of me to let him go. He said his father had been a clerk in Jones, Lloyd and Co's bank for nineteen years; and, on going there the following morning, I found that statement to be true. He was searched in my presence by an officer, and some letters were taken from him; I marked them, and believe these are the same. (The Learned Judge decided they could not be received). I inquired at two houses marked No. 10, Charles-street, Hoxton, and found no person of the name of Osborne living there. The prisoner was brought to Gloucester, and, on his examination before the Magistrates, stated that he had filled up the bill. Nothing had been said to him to excite either hope or fear. He said he had written the body of the bill and that his father had put the names to it. He was going to say something further, but was advised by some gentlemen present to say no more.

Mr. Andrew Dickie, examined by Mr. Phillpotts – I am the accepting clerk at Messrs. Coutts. I was so in September last. The firm was Messrs. Coutts and Co. This acceptance in question (it being handed to him) was written "Messrs. Thomas Coutts and Co". The name "A. Dickie" upon it is not my

Gloucester: Westgate Street in 1826, looking north-west, with St Nicholas Church in the distance.

writing. I never accept in red ink. The firm was "Messrs. Coutts and Co". (Witness here enumerated the names of the parties). Mrs. Coutts has an interest in the concern, but has no influence in the arrangement of the Bank.

Thomas Lee, a boot-maker, in London, said he had known the prisoner for thirteen years, by no other name than Daniel Pennington, which was his father's name.

Cross-examined by Mr. Osborne – The prisoner has friends and connections in Cumberland, and he lived with witness until his father came to town.

The bill was put in and read, and was as follows:-

"No. 4,651100*l*. Montrose, Sept. 5, 1822."

"Two months after date pay to my order the sum of One Hundred Pounds. JAS. ANDERSON."

"Messrs. Thomas Coutts and Co".

Across it in red ink, was written "Accepted for Messrs. Thomas Coutts and Co. –

A. Dickie". It was indorsed:-

"Jas. Anderson; W. Forbes and Co.; D. Osborne, for G. Osborne, 10, Charles-square, Hoxton".

The prosecution being closed, the prisoner in his defence said, in an unembarrassed manner, that his father was in business some years ago, and having failed, was desirous of not being known by his old acquaintances, and assumed the name of Osborne. With respect to the bill, he had received it from his father, and had been desired by him to get it discounted at the Gloucester Old Bank; that he went there accordingly but Mr. Wood declined discounting it; upon which he went to the Bank of the prosecutors, where he received the money for it, the whole of which he paid to his father, on his return to London.

Mr. Lee gave the prisoner an excellent character for sobriety and honesty, during all the time he had known him.

Mr. Justice Best told the Jury the prisoner was accused of a double charge, either of which was a capital offence. The several counts only varied the charge. He was accused of forging the instrument in question. If he assisted in framing it at all, his Lordship said, that would be a forgery in the eye of the law. If a person sat by, and saw another draw up an instrument by which parties were defrauded, and if such individual concurred in the act, that was a forgery. According to the evidence of the first witness, the prisoner had undoubtedly assisted in framing this bill, by which he had defrauded the prosecutors of a considerable sum of money. If that testimony was to be credited, certainly he was guilty of the forgery. The next charge was uttering the bill with an intent to defraud, knowing it to be forged; of this, there was but too much reason to fear he knew it to be the fact. The bill had been clearly proved to be put off, and that the prosecutors had been defrauded; and unless the Jury were satisfied he had been duped by his father, it would be their painful duty to find him guilty. His Lordship then read the evidence, and left the case in their hands.

After a few minutes' consultation, the Foreman (with tears trickling down his cheeks, and almost devoid of utterance) delivered the following verdict – *Not Guilty* of the forgery, but *Guilty* of uttering the bill knowing it to be forged. He then begged to say, in the name of the Jury, he hoped the Learned Judge would shew mercy upon the unfortunate young man, they believing he had been influenced by his father to commit the crime.

Mr. Justice Best – I am obliged to you, gentlemen, for your tender recommendation.

Mr. Ludlow – My Lord, I am requested to urge the same plea for the prosecutors as the Jury have humanely done.

Mr. Morris then addressed the Court, begging his Lordship would extend his mercy towards the unhappy young man, he believing him influenced by his father, whom he considered to be a very bad man. A prosecution had been brought against him for forgery, upon which, however, he had just been acquitted at Lancaster. There were hopes yet left, which led the applicant to believe he might be ultimately brought to justice. He had succeeded in several instances in defrauding persons of sums of money to a considerable extent, by means of forged bills.

The prisoner, when called up for judgment, knelt down, but did not offer a word in justification of himself.

Mr. Justice Best, in the most solemn manner, with a subdued tone of voice, evidently proceeding from deep emotion, addressed the prisoner in the following terms: "Daniel Pennington, you are a young man only 21 years of age, standing to receive judgment of death, being convicted of uttering a forged note, by which the prosecutors have lost a considerable sum of money in advancing it to you. In a commercial country like this, it is highly important to have crimes committed against its interests punished; and unless a Judge find any strong reason to recommend the unhappy violator of the laws to the Sovereign, it is usual to leave them to their fate. Your humane prosecutor, notwithstanding what he has suffered – and the Jury, who have suffered still more – have recommended you to mercy. I shall undoubtedly forward these recommendations to his Majesty, whose paternal heart is always awake to the lives of his subjects, being ever delighted when an opportunity presents itself, by which a single life can be spared. If mercy should be extended, it is fit that those grounds should be mentioned upon which it may be obtained. The Jury, and the prosecutors, believe that you have been led to the commission of this crime by your wicked father; who, forgetting the first duties of nature, has led you into those paths which you have trodden, and tempted you to do that which you otherwise would not have done. If mercy should be shown to you, let it not tempt others to be so persuaded, for they may depend upon it, should this crime be repeated in similar circumstances to yours, they will undoubtedly suffer the last dreadful sentence of the law. No person ought to yield obedience to others, by which he may be led to the commission of crime. And however proper it is to follow the advice of parents, yet if commands were given leading to infamy and disgrace, such commands should not be assented to. If mercy be extended to you, it will be only on condition that you spend the remainder of your life in a distant land – in a state of slavery – far from your native country and its liberties. When in

that distant clime, let me entreat you to endeavour to make reparation for your offences by a virtuous life". His Lordship then passed upon him the usual sentence, which he said he hoped would be suspended.

During the trial, an extraordinary degree of sympathy pervaded the Court, which was crowded to excess – many of the auditors wept on the delivery of the verdict, and several ladies sobbed aloud during the address of the Learned Judge, on passing sentence.

Our Assizes did not terminate until after middle day on Tuesday, nor would they as soon have been brought to a close, had not Mr. Justice Best lent his assistance, by trying prisoners in the *Nisi Prius* Court.

In addition to the ten capital convicts enumerated in our last, the four following likewise received sentence of death: *Henry Arnfield*, for stealing a sheep, the property of C. Smith, of Horfield; *Wm. Reed*, for stealing ten sheep, the property of J. Wickham, of Chipping Sodbury; *John Danvers*, for breaking open the dwelling-house of J. Wilson, of Stapleton, and stealing thereout 30*s.* in silver, a great coat, and other articles, his property; and *Edw. King*, for breaking open the dwelling-house of J. Bowsher, of Marshfield, a stealing thereout a gun and other articles, his property. All the capital convicts were reprieved before the Judges left town, with the exception of *John Hill*, for a highway robbery, who, it is expected, will suffer on Saturday next.

Wm. Martin, for stealing a great quantity of materials used in the manufacture of hats, from his master, Mr. W. A. Glover, of Tetbury, to be transported for seven years; and *Wm. Champion*, for receiving the same, knowing it to be stolen, to be transported for fourteen years.

CONDEMNED – *Daniel Pennington*, for feloniously uttering a bill of exchange for 100*l.* at the Bank of Messrs. Turner and Co. in this city, knowing the same to be forged; and *Saml. Hopkins*, aged 16, and *Wm. Birt*, aged 15, for breaking open the dwelling-house of J. Smart, in the Southgate-street, and stealing thereout a variety of millinery and wearing apparel.

These convicts were all reprieved.

Gloucester Summer Assizes

From the Gloucester Journal, 11 August 1823:

On Saturday afternoon, soon after three o'clock, both the Judges, Sir Jas. Allan Park and Sir John Bullock, Knights, were met with the usual ceremonies at Over, and being escorted into this city by the High Sheriff, John Smyth, Esq., of Stapleton, proceeded to the Shire Hall, when the commission was immediately opened. Yesterday their Lordships attended Divine Service at the Cathedral, when an excellent sermon was preached by the Rev. Mr. Bedford, the High Sheriff's Chaplain, from *2d Peter ii. 19, "While they promise them liberty, they themselves are the servants of corruption"*.

Business commences this morning in the *Nisi Prius* Court, at nine o'clock, and in the Crown Court at eleven, in order to give time for the arrival of the Grand Jury, &c. The calendar for the county contains the names of 44 prisoners, and that for the city [illegible]. There is a prospect of considerable business in the *Nisi Prius* Court, 41 *venires* having been returned, eight of which are entered for Special Juries; but at a late hour last night only 25 were entered for trial.

From the Gloucester Journal, 18 August 1823:

Gardiner v. Prosser – This was an action for assault and battery committed by the defendant, an exciseman, on the plaintiff, a young man of 20 years of age, an articled clerk to Mr. Stone, an attorney. The defendant pleaded the general issue, but did not appear by counsel or in person to defend the cause.

It appeared in evidence that in August last Mr. Prosser called at the premises of the plaintiff's brother at Chalford respecting a pointer dog which he claimed, but which was the property of Mr. William Gardiner. Whilst they were talking, the plaintiff came up, and his brother asked him to show the defendant out, as he was using violent language. The plaintiff accordingly walked out with the defendant, and the brother of the plaintiff returned into his house. He was shortly, however, called back, and found the defendant standing over the plaintiff, who was lying on the ground, and striking him over the mouth and face with a sword-cane, which was broken in the encounter. The defendant was then stopped from further violence, and it was found that three of the plaintiff's front teeth were

broken, and that his mouth was severely wounded. In consequence of his injury, he was unable to swallow solid food for several days, he was obliged to make a journey to Bath to obtain the advice of a dentist, and his speech was permanently affected.

Mr. Justice Park shortly pointed out to the Jury the aggravated nature of the assault, and of the injury for which they were to give compensation in damages.

The Jury, after a few minutes' consultation, found a verdict for the plaintiff – Damages 20*l.*

Mr. Justice Park – Really, Gentlemen, I wish you would reconsider your verdict. I did not read over the whole evidence to you; but I think you must see that the plaintiff complains of a very serious injury, which was utterly unprovoked on his part. He has lost three teeth, besides being obliged to take a journey to Bath; do you value three teeth only at 20*l.*?

The Jury consulted again for nearly a quarter of an hour, and then the Foreman said, "We think, under all the circumstances, that 20*l.* is enough. We find for the plaintiff, damages 20*l.*

The verdict was then recorded, without any further observation from the Judge.

1824

The French Revolution, with all its horrors, had been a shock and a warning to the governing classes of Europe, not least in this country. In 1799 the fear that its radical ideas might take hold here was still strong: at that very moment the nation was actually at war with those same Revolutionaries. That fear and the current general domestic unrest caused the government of the Younger Pitt, in that year and the following one, to introduce the legislation known as the Combination Acts, which forbade workers to join together against their employers, for the purpose of extracting improved conditions, in effect outlawing the nascent trade unions.

The laws were too stringent to survive as they stood. In 1824, Lord Liverpool's ministry, in a fit of enlightenment, decided to repeal them. Such incaution naturally opened the gates and the floodwater poured out: strikes, disturbances and mob violence broke out across the country. In 1825 Parliament took up the problem anew and later that year a new Combination Act appeared in the Statute Book, but in a milder form, less inimical to personal liberty.

Gloucester Spring Assizes

From the Gloucester Journal, 5 April 1824:

On Wednesday afternoon, about four o'clock, Sir James Allan Park arrived in this city, and alighted at the New Shire Hall, when the Commission was opened. His Lordship then proceeded to his lodgings, attended by the High Sheriff, T. J. L. Baker, Esq. Sir Wm. Garrow reached town a few minutes afterwards. On Thursday their Lordships, in the usual form, attended

Divine Service at the Cathedral, where a highly appropriate Sermon was preached by the Sheriff's Chaplain, the Rev. R. J. Cooper, from Isaiah, xlii. 4, *The isles shall wait for his law*. Soon after twelve their Lordships adjourned to the County Hall, where the business commenced, in the *Nisi Prius* Court before Mr. Justice Park, and in the Crown Court before Mr. Baron Garrow.

From the Gloucester Journal, 12 April 1824:

HIGHWAY ROBBERY – *George Cooper, Thomas Herbert,* and *Wm. Bridgewater* were indicted for robbing John Debanks on the highway within this city. Mr. Phillpotts conducted the prosecution; and the prosecutor deposed that he lives at Hatherop, in this county, and on the 14th Nov. last brought a patient to the Infirmary. In the evening, he went to the Upper George, where he drank some beer, and fell into company with the three prisoners. About eleven o'clock, he wished to return to his lodgings at the Green Dragon Inn, and, being a stranger, told Herbert if he would shew him the way, he would treat him with a pint of beer. Herbert consented, and the other two said they would go along. Under pretence of pursuing the nearest way to Southgate-street, they took him down Cooke's-lane, towards the County Gaol, when, suspecting they had some evil design in view, he attempted to run away. Bridgewater followed, and knocked him down; and Herbert came up, knelt on his breast, and held his hands, whilst Bridgewater picked his pockets of 23s. or 24s. Cooper was standing within a few yards during the transaction; after which they all ran off together. He had only had two pints of beer, part of which the others drank, and he was perfectly sober; it was a very clear moonlight night, and he swore most positively to the persons of all the prisoners.

A witness of the name of Wood fully and minutely corroborated the prosecutor's statement. He had seen the parties leave the Upper George together; and, from his knowledge of the prisoners, and observing the direction in which they were leading the prosecutor, he suspected their intention, and followed them at a distance. By carefully concealing himself from their view he watched their conduct nearly all the time. He afterwards met Debanks in Southgate-street, without a hat, and with his face covered with blood. Prosecutor told him he had been robbed and ill-used; and witness, from his knowledge of the parties, procured the assistance of two watchmen and proceeding to their lodgings, took Herbert and Bridgewater into custody in a very short time, when Debanks

instantly recognised and identified each.

One of the watchmen, named Critchley, swore that, from information he had obtained, he went next morning to Maisemore, and apprehended Cooper at the Ship public-house. On their way to Gloucester, without the vestige of a promise or threat from the witness, Cooper confessed the robbery, and added that Bridgewater gave him 2s. 6d. as his share of the booty.

The prisoners, who were assisted by Mr. Twiss, made no defence, and called no witness to character.

Mr. Baron Garrow, having summed up the evidence with his usual clearness and precision, proceeded to state that the case was one of most momentous consequence, inasmuch as it involved nothing less than the lives of the prisoners at the bar. He therefore conjured them to weigh with the utmost deliberation the evidence adduced in support of the prosecution; and if they were fully satisfied of the guilt of the prisoners, it was their bounden duty, however painful to their feelings, fearlessly and boldly to convict them. On the other hand, if they entertained any doubts on the subject, they would return a verdict accordingly.

The jury, having consulted for a few minutes, returned a verdict of *Guilty*, but recommended the prisoners to mercy. The judge enquired upon what grounds; when the jury hesitating a little his Lordship added, "It is my duty to tell you, Gentlemen, that I cannot receive that recommendation, unless you state the grounds on which you make it." The jury then stated that it was on account of their youth, and its being their first offence, to which the Judge replied that, in the faithful discharge of his duty, he could not join in their recommendation. The prosecutor now interposed, saying, "My Lord, I hope you will let them off as easy as you can". To this his Lordship observed, "I will convey your merciful recommendation, and that of the jury, to the proper quarter, which is all I can promise to do. The fountain of mercy is in the breast of his Majesty, where it flows in an unceasing stream upon all occasions where, in the opinion of his advisors, it can be extended consistently with the public justice of the country; but I must again add, I cannot join in that recommendation. I beg I may be clearly and distinctly understood. Let it not be supposed for a moment that I, or any other of the Judges, are desirous of hanging any of the unfortunate beings, whose fate we have to decide upon. God knows! we are far more anxious to lay hold of any favourable circumstances in their cases, upon which we can rest a plea for the Royal interposition of mercy. During the progress of this long and arduous Circuit, it has been

matter of no small consolation to me that, in only one instance, have I been called upon to carry into effect the awful denunciation of the law; and that was in the case of a father who had murdered his own child; and in this extensive county, the business of which I have just finished, altho' there were sixteen persons capitally convicted, yet, in the case of every one of them, I have been able to discover some circumstance upon which I felt justified in exercising the discretion reposed in me by a recent Act of Parliament, and thus spare myself that most painful part of my duty, namely, pronouncing the dreadful sentence of the law upon those unhappy offenders. Happy should I be, could I do the same in the case now before me; but it is attended with circumstances of so aggravated a character that, in the upright and honest discharge of the duty I have to fulfil, it is impossible I can do it. I promise however, Gentlemen, faithfully to report your recommendation; and this is all I can do".

Proclamation having then been made, the Judge proceeded to pass sentence on the prisoners, in the following terms: – You *George Cooper*, you *Thos. Herbert*, and you *Wm. Bridgewater*, have been severally tried by an impartial Jury of your country and, upon evidence as clear as was ever adduced in a Court of Justice, have been pronounced guilty of the capital offence of highway robbery, and that too under very aggravated circumstances. The person whom you have robbed, and the jury who have tried you have humanely joined in recommending you to mercy. That mercy can only emanate from the Royal breast. The recommendation I will myself faithfully state, with every note I have taken down of your trial, to the Secretary of State, upon whom I shall call immediately after my return to London. It will then remain for his Majesty's confidential advisors to consider whether, after being acquainted with every particular of the case, they can report you as proper objects for the Royal clemency; and here, I shall have done with it, for I tell you plainly and fairly that, in the honest and faithful discharge of my duty, I cannot add my weight to their recommendation, and I will state the reasons why. If we cannot restrain people from the commission of these heinous offences against the peace and security of his Majesty's subjects, it behoves us to visit, with more than ordinary severity, those instances in which the parties convicted are proved to have used violence in the perpetration of their crimes. In your case, under the pretence of shewing an act of courtesy and kindness to a stranger in your city, with whom you had associated for some hours, and whom you offered to conduct to the place where he proposed to seek repose for the night, you deliberately seduced him

to a spot more favourable for the committal of that enormous offence of which you have been found guilty, and there, not satisfied with depriving him of his property, you treated him with a degree of [illegible], dreadful to think of, and which must put an effectual bar on any interposition of mine in your favour. As I before observed, the seat of mercy is the Royal Breast; and to that seat I shall convey the recommendation of the jury and prosecutor. In the mean time, the best advice I can give you is to prepare for that event which I can hold out no hope to you will be averted. It will be consolatory and profitable to you to do so. Let not a moment be lost in reflecting upon your mis-spent lives; and, in seeking mercy and forgiveness at the hands of Him, who is the God of Mercy, and whose laws you have so dreadfully transgressed. Fly to that blessed Redeemer, whose atonement was a sacrifice for guilty sinners, and upon a reliance in whose merits you can alone depend for the remission of those sins in a future state, which cannot be extended to you in this. The Learned Judge then pronounced the sentence of the law in the most impressive terms.

From the Gloucester Journal, 26 April 1824:

The sentences of *Wm. Bridgewater, Thos. Herbert, Geo. Cooper, Wm. Adams, Saml. Smith*, and *Wm. Saunders*, who were capitally convicted at the late Assizes for this city, have since been commuted to transportation for life. From the very severe terms in which Mr. Baron Garrow animadverted upon the aggravated nature of the offence (highway robbery) of the three first, whilst passing the awful sentence of death upon them, it was supposed they would have been left for execution; and Cooper certainly evinced a proper sense of his dreadful situation under such distressing circumstances. We earnestly wish we could make the same report of the conduct of Bridgewater and Herbert, whose behaviour, subsequent to their condemnation, has betrayed such a total want of feeling, as to make it a subject of congratulation that such incorrigible characters are about to be removed for ever from this country. So far from the impressive language of the Learned Judge having had a proper effect upon them, or the extension of that mercy which spared their lives, exciting anything like a feeling of gratitude in their minds, a very recent daring but futile attempt to make their escape from the Gaol has subjected them to a more rigid system of coercion than would otherwise have been the case. Their removal from hence may be shortly expected.

Gloucester Summer Assizes

From the Gloucester Journal, 30 August 1824:

Between four and five o'clock on Wednesday evening, Sir J. A. Parke arrived in this city, attended with the usual formalities, by the High Sheriff, T. J. L. Baker, Esq. The Commission was immediately afterwards opened before his Lordship in the Shire Hall, soon after which the other learned Judge, Sir Joseph Littledale, reached here. On Thursday morning, their Lordships proceeded to the Cathedral, where Divine Service was performed, and a Sermon suitable to the occasion preached by the Rev. R. J. Cooper, the High Sheriff's Chaplain. A little before one o'clock the business commenced in both Courts, Sir J. A. Parke presiding in the *Nisi Prius*, and Sir J. Littledale at the Crown Bar.

The usual preliminary forms having been gone through, and the Grand Jury (of which Lord Edward Somerset was foreman) sworn, the Hon. Mr. Justice Littledale delivered his charge, observing that although the number of prisoners for trial was not so large as at the last Assizes, yet still the calendar enumerated a long list of offences, to the heinous nature of some of which he felt called upon to direct their attention. . . . His Lordship then . . . proceeded to animadvert upon [the case] of Wm. Williams, for cutting and maiming. This charge was founded upon an Act of Parliament, passed about twenty years ago, but before the Grand Jury could find a bill for the capital offence, it was essential that they should be satisfied that the injury complained of was done maliciously and with the intent to kill and murder. In this case the wounds had not been inflicted upon a vital part of the body, but supposing for a moment that they had, and that death had ensued, unless they could under such circumstances bring in a bill for wilful murder, to constitute which malice prepense must be proved to have existed, the charge for the capital offence under the statute alluded to would not lie, and they could find a bill for the assault only. His Lordship concluded his charge to the Grand Jury of the County by a remark similar to that which was reported in our last week's Journal to have been delivered at Hereford, relative to the power recently granted by the Legislature to Visiting Magistrates, authorising them to keep to hard labour, in the interval between their receiving sentence and their removal, such convicts as had been adjudged to be transported.

DEATH RECORDED – *Daniel Rogers*, for stealing a brown gelding, the property of J. Haskins, of Puckelchurch; *Daniel Wilkins*, for stealing

seven sheep and two lambs, the property of D. Bennett, of Westbury-on-Severn; *Wm. Chandler*, for breaking open the dwelling-house of W. Cox, of Upton St. Leonards, in the day time, no person being therein, and stealing a gun, his property; and *John Lockstone* and *John Anthony* (the latter pleaded guilty), for breaking into the dwelling-house of C. Butler, of Minchinhampton, and stealing therefrom a cask of pepermint water, &c. (These two prisoners were also charged with other felonies, &c. upon some of which they were tried and convicted).

SEVEN YEARS TRANSPORTATION – *Henry Fussell*, for stealing four silver tea-spoons, the property of J. Endicott, of St. Philip and Jacob; and *Thos. Taylor* (pleaded guilty), for embezzling several sums of money, the property of his employer, J. Garratt.

From the Gloucester Journal, 6 September 1824:

Our Assizes were not brought to a termination till Tuesday evening; and we present underneath an account of the sentences of those prisoners whose fate was not decided at the period of our last publication.

Thomas Cornock, for violently assaulting N. McDonald, at Dursley, and stealing from his person upwards of 14*l.* in money, and a miniature picture, was condemned and remains for execution. [*Thomas Summers*, an accomplice in this robbery, was admitted King's evidence.]

DEATH RECORDED – *Thomas Knight*, for breaking into the house of R. Winter, of Oxenhall, and stealing thereout a variety of wearing apparel, &c.; *Lot Maggs*, for breaking open a box of J. Winter, of Littleworth, and stealing 90*l.* therefrom; *Samuel Wood*, for stealing a bay gelding, the property of T. Phelps, of Sellack, Herefordshire; *Edward Webb*, for stealing from the dwelling-house of Priscilla Copner, of Haresfield, 11*s.* in money, a silver spoon, and various articles of wearing apparel; *Jacob Gibbons*, for breaking open the dwelling-house of D. Harris, at Bitton, and stealing thereout a pair of boots, a jacket, &c.; *William Hawkins*, for robbing Wm. Reeves of 2*s. 6d.* and Wm. Richings of 30*s.* &c. on the King's highway, at Tewkesbury; and *John Hare*, for breaking open the shop of R. King, at Clifton, and stealing thereout 20 yards of lace, 12 shawls, and other articles.

1825

The discovery and foiling of the 'Gunpowder Plot' in 1605 has, as we know, long been celebrated. In the 1820s, as now, a bonfire and fireworks were the central features of a night of high spirits. In Stroud, the open space at the top of the High Street, known as the Cross, had long been the natural arena for this revelry to take place. However, for some years, the occasion had been turning unduly boisterous and seemed to some to be getting out of hand. In particular, those citizens who dwelt close by were rather inclined to feel that the practice of rolling flaming tar barrels down the High Street, which had now become part of the entertainment, was taking innocent fun too far.

In 1824 therefore, the forces of order, led by the High Constable, James Withey, made a determined effort to persuade the unruly mob which, in defiance of Authority's wishes, had once more gathered at the Cross, to enjoy the festivities in a less disorderly manner. With this proposition the rabble unfortunately found itself unable to agree and the situation became sufficiently serious as to constitute a breakdown of public order. As constables moved in to detain the leading trouble-makers, matters deteriorated further and the two sides came to blows. Seriously outnumbered, the High Constable's party were driven back and forced to retire from the field, having failed to make any arrests and leaving their triumphant opponents free to celebrate their victory with the dispatch down the hill of another fiery tar barrel.

The sober light of a new day brought a different story: this time, with the mob dispersed, the authorities were able to have their way and a number of misguided revellers who had been earlier identified were rounded up and brought before the bar of justice. The episode falling into a less serious category than the others we have been studying, they were taken before the magistrates at the next Quarter Sessions, and we beg

leave temporarily to abandon the Assizes, in order to allow us to discover their fate.

From the Gloucester Journal, 17 January 1825:

General Quarter Sessions

Wm. Face, Chas. Stanley, Chas. Brown, Chas. Wager, Job Taylor, John King, Saml. Grimes, Thos. Soul, Henry Bowley, John Whitmore, Wm. Barrett, and Jas. Hammond appeared to an indictment for a riot and assault at Stroud, on the 5th of Nov. last, to which they severally pleaded guilty. This prosecution had its origins in the rejoicings which are so general in this country, in commemoration of the celebrated "gunpowder plot". It appears that the populace of Stroud, on each recurrence of this anniversary, had been in the habit of discharging fire-works, and lighting a large bon-fire, in the centre of the town. Many of the respectable inhabitants naturally becoming alarmed at the danger to their property, &c. with which such proceedings were pregnant, made an application to the Magistrates, and obtained their sanction to remove the scene of rejoicing to some convenient spot, which would not be attended with any risk of damage to persons or property; and, that the lower classes might not be deprived of their usual enjoyments, a subscription was made, with which an ample supply of materials for a bonfire was purchased, and deposited in the ground fixed upon. The majesty of the mob, however, was hurt by this interference with their accustomed sports, and, on the night of the 5th, demonstrations were soon made, evincing a determination on their parts to repair to the old arena of Guy Faux. To prevent this, the civil authorities, aided by the respectable townsmen, were called into action; but the populace, amounting to several hundreds, bore down all opposition, and quickly succeeded in taking forcible possession of their former situation; when a scene of great riot and uproar took place, and continued for hours, to the great annoyance and alarm of the inhabitants. A tar-barrel was procured, and, being set fire to, was rolled in triumph through the streets; and the peaceably disposed, finding all resistance ineffectual, were at length compelled to retire to their houses, but not until several had been severely hurt by sticks, stones, and other missiles. The windows of the high-constable were demolished, and several of the rioters who were taken into custody in the course of the night were speedily rescued by their companions. These were the facts of the case, as detailed in the address of Mr. Cross, and the evidence of several witnesses

for the prosecution. For the prisoners, Mr. Justice made a most forcible and animated appeal, in mitigation of punishment, enlarging with great ingenuity upon the excited feelings which such popular rejoicings always engendered, the jealousy of a mob at any interference with what they had ignorantly considered as a right, by custom, and dwelling with great effect upon the contrition they had shewn, manifested by the confession of their fault in their plea of guilty. The Court sentenced the three first (who were more conspicuous than the rest) to three months, and the others to fourteen days' imprisonment, in the House of Correction at Horsley.

Gloucester Spring Assizes

From the Gloucester Journal, 11 April 1825:

TRIAL FOR MURDER AT BITTON

On Friday last, before a most crowded Court, came on the trial of *Mark Whiting*, aged 24, *Jas. Caines* alias *Bush*, 20, *Isaac Britton*, 18, *Robert England*, 23, *Samuel Peacock*, 23, and *Francis Britton*, 40, charged with the wilful murder of Isaac Gorden, at Bitton, on the 27th Nov. last. The bill against *Thos. Wilmot*, committed with the above, was thrown out by the Grand Jury. The case for the prosecution was conducted by Messrs. Ludlow and Cross; attorney, Mr. Harmer; and the four last-named prisoners were ably defended by Mr. Phillpotts. We were prepared to have published a detailed account of the voluminous body of testimony produced, but a pressure of other matter compels us to give only an abstract, which, as more intelligible to our readers, we have reduced into the shape of a narrative, founded strictly upon the facts as proved in evidence.

It appeared, then, that the deceased, who was in the employ of Mr. John Brain, of Bitton, had orders in Nov. last, to impound cattle found trespassing; and in the execution of that duty, on the 21st, he impounded a horse belonging to Fras. Britton. On Saturday night, the 27th of Nov. the deceased was at a public-house called the Tennis Court, where, likewise, amongst a number of other persons drinking there, were assembled the whole of the prisoners. In the course of the evening, in consequence of Caines having thrown pieces of tobacco pipe at the deceased, words ensued between them, in the course of which Caines swore that he would knock Gorden's brains out. England was also proved to have said that

deceased ought to have a good hiding; and that it was "a d—d shame for him to impound Britton's horse", in which observation Caines joined. The deceased after this left the house to go home, but when he came outside the door he was knocked down by T. Wilmot, which induced him to return; and it would appear that immediately upon this Wilmot went away. About ten minutes past eleven o'clock, Caines and Isaac Britton left the house, and the other four prisoners only waited for six quarts of beer, which they were to carry in a jar to Fras. Britton's house. The deceased remained about a quarter of an hour longer, when he left, intending to go home. In going to Britton's house from which there were two ways, one along the turnpike-road, and turning up Grimsbury-lane, and the other, which was the nearest, by a foot-path through a ground called *Gibbett Patch*, which lay in the angle between the road and lane. On the opposite side of the turnpike-road, and about twenty yards from the stile leading to the footpath thro' Gibbett Patch, were situated two houses inhabited by persons of the names of Ponting and Lewis.

A female inmate of each of these houses deposed that, between eleven and twelve o'clock that night, a noise as of several persons laughing and talking proceeded from near that stile; that a silence then ensued of a few minutes, when they heard a faint cry of "murder!", followed by the sound of several blows, not very heavy at first, as though a person had struggled against them, but, at last, in the language of one of the women, "very heavy indeed, as if they had been struck upon a dead thing". After the blows, one of the witnesses deposed that she heard a voice say, "there thee be'st"; that subsequently another voice cried, "Bob"; and that very soon after, she heard a laugh, which seemed to proceed from the upper stile leading into Grimsbury-lane, and in the direct line to Britton's house. It was almost immediately after this that the body of the deceased was found on the road-side near the stile, by a person returning home, who giving an alarm, it was conveyed back to the Tennis Court. The deceased was found lying on his face in a gore of blood, with his arms extended, but quite warm. There were two stabs, apparently from a knife, upon the forehead, and a dreadful fracture on the back part of the head, extending from the right ear to the centre of the skull. Near the body were found a clasp knife, with one blade open, and nearly half an inch of the point broken off, and a heavy garden post, which had been used for hanging clothes-lines upon, both marked with blood.

It may be right here to mention that two witnesses who were at Britton's house on the night of the 27th swore that between eleven and twelve

o'clock, the two Brittons, England, and Peacock came in together, bringing with the the six quarts of beer; that Fran. Britton was completely drunk, and was obliged to be led, and that, after some interval, the other two prisoners, Whiting and Caines, also came in.

On the following day, all the prisoners and Wilmot were taken into custody; and upon examining their clothes, there was an appearance of spots of blood upon the flap of Caines' coat, which he said was occasioned by pitch from a boiler. Two "dabs" of blood were likewise observed upon Whiting's coat; and it was proved that, subsequently, whilst being conveyed before the Magistrates, his nose having been scratched by a briar, he took an opportunity of wiping off the blood with the same flap; but this being seen by one of the constables, the latter immediately cut off the part so stained. There was likewise an appearance of blood upon Peacock's breeches, but it did not seem recent, and the evidence upon this point was by no means conclusive. Upon the persons of the others, nothing was found to implicate them.

We now come to the consideration of as extraordinary a train of circumstantial evidence as was ever, perhaps, exhibited in a Court of Justice. The knife which was found by the body was proved, by a boy to whom he offered it for sale, to have been in the possession of the prisoner England on the morning of the murder. The pole or post, with which there can be no doubt the fatal blows were inflicted, was proved by the landlady of the Tennis Court to have been taken from her garden, in which she had herself used it on the Saturday evening; and, upon examination, the tracks of two pairs of shoes were distinctly followed to and from the spot whence it was taken, and which tracks were satisfactorily identified as having been produced by the shoes worn on that night by Caines and Isaac Britton. Close to the hedge, in the Gibbett Patch, immediately opposite where the body was found, were seen the marks where two persons had sat down on the ground, and here the track of one of Caines's shoes was again perfectly visible. But the most extraordinary circumstantial proof was found on the road-side, close by the fatal spot. Here was seen the place where a man had sat down on the bank under the hedge, with his feet resting against the inside of the ditch; the marks made by the shoes, altho' they were effaced before an opportunity could be had for fitting them, were doubtless produced by those worn by Whiting; this was fully substantiated by a peculiarity in the mending of the shoes, which was pointed out upon the first examination of the track by one of the witnesses, before Whiting was taken into custody. But, as an unquestionable corroboration of his

presence, an inspection of the mark upon the bank shewed that the person who sat there had worn cord-breeches, upon the seat of which there was a patch of a broader stripe than that of the material with which the garment was made, and that part of Whiting's dress corresponded with the impression in every minute particular!!! [The earth, with this impression upon it, had been dug up, and being carefully preserved in a moist state, was produced on the trial, to the complete satisfaction of the Court and Jury.]

The above comprehends the substance of the evidence of twenty-two witnesses who were examined for the prosecution; and that part of the case being closed, the prisoners were severally called upon for their defence, when Whiting and Caines each put in a written paper. The first denied any participation in the murder, or having entertained any animosity towards the deceased, at the same time calling the attention of the Court to the quarrel which had taken place between the latter and his fellow-prisoner, Caines, at the Tennis Court public-house. On the other hand, he stated that it had been proved that he (Whiting) had been drinking with the deceased on that evening. He had been in habits of intimacy with him for twelve years, and had had no mis-words with him; and he concluded his defence by alluding to the improbability that, under such circumstances, he should have been induced to take away the life of the unfortunate deceased.

The defence of Caines likewise declared his entire innocence of the charge; and in a narrative which he gave of the circumstances of the fatal evening, he stated that he was at a distance from the spot where the murder was committed, near which place he had left Whiting, when he was on his way home from the public-house, and strongly denied all knowledge of the transaction.

Whiting also called a witness to speak to his character, but it appearing that he could say nothing in his favour, his examination was not pursued.

In behalf of Isaac Britton, Jos. Parker, Esq., one of the Magistrates who committed the prisoners, was called, who stated that he only knew the prisoner by sight; but that, since this transaction, he had taken great pains to enquire about him, and the result of those enquiries had been highly favourable to his general character. He had likewise reason to believe that Isaac Britton was comparatively a stranger to the other prisoners, and that he had not been in the habit of associating with them.

The Learned Judge now commenced his summing up, which occupied

upwards of three hours, and through which we have neither the space nor the power to follow him. His Lordship took more than common pains in dwelling upon every point which could operate in favour of any of the prisoners; and having concluded his charge, the jury, after about ten minutes deliberation, returned a verdict of GUILTY against *Caines* and *Whiting*, and acquitted the other four. The awful sentence of death was immediately passed upon the two unhappy men, and they will this day terminate their earthly career upon the scaffold.

The significance of the repeal of the Combination Acts was not lost on the weavers of Gloucestershire and they seized the opportunity to press their claims. These, given their parlous financial conditions, were not unjustified and met with some sympathy from certain of the clothiers. Others, unfortunately, were not so ready to meet the weavers' demands.

From the Gloucester Journal, 16 May 1825:

STRIKE OF THE CLOTH WEAVERS! – We regret the necessity of stating that the looms throughout the Clothing Districts of the county have for some time been in a state of total idleness, in consequence of the non-compliance of the Manufacturers with the demands of the weavers for an increase of prices. The cessation from labour commenced on Friday, the 29th ult.; and on the Monday following, the weavers assembled in considerable numbers at Cainscross, where they were met by several of the Manufacturers; but, not coming to any satisfactory arrangement, shuttles to the amount of several hundreds were instantly collected. Meetings of more than 3000 weavers were held on subsequent days, on Break Heart and Stinchcomb Hills; and on Monday last, they congregated on Selsey Hill to the number of not less than 6000, for the purpose of learning the sentiments of the Manufacturers of the Stroud and Nailsworth districts. On each of these occasions, several of their employers agreed to advance the prices; but a number sufficient to satisfy the weavers not having yet consented to their terms, another meeting was held on Wednesday last, at Nympsfield, when deputations of workmen from several parishes attended, and it was strenuously urged that they should resume their labour for those Gentlemen inclined to accede to the new prices. The majority, however, obstinately resisted this reasonable proposition until the whole of the Manufacturers had expressed their compliance; and the business consequently remains unsettled. But it is justly due to the weavers

to add, that their conduct has throughout been orderly and respectful to their superiors; and they have gained general approbation by their quiet and peaceable demeanour, even when assembled in the greatest numbers.

Unfortunately, such a sanguine view of the confrontation was doomed not be sustained, as the inevitable collision courses adopted by both weavers and clothiers became apparent. With a majority of the clothiers refusing to countenance the weavers' demands, the latter became ever more militant. In Stroud, the centre of the clothing district, the town once more found itself the scene of mob violence, just a few months on from the depredations of the Bonfire Night rioters.

From the Gloucester Journal, 13 June 1825:

RIOTS IN THE CLOTHING DISTRICTS – From intelligence which reached us ten days ago, we were led to believe that the differences which had existed between the Manufacturers and the Weavers, in this county, were in a fair train to be immediately and amicably adjusted; but we grieve much to have to announce that, since that time, occurrences have taken place, so totally at variance with that peaceable deportment which had hitherto characterized the *turn-outs*, as to render it necessary to call in the assistance of the military in aid of the civil power, whose efforts to preserve the peace of the community in the neighbourhood of Stroud, had been rendered ineffectual. The circumstances, as they have been related to us, are briefly as follow: Some of the weavers, tired of eating the bread of idleness, or, what is more probable, no bread at all, had undertaken work for Messrs. Wyatt, of Vatch Mills, contrary to the determination of the great body; and this coming to the knowledge of the latter, on Friday se'night they took by force several ends of cloth from their brethren who had it in hand, and proceeded in considerable numbers to Messrs. W.'s manufactory, to return the work to those gentlemen. On arriving at Vatch Mills, they conducted themselves in a very disorderly and tumultuous manner, and made such demonstrations as to call from Mr. Geo. Wyatt a threat, that he would have recourse to desperate measures to protect his property, if they did not desist. This led to a scuffle, and ultimately to a complete riot, to the terror of all well-disposed persons. In consequence of this, two of the most active of the rioters were taken into custody, and committed to the Blind-house at Stroud.

Early next morning, the malcontents, to the number of many thousands,

assembled in the streets at Stroud, making use of very violent language; and upon the delinquents being brought before the Magistrates, who had assembled for the purpose of their examination, at the Office of Messrs. Newman, the rioters swore that, unless their companions were set at liberty, they would pull down the premises brick by brick. Indeed, such was the density and disgraceful conduct of the crowd, that those Gentlemen who felt themselves interested in the investigation, as well as the witnesses, encountered considerable difficulty and danger in reaching the Office. Things were in this posture when, as Mr. Wyatt's foreman was making his way in to give evidence, he was seized by the rioters, and carried down to the pond of the Little Mill, where they ducked him as long as they thought they could do so without endangering his life! His evidence was of course lost, and one of the captives was set at liberty, the other being held to bail to appear at the Sessions. Messrs. Peter and George Wyatt, in attempting to get into the Office, were assaulted by the rioters, and desperately beaten. In a short time afterwards, the crowd went to the premises of Messrs. Wyatt and, seizing eight of the men who acted as special constables on the preceding day, ducked them in the pond of Vatch Mill. Nearly at the same time, a party proceeded to Frogmarsh, a small village near Nailsworth, where they ducked fourteen weavers who had refused to turn out. They went to the house of a man named Burford, aged 80, and expressing the utmost concern for the unavoidable necessity they were under of visiting him with their vengeance! they led him to the pond and, previously to his immersion, they made him drink half a pint of gin; then ducked him, but without violence, and immediately after made him change his clothes! On Sunday, Stroud was comparatively quiet, but on Monday, the spirit of insubordination and violence was again manifested in the town and neighbourhood. They seized and carried three men to Mr. Holbrow's fish-pond, where they ducked them severely, laughing at them during their suffering!

From the threatening appearance of affairs on Saturday morning, an express was sent off to the Secretary of State, soliciting military aid; and, such was the alacrity with which this request was granted, that about seven o'clock on Monday evening a troop of the 10th Hussars, under the command of Lieut. Wallington, arrived at Stroud, from Bristol; but by this time the riot had subsided. The mechanics, however, thronged the streets until Tuesday afternoon, when the principal cloth-manufacturers determined upon acceding to their demand for an increase of wages.

Disturbances likewise prevailed at Chalford, and other places in the

vicinity, but which were speedily put an end to on the appearance of the military. The civil power, supported by the soldiery, were now dispatched in various directions, and succeeded in apprehending many of the ring-leaders in these desperate proceedings, sixteen of whom have been committed to our County Gaol, and four have been sent to the Bridewell at Horsley, for want of sureties.

We cannot speak too highly of the firm demeanour of H. Burgh, Esq, or of the indefatigable exertions with which, in his Magisterial capacity, he laboured to preserve the public peace. Wherever he thought his presence could be at all serviceable, he was always at his post, evincing a thorough disregard of personal trouble or inconvenience; which, added to the steady and highly praiseworthy conduct of the Hussars, under Lieut. Wallington, had the happy effect of speedily quelling a disturbance, which might otherwise have been attended with very disastrous consequences.

By subsequent accounts we are rejoiced to find that the greatest part of the workmen have at length returned to their several occupations.

Their protests had in fact borne fruit, since the clothiers, faced with such vehemence, decided to pay up. Nonetheless, however much the weavers' claims might have been justified by the financial straits in which they and their families found themselves, some of their number, in the heat of the moment, had behaved in a manner which could not be tolerated. There was a price which had to be paid.

To follow the fate of these hot-heads, we must once more visit the lower court, to which they were brought to answer for their actions, rather than the Assizes.

From the Gloucester Journal, 18 July 1825:

GENERAL QUARTER SESSIONS

RIOTERS IN THE CLOTHING DISTRICTS – At these Sessions, the calendar exhibited the names of twenty-two persons, charged with different acts of riot and disturbance in the clothing district of this county, arising out of the recent Strike of the Weavers for an advance of wages. The bill against one of this number was ignored; and of the others, ten, when brought up, pleaded guilty, and the other eleven took their trials in the course of Thursday and Friday. In our paper of the 13th ult. we gave a detailed account of the outrageous proceedings of these misguided men, and the facts we then stated were so completely borne out by the evidence

now adduced that we deem it unnecessary to give a lengthened account of the trials. Suffice it to say, that the charges were brought home to the parties accused, and that, in some instances, the unfortunate objects of the vengeance of the mob were so severely ducked as almost to involve the risk of life.

On Saturday afternoon, the twenty-one individuals (mostly weavers), whose names are enumerated below, were placed at the bar to receive sentence; when Mr. Justice, who, with Mr. Phillpotts, was retained to defend them, addressed the Court in mitigation of punishment, in a pathetic, classical, and well-delivered speech, of which we can only give our readers a very brief and imperfect idea. He contrasted the comfortable situation of the weavers many years ago, when they were almost assimilated with the clothiers of this day, with the wretched circumstances under which these individuals now stood, to receive judgment at a bar of justice; and proceeded to draw an affecting picture of the state of poverty to which this meritorious class had been reduced. Formerly, by their own honest industry, they were enabled to maintain their families in comfort and respectability; but now, after their daily labour, of perhaps sixteen or eighteen hours, they returned to their cottages in a state of misery and dejection, with a pittance insufficient to provide for those dependant upon them, the common necessaries of life, and utterly hopeless of any amelioration of their condition. In this happy country, each class of the community contributed in its proportion to supply the wants, and to promote the welfare, of the whole. Into the general market these men, too, had brought their little stock of merchandise, in the shape of muscular exertion; and surely they had a right to look for a fair remuneration for that labour which had cost them the sweat of their brow. At the commencement of the differences between the weavers and their employers, the former had acted in a peaceable and legal manner, by respectfully petitioning for that increased return for their exertions to which they thought themselves justly entitled; and that there was reason in their claim, was to be fairly inferred from the readiness with which the more opulent and respectable manufacturers complied with their request. Unfortunately, however, there were other of their employers who turned a deaf ear to their complaints; and the weavers were hurried by some of those passions which are the bane of human happiness, from the exercise of a just and legal right, to the commission of those acts of violence, for which the prisoners at the bar were now called upon to answer. He stood not there to justify their conduct, but much might be urged in extenuation;

and on the score of mercy, he made an earnest and impressive appeal to the feelings of the Court, advancing many forcible reasons why lenity should be extended to them. He concluded by observing that if his prayer were attended to by the Court, it would have the happiest effect, as related to the differences which had existed, and would secure to the manufacturers honest, industrious, and grateful servants, who would be bound to their interests by the favour exhibited upon this occasion.

Mr. Phillpotts followed on the same side, and urged that whatsoever punishment might be inflicted upon the prisoners, it would not fall upon them alone, but would be extended to their wives and families, and eventually entail a heavy burden upon the parishes to which they belonged, and to which they could alone look for support.

The Learned Chairman, the Rev. Dr. Cooke, now proceeded to pass sentence, in an address to the prisoners, full of energy, argument, and feeling, and which, for the sake of the manufacturing class in general, we wish we could give at length to our readers. Their cases, he observed, had received the most mature and deliberate consideration from the whole Bench of Magistrates; and however anxious they might be to extend lenity to the prisoners, yet a sense of duty to the laws, to the public, and to the prisoners themselves, called for a heavy visitation upon some of them. They had shewn to what lengths they could go, in contravention of the laws and of the public peace; and by the sentence he was about to pronounce, the Court was actuated, amongst other reasons, by an earnest wish to protect the prisoners against themselves. He then enlarged upon the grievous nature of the outrages which had marked their conduct – outrages which had become so alarming as to render it necessary to call in the aid of the military. But for this, probably, they might have proceeded to still greater extremities, and have committed acts for which their lives might have become forfeited to the offended laws of their country. He brought to their recollection the combination which had been entered into by the weavers in the year 1803 – a combination, the rules of which were so pregnant with danger to the community, that the late respected Chairman of the Quarter Sessions had felt called upon to make it the subject of a public charge in that Court. A year or two after that arose the combination then well known by the name of the Luddites; shortly after which occurred the disturbances in the manufacturing districts of Lancashire and Cheshire; and these again were succeeded, at an interval of a year or two, by similar scenes in Yorkshire. Most of these had originated from similar beginnings with the present, but had assumed such alarming aspects as to call for the

active interference of Government. Special Commissions were issued; and eight rioters at Manchester, two at Chester, and eighteen in Yorkshire, paid with their lives the penalties of their dreadfully outrageous deeds, besides others whom it was found necessary to banish from their native land, to spend their days in exile and ignominy. As in these instances, the prisoners, in this case, unless checked by the heavy hand of the law, might have proceeded in their mad career till it had terminated in murder, or some other capital offence. As it was, their conduct had on some occasions been marked by acts of excessive violence; and it was his duty to tell them that, had death ensued to any one of those individuals who had been so severely ducked, it would have been deemed murder, and they would have been tried for their lives at the Assizes, and in all probability have suffered death upon the scaffold! But most fortunately for them, no such fatal termination had occurred. The Learned Chairman feelingly exhorted them to bear in mind the narrow escape they had, and made some very pertinent and impressive observations upon the relative duties of employers and workmen. He pointed out to them the ruin which must fall upon themselves and their families, should such scenes be persisted in or renewed; and instanced a case, which some of them might understand, in which, owing to their refractory conduct, an order from the East India Company for *stripes*, which would have been the means of distributing among the working class alone the sum of 40,000*l.*, had of necessity been transferred from this county to Yorkshire. He likewise put another case in the cassimere trade, in which, owing to the same cause, foreign manufactures had been introduced instead of our own. These two instances were an absolute loss to themselves; and who knew whether the evils which they had thus occasioned might not have permanent bad effects. In the course of his address, the worthy Chairman took a view of the comparative nature of their several cases, which our limits preclude us from entering into, and in conclusion pronounced the sentence of the Court, which was –

That *Thos. Osborne*, who was convicted upon two indictments, should be imprisoned two years; *Wm. Pickford, John Mind*, and *Isaac Nutt*, one year; *George Hoskins*, nine months; and *Rd. Preen*, six months, in the House of Correction at Northleach; and *Wm. Fitting, Peter Workman, Geo. Fletcher, Luke Robins* and *Thos. Weir*, three months each, in the House of Correction at Horsley, and all to be kept to hard labour. *Adam Smith, Adam Glastonbury, Wm. Stephens, Wm. Pegler, Enoch Brown, Silas Smith, Chas. James, Jos. Mayo, Jas. Elliott*, and *John Chandler*, all

except one of whom had pleaded guilty, were discharged on entering into their own recognizance to appear to receive judgment when called upon.

Gloucester Summer Assizes

The next tale takes us back up the social scale, away from rustic mayhem to the genteel drawing rooms of Cheltenham and Cambridge. For, if Mrs Smith (senior), with her apparently inexhaustible supply of daughters, did not spring straight from the works of Miss Jane Austen, she surely should have done! It might perhaps also be worthwhile to caution the reader not to allow his attention to wander as the story unfolds, in order to ensure that, given the abundance of Smiths in the story, he is at all times sure of which Smith it is who is being referred to.

From the Gloucester Journal, 22 August 1825:

LIBEL – *Jones v. Binckes* – Mr. Taunton said this was an action brought against the defendant for a libel, contained in a letter, which was addressed to an individual named Woodley. In order to enable the Jury to understand this case, it was necessary to state that Woodley, who lived in Cambridge, was married to Caroline, the daughter of a lady named Smith, residing near Worcester. Binckes, the defendant, a wealthy and respectable wine-merchant at Cheltenham, married another daughter named Sarah; and Mr. Smith, who resided at Bridgenorth, married a third daughter, named Sophia. It happened some time ago – he should rather say it was currently reported – that Mrs. Smith (Sophia) had eloped from her husband with Capt. Jones, who was the brother of the plaintiff. The plaintiff, who is a retired wine-merchant, at this time was paying his addresses to Miss Mary Smith, a fourth sister of the ladies above-mentioned; and he, in company with this young lady, was on a visit, in November last, with Mr. Woodley, the lady's brother-in-law, at Cambridge. Whilst she was there, and after Mr. Jones left it, the letter containing the libel was received. In this letter, the defendant imputed to the plaintiff that he had assisted, by the worst of arts, in effecting the seduction of Mrs. Smith by his brother. It was to this effect, omitting some immaterial passages:

"Cheltenham, Nov. 11, 1824".

"Mr. T. Smith (a brother to the ladies) is at the Mythe. I saw him the other day, and he said that Mr. Jones (the plaintiff) called on him in town,

which we were surprised to hear. Whether Mary was with him or no he could not learn as he was from home when Mr. J. called. I suppose he has returned to your house – or has he left you? If he has, it is perhaps quite as well, as it has lately come out that he has been for a long time playing a double and deceitful part. You are of course aware of the circumstances relative to Capt. Jones and Sophia. Will you believe me when I tell you that Mr. Jones (the plaintiff) had been at the bottom of every thing, and was the cause of that unhappy business. The Captain threatens to expose him, and you may rest assured that what I now tell you is fully proved and substantuated. I cannot tell you, nor do I know half the diabolical behaviour he has put in practice with regard to the above affair; and as to Mary, if she did but know what he says and how he talks of her, she would, I think, never see or speak to him again. Mr. Longmore (married to another sister) says he shall never enter his house again. Mrs. Smith says the same. All this I tell you in confidence – act as you please".

Mr. T. B. Woodley, of Cambridge, was examined, and proved Mr. Taunton's statement of the case. It was to this witness that the offensive letter was addressed by his brother-in-law, Mr. Binckes, the defendant, and it was the witness's anxious care to prevent this epistle from falling into Miss Smith's hands; but, having confided in his wife, she betrayed her trust, and, yielding to her sister's entreaties, admitted her to a perusal of the friendly document.

Mr. Justice Burrough: "Poh! you ought to know, man, that no woman can keep a secret". (*Much laughing*).

Witness: "Now, my Lord, I know that they cannot; but what in the world could I do? I was like Adam in the garden. I yielded to temptation. (*Great laughing*). The fair sex always carry their point. They'll have their own way first or last". (*Much laughter*).

Mr C. Phillips addressed the Jury for the defendant. It was deeply to be regretted that the circumstances of this case had been made matter of public inquiry. The recital of them was calculated to reflect any thing but credit on the parties who were implicated in the transaction. With reference to this letter, he contended that it was written in confidence to Mr. Woodley, and that it was exempt from the motive of malice, which was necessary to constitute a publication of any description a libel. The doctrine which had been proclaimed by the law of England, which had been derived from the wise institutes of Justinian, and which was re-affirmed in the numberless cases of modern decisions, was that neither libel nor slander could be properly charged upon a publication, or upon

words spoken, unless a malicious intention could be traced in either. The wisdom of Rome, in the best days of her republican or her imperial existence, nourished this great principle. It had been sanctioned by the consent of ages, and received authority from the united judgments of modern tribunals. The law made a distinction, in which it was supported by common sense, between the language of him who was addressing the confidential words of friendship to a brother-in-law respecting a third party, and the man who superfluously took upon him the office of a traducer. In the case of *Harmer* and *Dawson*, where the alleged slanderous words were: "he cannot stand long – he will be bankrupt soon", the then Chief Justice told the Jury that if they thought the words were spoken in confidence, they ought to find for the defendant. In *King* v. *Wright*, it was held that an advertisement in a newspaper, tho' reflecting on a party, was not libellous, if it appeared to have been inserted for the purpose of making an inquiry, in which the party causing it to be made was interested. The case of *McDongel* v. *Claridge* was a libel alleged to have been contained in a letter written by the defendant to Messrs. Wright and Co., bankers, at Nottingham. It charged the plaintiff with improper conduct in the management of their concerns. It appeared, however, that the letter was intended as a confidential communication to these gentlemen, and that the defendant was himself interested in the affairs, which he supposed were mismanaged by the plaintiff. What was Lord Ellenborough's[4] conduct on this occasion? He said this, as soon as the case for the plaintiff was opened, that if the letter was written confidentially, and under the impression that its statements were well-founded, he was quite clear that the action was not maintainable. It was impossible to say that the defendant had maliciously published a libel to aggrieve the plaintiff, if he was acting *bona fide* with a view to his own interest, or that of the person he addressed; and if such communications, which were not intended to go beyond the knowledge of those persons immediately concerned, were to be subjected to the inquisition of a Court of Justice, the affairs of men could not go on. In giving this opinion, his Lordship referred to a case which occurred on the Northern Circuit, whilst he was at the Bar. A letter had been written by a party to the Bishop of Durham, informing him of the mal-practices of a steward in his employment. The Judge presiding said it was a case where the defendant acted *bona fide* – a nonsuit was directed, and never attempted to be disturbed. Were not these cases quite analagous to the present? Let the Jury only remember the relation of the parties to one another. The defendant and Woodley were married to the

two sisters. That was one ground of confidence. There was another – the first wife of the defendant, the choice of his early love, she whom he had lost in the spring of their affection and happiness, was the sister of Mr. Woodley. Was it surprising that an intimacy of the most confidential nature should exist between persons who had been thus brought together, whose feelings of mutual regard had been so strongly stimulated by a double alliance. Let it be supposed that one of the gentlemen whom he was addressing had a sister-in-law at Liverpool, about to be married to a suitor who had been paying his addresses for a number of years; let her be sojourning at the house of a bosom friend; at the house of a brother-in-law; let it be supposed that the gentleman was acquainted with the suitor of his sister-in-law; that he heard something to his disparagement. What! was he not to intimate the report to his confidential friend – was he not, in the technical language of the case, referred to – was he not acting perfectly *bona fide* with a view to the interest of himself and the party addressed? That Mr. Binckes wrote this letter in the strictness of confidential friendship, there could be no doubt. The whole tenor of its contents indicated the feeling – every syllable informed the reader that it was destined for the secret ear of him to whom it was addressed – it was a silent warning, communicated to the friend of his bosom, with the view of arresting, while yet there was season, an alliance which he had reason to believe would involve the perdition of his own and Mr. Woodley's sister-in-law. But it was said that the plaintiff lost his intended wife by the effect of this letter. He (Mr. P.) did not know how young people made love in Gloucestershire; but he was not surprised, he owned, to find a gentleman of years and discretion, who thought it necessary to serve an apprenticeship as a lover, and actually complete the term of seven years of hard servitude to his mistress, before he dared to think of matrimony. The "interesting question" was kept back by the ardent suitor, until he was obliged to mumble it without his teeth. Seven years of courtship? Why, such a man should live to the age of Methusalem, in order to make a natural proportion between the period of matrimony and the preliminary term of courtship. Was it modesty that held him back, all blushing and abashed in the timidity of youth? Was the *stripling of fifty years* too inexperienced and difficult to venture on the important question to the object of all his sighs and tenderest emotions? Yet they were told that "Mr. Jones was a wife out of pocket". A wife out of pocket? No: if it were so – if he had lost a wife, the privation was too serious for jocularity, and would excite no other feeling where it was announced but sympathy and sorrow. But he

had not lost a wife; and if he were deprived of his mistress on this occasion, the only reason why he merited compassion for the loss was that he would have to begin a new courtship over again; and, poor man! have to encounter over again another seven years probation of love and bashfulness, and fears and doubts! In fact, there was not the least ground for imputing malicious intention to the defendant in this instance; and, in all probability, neither the letter nor the action could ever have been heard of but for – woman, often the source of man's supreme delight; but, alas! too, sometimes (seldom he should rather have said) the mother of mischief! Justly was his Lordship astonished to find any human being so devoid of observation, as to expect that a woman could keep a secret. In Gloucestershire and Cambridgeshire it was said, husbands keep nothing from their wives. Let it be henceforth understood in the connubial circles that this was a custom more honoured in the breach than the observance; for, in conformity with her promise *not to tell*, thay found that the first thing this Cambridgeshire lady did was to open the whole affair to the very person from whom she was desired to withhold it. This reminded him of an anecdote related by the late Mr. Sheridan. It happened to this gentleman that by good fortune he got a prize of 10,000*l.* in the Lottery. He was much involved at the time; and he said to his wife, "My dear, we must keep this a secret, or we shall have creditors upon us for ten times the amount tomorrow morning". They were just going out to a party; and, when arrived at the house of the friend who invited them, Mrs. Sheridan, with an air of mystery, invites the hostess to a private interview up stairs. Sheridan at once saw the secret was disclosed; so he called his host to the fireside and told him of the prize. Said he, "My wife and I agreed to keep the matter to ourselves, but smack she is gone to tell it all to your wife. Now, I'll be first with you, and, in this instance at least, I'll disappoint my wife". The story told, Mrs. Sheridan returned to the parlour, big with the glorious hope of astonishing the host. She beckoned to him – she put on her best mysterious look, and, whilst on tip-toe to retire to unburden herself of the mighty secret, Sheridan interposed – "My dear, I have told him – I knew it was no use to trust to you". *(A laugh).* The lady was outwitted – she was anticipated in the communication of the secret. No one but an extraordinary man – a man of Sheridan's supreme power, could have contrived a means of outwitting a woman in the development of a secret. The Learned Counsel concluded by insisting that he was clearly entitled to the verdict of the Jury.

Mr. Justice Burrough gave it as his opinion that the letter was clearly a libel. The defendant, in the letter, asserted that these matters had been proved and substantiated, and not merely that he had heard them. If the defendant had only stated it as hearsay, or had now proved it as fact, the observations would have had great weight; but, instead of that, he takes upon himself to state that the plaintiff had been guilty of diabolical conduct, and that he does not know half of what he has been guilty of. As it was not justified, it must be taken to be false; and on the mere publication of such matter, the law implied malice. The publication was proved; the damages were a question for the Jury, and the amount of them ought to be a fair and moderate compensation for the injury done.

The Jury, after deliberating for a quarter of an hour, found a verdict for the defendant.

The Promenade from the bridge, Sherborne Spa.

1826

This year, the population of Cheltenham reached 20,000, compared with 3,000 fifteen years earlier. By 1826 a number of spas had been discovered, each provided with its Pump Room and other amenities. In 1818 the Sherborne Spa had been built, where the Queen's Hotel now stands, and was linked to the town's High Street by a fine tree-lined walk (later to be named The Promenade), replacing what had been a muddy lane passing through swampy ground on either hand. In 1825 the Pump Room of the nearby Montpellier Spa was enhanced when the Rotunda was built above its Long Room. Meanwhile, the most extensive development of all, the estate known as Pittville, after its developer the self-made Joseph Pitt, had been taking shape and it was in 1825 also that the foundation-stone for the largest and most magnificent of the Pump Rooms was laid.

Gloucester Spring Assizes

From the Gloucester Journal, 3 April 1826:

The Commission for this County and City was opened in our Shire Hall, on Wednesday afternoon between four and five o'clock, before Sir Jas. Allan Park, Knight, who, having been met at the usual place by the High Sheriff, Robert Hale Blagden Hale, Esq., was escorted into town with the accustomed formalities. His Learned Brother, Mr. Baron Garrow, arrived very soon afterwards. On Thursday morning their Lordships attended Divine Service at the Cathedral, where a sermon appropriate to the occasion was preached by the High Sheriff's Chaplain, the Rev. J. K. Whish; who took his text from Psalm xcvii, 2, *Clouds and darkness are round about him; righteousness and judgment are the habitation of*

The Promenade, with its sylvan backdrop forms a wide and agreeable avenue for ladies and gentlemen visiting the Montpellier Spa.

his throne. Immediately after Church their Lordships proceeded to their respective Courts, and commenced the business of the Assize.

Mr. Baron Garrow presided on the Crown side; and the following gentlemen were impannelled as a Grand Jury:

The Right Hon. LORD EDWARD SOMERSET, M.P., Foreman.

The Right Hon. Chas. Bathurst.	Parnell Bransby Parnell, Esq.
Sir William Hicks, Bart.	James Clutterbuck, Esq.
Sir B. Wm. Guise, Bart., M.P.	Edward Cripps, Esq.
Edward Webb, Esq, M.P.	Henry Norwood Trye, Esq.
Robt. Bransby Cooper, Esq, M.P.	Robert Canning, Esq.
John Browne, Esq.	Walter Lawrence Lawrence, Esq.
John Delafield Phelps, Esq.	Robert Stephens Davies, Esq.
Thos. John Lloyd Baker, Esq.	Osman Ricardo, Esq.
Henry Elwes, Esq.	George Worrall, Esq.
William Goodrich, Esq.	Stephen Wilkins, Esq.
Henry Clifford Clifford, Esq.	Edward Austin, Esq.

BIGAMY – *Richard Millard*, a very decent looking man, aged 35, was indicted for having, on 17th Jan. 1819, feloniously intermarried with Mary Anne Holder, his former wife, Jane Millard, being then alive.

Mr. Ryan appeared for the prosecution; and Mr. Maule was for the defence.

Elizabeth Spurrier, the sister of the prisoner's first wife, whose maiden name was Jane Giddings, saw them married on 31st Jan. 1811, at St. Cuthberts, Wells. The prisoner was a respectable farmer, and witness saw her sister, who was his wife, on Tuesday last, alive. On her cross-examination, she said the prisoner and the witness's sister lived together for the first six years after their marriage, but after that they did not cohabit together.

Ann Watts was at St. James's Church, Bristol, on 17th Jan. 1819, where the prisoner was married to Ann Holder. Ann Holder is a girl about twenty years of age now. This witness, on being cross-examined, stated that Ann Holder, at the time of her marriage, knew that the prisoner had been married before, and that he had separated from his wife.

An attested copy of the entry of the first marriage, and a copy of the register of the second marriage, were then put in.

The prisoner, in his defence, said that, his first wife having left him and taken up with another man, she wrote him a letter stating the fact, and setting him at liberty to do as he liked. He told Ann Holder of this fact, and she consented to marry him. Previous to the ceremony, he consulted an attorney, to ascertain whether he had a right to do so, under all the circumstances of his case, and the attorney said he would be warranted in taking a second wife.

Neither of the prisoner's wives appeared against him, and good reasons were supposed to exist, establishing the truth of the prisoner's defence. The Jury found him *Guilty*; but recommended him to mercy, on the ground that his first wife was the first aggressor.

Mr. Baron Garrow, in passing sentence, told the prisoner that the infidelity of his first wife was no excuse for the offence he had committed against law and morality. His case was not, however, characterised by that baseness which distinguished some others of the same description, and therefore his Lordship would only inflict a lenient sentence. It appeared among the circumstances in his favour, that he had not deserted his first wife, but she had deserted him; and he had subsequently behaved with affection and kindness towards the girl that he afterwards married. His Lordship, therefore, felt himself warranted in sentencing the prisoner

to one week's imprisonment only.

In an echo of the previous summer's unrest amongst the weavers, no less a person than one of the county's magistrates, who was not surprisingly awarded the accolade of 'respectable', now found himself facing the Bench, instead of sitting upon it.

From the Gloucester Journal, 10 April 1826:

The King v. Edward Aldridge, Esq. This was an indictment against the defendant, a Magistrate of this county, charging him with having unlawfully, wickedly, and maliciously counselled, advised, incited, and encouraged divers weavers in the parish of Bisley, in this county, to combine against their masters, for the purpose of procuring an advance of wages. Other counts charged him with inciting and encouraging divers weavers, at the said parish, to riots and assaults; and one count particularly charged him with encouraging divers weavers to return their work to their masters in an unfinished state. The defendant pleaded Not Guilty.

Mr. Horace Twiss opened the indictment; and Mr. Taunton, in stating the case, said the defendant, one of the Magistrates of this county, was charged with having instigated some of the manufacturers to proceed by force, violence and intimidation, to compel other workmen to return that work at what they were pleased to consider under prices, to their employers; with having aided and abetted these persons, afterwards, in the commission of riotous proceedings, with having been present at, and assisting in, the commission of assaults upon unoffending individuals; and with having also, while bearing the character of a Magistrate, been present at the violation of the public peace, and using no exertion whatever to preserve it. These were the general features of the charge. That a gentleman who had been thought fit by his Majesty to be one of the Magistrates of the county – who from his station in life is supposed to be a man of education and of good conduct – should be found to be a principal in a proceeding of this sort, was a circumstamce that must affect every one who heard it with grief, and also to a certain degree with surprise, perhaps with more of the former than of the latter sensation, because he was sorry to say that in these times there prevailed a silly ambition of notoriety, a vain desire after that which is falsely called distinction, which very often make some persons prefer the transient plaudits of a rabble to honourable and fair popularity. Whenever this silly affection laid hold

of an individual, he was so far intoxicated by it as to become reckless of consequences both to himself and others; and he (Mr. T.) was ready enough to acknowledge that, if the defendant could have foreseen the situation in which he was placed by his imprudent conduct, he would not have acted in the way in which, from testimony too numerous and too clear for an instant to be doubted, he would be proved to have conducted himself. In the early part of the last year, a considerable ferment began to shew itself in the manufacturing districts of the county; whether owing to the enactment of a certain statute passed in that year, or to other causes, it was not material to inquire. On such an occasion, it was the duty of every good subject, and much more the duty of every person exercising the duties of Magistracy, to do all that he could to allay the rising tumult, to exert himself to his utmost for the preservation of the public peace; to stifle, if possible, the murmurs of discontent and to bring every thing back to a state of tranquillity and quietness. Not so at that time thought Mr. Aldridge; for before the explosion took place in June, by acts of violence, it would be seen that Mr. Aldridge was in the habit of meeting the weavers and other persons employed in the clothing manufacture, upon roads, in public-houses, and on other occasions, particularly the meetings of the delegated portion of the united body, as they were called, who were the most dangerous and the most active among them, and therefore the portion with which it least became Mr. Aldridge to bring himself into contact. It would be proved that, on these occasions, Mr. A. used language of incitement and of instigation; that he gave to their projects the sanction of his presence and of his encouragement; that he actually met them on one occasion at a public-house, and distributed beer to them; that then, as well as on other occasions, he desired them to take all the work back off the looms to the clothiers – that is to say, all the work which had been contracted for by some of the other weavers to be done at what the united body was pleased to call under price, or "under foot". Indeed, at one of these meetings at some public-house, something having occurred which gave them a sort of temporary triumph, he actually told them, joining profaneness with folly, that he would order the parson to preach a sermon of thanksgiving and have the church bells rung. On another occasion, he said to them at his house at Bisley, "take all those weavers who work under foot, and who live near the water, and duck them, and take all those who do not live near water up to the common and kick their --", using a vulgar expression, "well". The Learned Counsel then stated various other incidents, and concluded by observing that, whatever regret the Jury

might have in finding a person of the defendant's rank in life guilty of the offence imputed to him, he was certain that if they could not satisfy their consciences without coming to that conclusion, they would do their duty firmly, and not permit any feeling of false humanity, or any luke-warm tenderness to prevail against the force of evidence. If the defendant was not guilty of that with which he was charged, if the evidence against him was not full and complete, let him take the benefit of any doubt fairly raised in his favour; but if the evidence be full and complete, as he apprehended it would be, the cause of justice and the necessity of example to others in his station of life demanded that they should give a verdict of guilty.

The following witnesses were then called and examined:

William Pettit, a weaver at Chalford Hill, was a member of a committee of weavers, thirteen in number, formed when the weavers first struck, about the beginning of May last year. The nature of the dispute between the weavers and their masters was this: the weavers complained of the smallness of their wages, and they refused to work unless they were raised. On 18th May the witness was at a meeting of a great number of weavers on Bisley Common, and saw Mr. Aldridge there. The meeting was assembled to consider about taking the work back to the clothiers who had refused to give an advance. Mr. Aldridge, before that meeting, was asked if he would come down to it, and he said, if there was any thing likely to be the matter he would. On the 18th, when on the Common, some hundreds of weavers went towards Mr. A. who, when they met, said he wondered they did not go to work for the gentlemen who would give the price. Witness said he would be very glad to go to work for any master who would give the full price; and he would give 9s. a week out of his earnings during the time any others were at play, that could not get work; for it would be better for those who could get their wages to go to work, than for all to play together; on which Mr. Aldridge turned round and said he was "a good fellow". After that, he asked whether the work had been taken back to the clothiers who had refused to give the prices? He was told they had not done it, and he seemed angry. He said, "then I shall consider it a mark of dishonesty if you don't do it". They then all agreed that they would take the work back. Reuben Hunt, who was president, promised him it should be taken back, and Mr. Aldridge then seemed better pleased. The meeting dispersed in about half an hour afterwards, and next morning most of the work was carried home to the masters. About 23rd May, witness and Reuben Hunt went to Mr. Aldridge's house. Hunt went in, but witness remained outside. Before he went in, Mr. Aldridge said that Mr. Davis, a

master clothier, had been with him, and had agreed to give the full wages; and he said he believed it was on account of threatening the clothiers respecting the informations that were likely to be laid against them for paying in *truck*[5] instead of in money. Mr. Aldridge said many times that it was a pity the weavers should take *truck* instead of money. On 24th May, saw Mr. Aldridge at the Duke of York public-house in Chalford. There was a meeting of the Committee there, and Mr. A. said, "You must have your shuttles out and go to work". The committee agreed to do so, and he ordered two gallons of beer for them, but they only had one.

Cross-examined by Mr. Ludlow – The shuttles were returned to them very soon afterwards. They had been collected some time before, in consequence of the rising at other places. They all then went to work, and the Rev. Mr. Mansfield preached a sermon the Friday in Whitsun week, on the occasion of peace being restored in the neighbourhood. Mr. Aldridge had been a Magistrate for a great number of years, and witness thought him about seventy years of age.

John Ridler, an old man apparently about seventy, was next called and examined by Mr. Taunton. Witness is a weaver, and remembers being at Mr. Aldridge's on 12th May. Nathaniel Young and John Workman were there with him. Mr. Aldridge ordered witness to take those who worked *under foot*, where there was water handy, and duck them; and where they were not handy to water, to take them upon the common and kick their – well, and he would see them righted, he said. Witness had gone to him for a warrant, and he asked how the weavers got on. Witness told him as well as he knew concerning the prices, but said he and the other two men did not walk about with them, because they were old men.

Cross-examined by Mr. Russell – Had gone to get a warrant against his master for wages. Mr. Aldridge did not say that there was a bustle and confusion between the weavers and the clothiers at that time, and therefore he would not grant the warrant. He never said a word of the sort. Witness did not get the warrant, however.

Nathaniel Young, examined by Mr. Campbell, gave his evidence in a very indistinct and muttering manner. Was at Mr. Aldridge's house with Ridler and John Workman, on 12th May. Ridler had some little business with Mr. Aldridge.

Mr. Justice Park – "I hope you can weave better than you can talk, or else you must be a very bad weaver". *(Laughter)*

Mr. Campbell – "Come, Sir, speak out, and let your tongue go like your shuttle". *(Laughter)*.

Mr. Justice Park – "No, no, not so fast as that if you please, for my sake".

Examination continued – Mr. Aldridge asked how the weaving went on, and was told they could not say much about it. Some had taken work out *under foot*, and others had not. Mr. Aldridge said that those who took work *under foot*, the weavers were to duck them, and if there was not water, to take and kick their --.

Mr. Ludlow – "You did not follow this advice".

Witness – "I never ducked nobody, Sir".

John Workman, examined by Mr. Twiss, corroborated the evidence of the two preceding witnesses.

John Tye, examined by Mr. Taunton – Is a shop-keeper, and lives at Chalford. Recollects seeing Mr. Aldridge on 6th June, between five and six o'clock in the afternoon; he was on horseback at the corner of witness's shop, and continued riding for sixty or seventy yards backwards and forwards. About a quarter of an hour after that the weavers passed by in a body. In about half an hour or three quarters of an hour they came back again, and they had some fore-beams with cloth upon them, belonging to Mr. Davis the clothier; it is not certain whether it was cloth or chains. Saw Mr. Aldridge on the bridge between seven and eight o'clock same evening; and saw the weavers go down to the bridge; witness then went back into his shop.

Thomas Workman, a weaver, on the evening of 7th June saw Mr. Aldridge on horseback in the middle of about a thousand persons. After that, he saw the crowd go down to the grist-mill with a man named Gardner, whom they almost drowned in the water. He also saw two persons of the names of Hyde and Tanner ducked by the crowd in the Canal.

Amos Tyler said his wife was a weaver, and the crowd came to his house and forcibly took away some work belonging to Mr. Davis.

Eli Pearce, a weaver, on 6th June saw Mr. Aldridge just above the turnpike gate by Chalford, with many hundreds of persons round him. He was near enough to Mr. Aldridge to touch his horse, and heard him say, respecting the weavers who had taken work *under foot*, "duck 'em! duck 'em well; but spare their lives".

Mr. Handy Davis, a woollen manufacturer at Chalford, on the evening of 6th June, between seven and eight o'clock, had a quantity of work brought back on the fore-beams, by a crowd of persons who were strangers, but were, as he supposed, weavers. The mob altogether consisted of more than a thousand. The gates had been fastened, but they were opened to admit the work when it was brought back. When the gates were opened, the

first person witness saw was Mr. Aldridge. He rode in on horseback. The weavers followed him in with the work upon their shoulders, and he said, "put the work down, but don't injure it". The work was not injured, and it was in an unfinished state. It was about half woven.

Cross-examined by Mr. Russell – Before that, witness had said that he would not come to any arrangement until the work was brought home. Mr. Cox, another considerable weaver, had also made the same declaration. Mr. Aldridge had not appointed special constables that night, but did the next morning.

Mr. Taunton now objected that no evidence could be given of any thing that Mr. Aldridge did after 6th June; and argued the point together with Mr. Campbell and Mr. Twiss.

Mr. Ludlow and Mr. Russell submitted that it would be extremely unjust to shut out the conduct of the defendant throughout the whole transaction. Isolated facts were here selected and brought against him, the effect of which might be explained or done away with, if all his conduct was admitted in evidence; and they cited Phillips on Evidence, pp. 170 and 182, where it was laid down that any thing done contemporaneously with the facts charged against a defendant was admissible in evidence.

Mr. Justice Park was clearly of opinion that "contemporaneously" did not mean any thing done *after* another thing, and therefore rejected the evidence.

Thomas Hyde, mill-man to the last witness, was at Bisley Church on the Sunday after the Friday on which the thanksgiving sermon was preached. As he was going to the church, the defendant was standing in the garden before his house, and said, "how do you do, Hyde? It is stormy weather". Witness said, "yes, sir". The defendant said, "we have storms from the elements; but, it is peaceable on the land at Chalford now, is it not?" Witness said, "yes, they have got to work and I am glad of it". The defendant then said, "I hope the next man who takes out work *under foot* again, or takes any thing for it except money – any *truck* – will have it thrust down his throat wholly and solely with a shuttle". On the evening of 6th June, witness heard that the weavers were going to bring work back, and he was ordered by his master to shut the gates. He fastened the gates, and got up on one of the pillars to which the gates were hung. He then saw Mr. Aldridge coming down on horseback, in front of a great number of people bringing his master's work. When they came up, Mr. Aldridge put his stick against the gates to try if they were fast, and finding they were so, he desired them to put the work down outside. He then rode round the corner of a wall, and said, "here, I want to speak to some of you".

A great number were going to him, and he said, " I don't want you all". He then said something in private to some of them, and after that turned his horse and rode thro' them. They made way for him, and reverenced him as he passed. After that, Mr. Aldridge said, "well, my men, we are all standing idle in the road here, filling up the road and doing nothing. Are you going to fetch any more back?" Some of them made answer and said they should. He then said, "if you are going, go with me, but if not, leave off". They then dispersed from the factory, and witness opened the gates and took in the work. After that, the same evening, witness saw a great crowd coming down the turnpike-road with Nathan Gardner, pulling him along in a shameful way; to throw him into the water. While they were flinging him into the water, the witness looked over his garden gate and said, "you are foolish people for doing so; you ought to be shot!" on which some of them, looking up, pointed at the witness and said, "you shall go in next for saying so". The witness then went on to describe that they were as good as their word, and after treating him in a very brutal manner, dragged him to the bank of the Canal, into which they were about to fling him, when he thought it best to jump in himself, and they would not let him get out for twenty minutes.

George Oldham proved that he had worked under price, as it was fixed by the United Body, and the mob ducked him on 6th June.

A vast number of witnesses were then called who proved the ducking that took place, and swore that Mr. Aldridge was in sight of it; that he expressed his approbation of it; that he exclaimed, "duck him! duck him! it will do him no harm, and make him know better than to take the work out *under foot* again!" and that the mob gave three cheers after the ducking was over, in which Mr. Aldridge joined, waving his hat in the air.

Mr. Ludlow, in a long and ingenious speech, which we regret we have not space to insert, addressed the Jury on behalf of Mr. Aldridge. He sollicited a calm and dispassionate attention to the present case, and warned the Jury against any prejudice with which they might possibly have been assailed out of doors. He submitted to them that the case on the part of the prosecution had been inflated and distorted, where it had any foundation in fact, but was totally devoid of truth, as he should prove by numberless witnesses, in all the material parts that affected Mr. Aldridge. Indeed, it was impossible to suppose that any Magistrate, who had filled that station for years with honour to himself and benefit to his country, should, without any assignable motive, without any possible benefit that could be derived, at once trample down the credit of a spotless life. The

Learned Counsel was prepared to admit that his client might perhaps have used indiscreet expressions; but then the Jury would recollect the situation in which he had been placed. He alone had to stem the fury of a misguided rabble, without the assistance of a single brother Magistrate; and without the aid of a solitary constable; and the Jury, therefore, in viewing his conduct, would anxiously look at his demeanour, to see whether they could not account for what he had done in the wish to temporize with those by conciliatory means, whom he was unable to cope with by force, until he received the aid of the military, for whom he had written to the Lord Lieutenant. Under all the circumstances of the case, and after the evidence for the defence was gone through, the Learned Counsel felt convinced that the Jury would acquit Mr. Aldridge, and restore him to that fair and honourable reputation which he had always hitherto held spotless.

Mr. Thomas Hall said he was a churchwarden of Bisley parish. In May last, that parish was in an extremely distressed state, owing to the strike of the weavers; at the suggestion of Mr. Aldridge a vestry meeting was called, and the neighbouring clothiers invited to attend, for the purpose of seeing whether the differences between the weavers and their employers could be adjusted.

John Hazle, who lived in the parish of Bisley, recollected Ridler applying to Mr. Aldridge for a warrant against his master, a Mr. Clutterbuck, on 12th May; and Mr. Aldridge refused to grant it, saying that there was a bustle and confusion between the weavers and the clothiers then, and he did not like to interfere. He recommended Ridley to go to his master, and said he was sure his master would pay any thing that was due without a warrant. The witness further contradicted the evidence of Ridler, Young, and Workman, as to what they alleged Mr. Aldridge had said about kicking or ducking the weavers that took in work *under foot*.

Mr. John Driver proved that Mr. Aldridge had interested himself very actively to induce the weavers to take the prices offered by the clothiers.

Mr. Daniel Cox, examined by Mr. Russell, said he was a clothier residing at Chalford. Upon 17th May, he met Mr. Jones and Mr. Davis upon the subject of the trade. After that, he communicated to Mr. Aldridge the opinion of the meeting; and told him that they should be very glad to have the cloth that was out brought back again, to prevent its being damaged. The weavers had then struck. On 6th June, there was a great mob in Chalford, about half-past six in the evening. Mr. Aldridge first communicated to witness that the mob was coming, and invited him to

go to his house at Bisley for safety, because he feared the mob might do him some injury. He refused that, and at the persuasion of Mr. Aldridge he went inside his own gates and fastened them, arming his people, who amounted in number to between fourteen and twenty, some with sticks, some with pitch-forks, and some with bill-hooks. The mob came outside the house, but made no attack. Did not know that Mr. Aldridge led them away, because witness was inside. Mr. Aldridge came back again to witness's house after that, and wrote a letter that evening to the Duke of Beaufort. (The letter was here put into the hands of the witness and identified).

Cross-examined by Mr. Campbell – Did not express any wish to Mr. Aldridge that the work which had been begun should be returned. Suggested to Mr. Aldridge that evening the propriety of swearing in constables, but he said constables would not be sufficient to protect the property without the aid of military; and witness believed he (the witness) said, "what, then you have nursed the baby so long that it is too big for you".

Mr. Justice Park – "Was Mr. Aldridge very popular with the poorer classes?" – Witness: "I believe he was, my Lord".

Mr. Justice Park – "Was he not so popular, that they would have readily obeyed him in any thing he had told them to do?"

Witness – "I don't think they would have obeyed any one at that time, my Lord".

Thomas Jones described the very unsettled state of affairs between the weavers and the clothiers in spring and summer of last year, and said that Mr. Aldridge had interfered to get them settled. He also described a part of that which took place on the night of 6th June, and identified the letter shewn to the last witness, as having been written by Mr. Aldridge in Mr. Cox's house, about ten o'clock that night.

The letter was now put in and read. It was as follows:

"Monday, Chalford, 10 o'clock night."

"My Lord – The peace of our county is most seriously disturbed. I have witnessed a scene at Chalford this evening, of the most alarming nature, by the assemblage of thousands, and the most daring acts of wrong to the manufacturers here, and alarm to the peaceful inhabitants. Stroud has been also signally visited, the civil power put to nought, and nothing can restore order but force. For my neighbourhood and for our county, I beg your Grace's instant help, and orders how to act.

Your Grace's most obedient humble Servant,
EDWARD ALDRIDGE

To His Grace the Duke of Beaufort, Lord Lieutenant."

Mr. Justice Park observed, this was a very proper letter.

The witness then proceeded to state that he took the above letter to Stroud, on the way to the Duke of Beaufort's, but it was rendered unnecessary by the military having arrived there from Bristol, though no intelligence of that circumstance had been received at Chalford.

An immense number of witnesses were then called, who swore positively that Mr. Aldridge used every exertion in his power to discountenance the riotous proceedings of the weavers, from their commencement until 6th June; that he was not present at the ducking; and that after remonstrances and threats, the mob were prevailed upon by him to disperse quietly. It also appeared by their evidence (to account for the cheering that took place after the ducking was over) that the mob being told by some persons that Mr. Aldridge was a great friend to the poor, they said, "then we will give him three cheers", which they did; and Mr. Aldridge took off his hat to acknowledge the compliment paid him.

In the course of this evidence, Mr. Ludlow apologised to his Lordship for calling so many witnesses, and said he would take their evidence very short.

Mr. Justice Park – "Indeed, I beg you will not Mr. Ludlow. When the character of a respectable Magistrate has been assailed in this way, it is your duty to go through with your evidence; and I would sit here until tomorrow morning to take it.

Several witnesses were next called to character.

Mr. Taunton then replied, after which, at nine o'clock, Mr. Justice Park commenced summing up. His Lordship said that, from the great anxiety which prevailed in the crowd this morning to obtain seats in Court, he was convinced that this was a case which excited the most intense interest in this county. He therefore felt it his duty most solemnly to beseech the Jury to dismiss from their minds every thing they had heard about this case, up to the moment that they were sworn. Deep and important as the interest was, which existed in the public mind about this case, it was no less deeply interesting to the gentleman who was the defendant on the record; because if the verdict were against him, however mitigated the sentence of the Court of King's Bench might be, yet the result must be his utter extirpation from all respectable and decent society. When this case was first opened, his Lordship thought it one of the most wicked he had ever heard stated against a Magistrate; but when he heard the evidence, he could not help thinking that it was greatly over-charged, and far from

being made out to the extent of the statement. If the evidence was true on the part of the prosecution, unquestionably the defendant was guilty of the charge imputed to him; but then, if any other construction could be fairly put upon his conduct, and if his guilt was a matter of doubt, his Lordship was of opinion that here, as in the Crown Court, the Jury were bound to give the defendant the benefit of that doubt, and acquit him. His Lordship then proceeded to comment upon the evidence of all the witnesses, and made several very strong remarks upon the contradictions that appeared. Among other things he said that when the case was opened, he had been led to believe that the defendant had been guilty of profamation, when he said that he would get the Clergyman to preach a sermon; but there was not the slightest foundation for such an assertion. His Lordship felt bound to say (though of that the Jury were the judges) that the witnesses for the defence had given their evidence in a much more respectable manner than the witnesses for the prosecution; and he could not help saying that the latter did not all of them entitle themselves to full credit in his Lordship's estimation. He thought this was a case of very great doubt, because it was difficult to conceive why a respectable Magistrate, as this gentleman had been proved to be, should go two miles from his own house, to mix himself with a pack of blackguards, and encourage them to acts of mutiny and sedition towards their employers. Such a thing was so improbable at first sight that when his Lordship heard it opened he thought, if it should be proved, it could only be reconciled with a state of insanity. Upon the whole, the Jury would take into their consideration all this mass of contradictory evidence, and they would see where the facts really lay; and next they would consider whether those facts were not reconcileable with perfect innocence, or whether they must necessarily establish against the defendant the very serious offence with which he was charged.

The Jury, after two or three minutes' consideration, found a verdict of *Not Guilty*, at eleven o'clock.

Mr. Justice Park said he highly approved of that verdict, for a more shocking case he had never witnessed.

The irreconcilable conflict between the testimonies against the defendant and those in his support would, one might think, have presented the Jury with food for thought. How surprising, therefore, to find the latter, far from retiring to weigh these discrepancies against one another, finding in the defendant's favour in a matter of minutes!

To return to the class of criminal more usually found at the bar of the Criminal Court, there was at these Assizes a rather larger than usual crop of prisoners who were condemned to capital punishment, nearly all of them for stealing. On this occasion, the *Journal* seems in most cases not to have found the space to provide detailed reports of their trials.

From the Gloucester Journal, 10 April 1826:

> The business of our Assizes not brought to a close till middle day on Thursday, by which time Mr. Baron Garrow had got through the heavy calendar of prisoners for trial. A few of the most interesting cases in both Courts are reported in our fourth page, and we subjoin a recapitulation of the sentences, &c.
>
> CONDEMNED AND LEFT FOR EXECUTION – *John Oliffe*, for stealing a mare, the property of W. Abell, of Winstone; also for stealing a mare poney, the property of W. Mills, jun., of Bisley; and *John Sparrow*, for stealing a sheep, the property of W. Priday, of Quedgeley.

The above two felons, John Oliffe and John Sparrow, had committed crimes – horse- and sheep-stealing respectively – which in those days were regarded with great severity, and they found themselves recalled, to be given notice of their fate in the stern and sombre terms habitually used by the judges for that purpose:

> At the close of the business for the county, *John Oliffe* was put to the bar. The prisoner had been convicted upon two indictments for horse-stealing, by the most clear and satisfactory evidence. Mr. Baron Garrow addressed the unhappy man as follows:
>
> "John Oliffe, the termination of my duties with respect to the county of Gloucester is that I perform the painful duty of communicating to you the fate that awaits you. The crime of horse-stealing has of late become so frequent in its commission, and it is carried to such an extent, that property of that description has no longer any protection afforded to it, except that which may be derived from the fulfilment of the law. It has become imperatively necessary to make severe examples in proper cases. It was my duty to tell you, when a verdict was recorded against you in a second case, upon evidence which it was impossible for those who had to decide upon your guilt or innocence to doubt, that it would become you to prepare, in the interval between that moment and the present, for that

which is now about to pass. It is not possible for me, consistently with my duty to the public, to give you any hopes that your life can be spared. I am about (after discharging some of the business of the city) to leave this place, and you will be left for execution. You will do well to employ all the short, and God knows very short, period which will elapse between this and the hour of your execution, in preparing for that change which is about to take place. It is impossible not to fear that the habits, in which you have been engaged for a considerable time past, require retrospection, founded upon a desire to look back upon the past with sincere repentance for all that has been done amiss. You ought from this moment to take leave of this world; its pleasures can be no excitement to you – its vanities can afford you no interest – you are fast approaching towards another world. Lose no time, I implore you, in applying yourself, under the assistance of those charitable and humane men of our religion, who will visit you in the distress of your solitude, to the Throne of Mercy. Take counsel from them. Submit yourself and humble yourself before God. Become sincerely penitent for all that has been done amiss; and with the hopes which our religion has given even to the worst of sinners, upon sincere repentance, through the intercession and through the merits of our Redeemer, you may hope for mercy in another world, which the interests of the community render it necessary to refuse in this". His Lordship then passed sentence of death in the usual form, having previously discharged the same distressing office in the case of *Sparrow*, convicted of sheep-stealing.

Sarah Barratt, Elizabeth Barratt, and *John Gribble* were indicted for feloniously assaulting Ann Hicks, single-woman, on the King's highway on 5th Sept., and taking from her person 200 guineas in gold, one sovereign, one half-sovereign, and several other articles, her property.

The prosecutrix, a woman apparently about 30, not of the most prepossessing appearance, and *enciente* though a spinster, told the following extraordinary story: On the 5th Sept., she went to Bristol fair about four o'clock in the afternoon, together with a young man named William Brain, who kept her company. At this time, she had the whole of her money tied up in her pocket. She went to different shows, but only to one public-house all the evening, and between ten and eleven o'clock at night she and Brain set out for her lodgings at Hanham. On their road, when they came to a place called Balloon Hill, they were attacked by the two female prisoners, and two men named Crow and Britton, who all beat them unmercifully, and while she was on her back in the road, Sarah

Barratt knelt on her breast, while Crow broke the string of her pocket and carried it off. The only thing that Gribble did, was to ask her whether she said he had robbed her. Brain did not appear, and she had not seen him for two months. Mr. Baron Garrow then ingeniously led the prosecutrix through a long cross-examination into all the ramifications of her story. The money in question, she said had been given to her by her mother, who had kept a small garden ground consisting of an acre and one or two patches. The mother had eight other children, to whom she gave but five pounds each, but she gave the prosecutrix 200 golden guineas[6]. She hid them under a stone in the kitchen during her mother's life time, and none of the other children knew she had so much. After the death of the mother, she took the guineas up, and went to live with her sister; they could not agree together, and then she took lodgings for herself and lived with Brain. She used to keep all this money in her box; but when she was going to the fair, she thought it was safest to put it into her pocket, for fear it might be stolen at home. Brain was going to marry her, after she had been robbed, and the banns were regularly published three times; but when the appointed morning came, she thought better of it, and did not think she wanted a husband. Brain was examined before the Magistrate and was bound over to prosecute, but did not appear. The constable who apprehended the prisoners merely proved, in addition to that fact, that the prosecutrix had two black eyes, and appeared to have been very much beaten when she applied to him to get a warrant.

The master of the prisoner Gribble, a respectable comb-maker in Bristol, gave him a most undeniable character, and expressed it as his opinion that he was merely on the spot by accident. Mr. Baron Garrow recapitulated the evidence of the prosecutrix, and the Jury without hesitation found all the prisoners *Not Guilty*.

NISI PRIUS COURT

Jones v. Beady – Mr. Campbell stated that this was an action for an assault. The plaintiff had been first a Private, and afterwards Serjeant-Major of the 10th Hussars. This was material as the assault arose from it. He had served his country for many years, and was with his regiment at the battle of Waterloo. On 28th April, the plaintiff, who then kept the White Lion Inn at Wotton-under-edge, returned from a journey, and the defendant, who was in the house, said, "Here comes a 10th – Here comes a Waterloo man." The plaintiff returned a civil answer, and the defendant then mimicked the voice and manner of Col. Quentin, who had

commanded the regiment, and told a story about his swearing at a man for having his jacket unbuttoned; and then said the 10th were all cowards, and had never drawn their swords at the battle of Waterloo. This the plaintiff said was not so, and the defendant threw a number of tobacco pipes at the plaintiff; and after that, knocked his pipe out of his mouth. Under these circumstances, but two courses were open to the plaintiff – either to resent the insult at the moment, which would have been highly improper, as the circumstances occurred in his own house; or to ask a Jury for a fair compensation for the insult he had received.

Evidence was called to prove this opening; after which Mr. Ludlow addressed the Jury for the defendant, and said he could not resist the verdict, and therefore it would become a question of damages. It appeared that no personal injury was done to the plaintiff; and on the second occasion the plaintiff was stationed behind his wife, no very proper situation for a hero of Waterloo; the defendant had reached over the wife's shoulder, and whether he broke his pipe or not the witnesses hardly saw, and it did not appear very material.

Mr. Justice Park said that, in general, public-house assaults called for little more than nominal damages, but this appeared to be a case of considerable aggravation. With regard to the imputation on the hero of Waterloo being defended by his wife, it should be observed that he was smoking his pipe, and probably had almost forgotten the first assault, when Mrs. Jones, who acted as a very good wife, stepped in between this violent man and her husband, to prevent another disturbance. It was certainly a case which called for fair and temperate damages; for they all knew that soldiers, if they were respectable men in their station of life, did not like to hear their commanders, under whom they had served for a considerable time, spoken ill of.

Verdict for the plaintiff – Damages 40s. Mr. Justice Park: – "I think that a very proper verdict."

From the Gloucester Journal, 17 April 1826:

EXECUTIONS – On Saturday last, *John Sparrow*, for sheep-stealing, and *John Oliffe*, for horse-stealing, the two wretched culprits, whom we announced in our last as having been left for execution, terminated their mortal career upon the public scaffold at our county Gaol, thus expiating by their lives, the offences they had committed against the laws of their country. The former was a native of Painswick, and the latter of

Duntisbourne Abbotts, in this county, and both were notoriously bad characters, having before been inmates of the same prison upon charges of felony. Subsequently to the announcement of their awful doom, it is gratifying to be enabled to state that their behaviour was appropriate to their unfortunate situation, and that they paid due attention to the religious advice of the Reverend Chaplain, whose unwearied efforts seemed to have a happy effect in tranquilising their minds, and preparing them for the dreadful change they were fated to undergo. On Saturday morning both convicts attended the performance of Divine Service in the Chapel of the prison, where the holy sacrament was solemnly administered to them, after which, at the appointed hour, they were conducted to the scaffold over the Lodge. In their way from the interior of the prison to the place of execution, both prisoners evinced an unwonted degree of firmness and self-possession. Sparrow was the first to ascend the fatal scaffold, when he appeared to falter, but it was only for a moment, and immediately assumed a resigned attitude, while being tied up to the fatal beam. Oliffe then mounted the steps in a brisk manner, and having instructed the executioner how to adjust the rope, requested permission to address the multitude. With a firm voice, he exhorted the spectators to avoid those evil courses which had led to his own destruction, and to follow the ways of truth and religion. After some sentences to this effect, he concluded by reciting with a distinct and audible voice, the whole of the cxiii *Psalm*. He then exclaimed, "The Lord bless you all", and turning round shook hands with his unfortunate fellow-sufferer, when the drop fell, and the thread of existence was snapped. The sufferings of both seemed to be but of momentary duration, and in the evening the bodies were delivered to their respective friends for interment. An immense concourse of people were present on the melancholy occasion, and we would fain hope these dreadful examples may have due effect in checking the commission of crime.

It seems that for some time the southern part of the county had been plagued by a number of malefactors who had joined together to pool their criminal talents, for their own profit and to the detriment of their more honest neighbours. The centre of their activities was today's inoffensive, not to say rather dull, village of Wickwar, after which the 'gang' was named. Before the Summer Assizes opened, the forces of the law had been busy, rounding them up in considerable numbers:

From the Gloucester Journal, 29 July 1826:

EXTENSIVE GANG OF DEPREDATORS – Within the last ten days, discoveries have been made which have led to the detection of a most extensive gang of depredators, in the neighbourhood of Wotton-Underedge and Chipping Sodbury. The general business carried on by this novel sort of joint-stock company seems to be aptly exemplified by the variety of goods found in the depository of the stolen property, such as cloth, wheat, barley, oats, cheese, &c, &c. No less than twenty-seven individuals are already in custody, as concerned in this gang; and the officers of justice, we are informed, are still in pursuit of others. The examinations have now occupied some days, under the active and competent superintendance of the Rev. Dr. Cooke; and it is expected that a numerous list of prisoners will be added to the present extended calendar of felons for trial at our ensuing Assizes. One of the parties apprehended has, we know, given information of not less than *forty-one* felonies in which he and his associates have been concerned! We are in possession of names and other particulars connected with these transactions, but which we deem it prudent to withhold at present, lest a premature disclosure should tend to defeat the ends of justice.

The following week brought more news of this nest of thieves. One interesting feature of the account is its inclusion of an example of how, in days when the 'officers of justice' were not very numerous, members of the local community were prepared – one might almost say, expected – to contribute their time and energy to assist in the practical measures needed to deal with the criminal element.

From the Gloucester Journal, 5 August 1826:

THE WICKWAR GANG – In our last week's Journal, we mentioned the formidible gang of depredators which had been discovered in the lower part of this county, and in this week's list of commitments will be found the names of twenty-one individuals belonging to this band, who have been consigned to our County Gaol upon charges of felony. They were conveyed to this city, on Wednesday, in two gigs and two waggons, guarded by a numerous escort of farmers and yeomen. In the accounts which have gone forth to the public upon this affair, much exaggeration has been used, and the aid of fiction and romance has been called in to give a more

imposing colour to the features of the case. It is, however, not less strange than true, that this gang has existed for more than seven years; and tho' their operations have extended over a very considerable tract of country, and the eye of justice has long viewed some of the parties with suspicion, yet with such secrecy and adroitness were their affairs managed, that till now they have evaded the hands of the law. The grand depot of the stolen property seems to have been established at the house of an old man of the name of Mills, at Rangeworthy Common, near Wickwar, where a miscellaneous collection of articles has been discovered. A principal place of deposit was an oven, the mouth of which was at the back of the kitchen fire-place, where a large pot was generally hung to prevent suspicion. This simple contrivance has been magnified, by the lovers of the wonderful, into a *subterraneous cave*, and stated to have contained more goods than could by possibility have been crammed into it. Much stolen property was, however, brought to light, from different places of concealment. From information given by some of the gang, upwards of thirty persons were taken into custody, twenty-one of whom, as above stated, have been fully committed, and one remains for further examination. Two of the persons apprehended unfortunately succeeded in making their escape into the Duke of Beaufort's woods, on Sunday se'nnight, and have not yet been retaken. The Rev. Dr. Cooke and the Rev. Mr. Jones have been indefatigable in their exertions to bring these offenders to justice, and amply deserve the the gratitude of the community for their successful labours, in which they were most actively and effectively assisted by many respectable individuals in the neighbourhood. As may be readily supposed, the affair has excited great interest in that part of the country, and numbers of people have been induced by curiosity to visit the spot.

Extensive Gang of Depredators! – On Wednesday, the following persons, composing a part only of the extensive gang alluded to in our last, and mentioned in another part of this paper, were fully committed to our County Gaol, by G. Cooke, D.D. and Th. Jones, Clerk, for trial at the present Assizes, viz. *Thos. Gardiner* and *Betty Cobb*, the former charged with breaking open the house of S. Long, of Charfield, and stealing a quantity of cloth, and the latter with receiving the same, knowing it to have been stolen. *Job. Mills, jun.* charged with breaking open the house of R. Gay, of Old Sodbury, and stealing ten sides of bacon; and *James, George* and *Betty Gardiner*, for receiving the said property. *Wm. Chivers*, charged with breaking open the house of F. Cam, of Iron Acton, and stealing twenty-one cheeses. *John Mills*, charged with breaking open the

house of Charlotte Wherratt, of Rangeworthy, and stealing silver spoons, and other articles. *John Lewis*, charged with receiving a safety lamp and a measure, knowing them to have been stolen from Martha Keeling, of Cromhall. *Mark Dyer*, charged with reciving a quantity of bacon, knowing it to have been stolen from J. Orchard, of Hawkesbury. *Thos. and Wm. Mills*, charged with breaking open the house of W. Cousins, of Wotton-Underedge, and stealing a quantity of cloth; and *Hester James, Stephen Woodward, Catherine Woodward, Job. Mills, sen, Unity Mills, Wm. Dyer, sen, John Dyer, Wm. Somers*, and *John Seaborne Vines*, charged with receiving the said cloth, knowing it to have been stolen.

Gloucester Summer Assizes

From the Gloucester Journal, 5 August 1826:

On Thursday afternoon, Sir James Burrough, Knight, was received at Over, by the High Sheriff, R. H. B. Hale, Esq., and from thence escorted into this city with the customary formalities. His Lordship immediately proceeded to the Shire Hall, when the Commission was opened. The other Learned Judge, Sir Wm. Garrow, Knight, arrived here very shortly afterwards.

At ten o'clock yesterday morning, their Lordships attended at the performance of Divine Service, at the Cathedral, where a Sermon appropriate to the occasion was preached by the High Sheriff's Chaplain, the Rev. J. E. Whish, from Romans vii, 12, *"The law is holy; and the commandment holy, and just, and good."* After church, their Lordships returned to their lodgings, whence, in the course of a few minutes, they proceeded to their respective Courts, and commenced the business of the Assize.

We do not have available the report of the trial of the 'Wickwar Gang', which took place at these Summer Assizes, but the following two items reveal the fates of some of them:

From the Gloucester Journal, 19 August 1826:

William Mills and *Thomas Gardiner*, the two wretched leaders of the Wickwar Gang, who were left for execution, will, it is expected, suffer the punishment awarded for their offences, at the usual hour and place this

day. Altho' there was not much appearance of feeling manifested by them at the period of receiving their awful sentence, it is gratifying to learn that their behaviour since condemnation has been perfectly becoming their dreadful situation. Both culprits have expressed the utmost contrition for their past conduct, and seem prepared to meet their appalling fate with resignation and fortitude.

Two other members of the gang, William Chivers and Thomas Millard, had also been sentenced to death, but this was reduced to transportation for life. As we shall see, at least two others were acquitted, while one other bought his freedom, even perhaps his life, by giving evidence against his former associates in crime, one of whom was his own brother – the luckless William Mills.

From the Gloucester Journal, 26 August 1826:

EXECUTION OF WM. MILLS AND THOS. GARDINER – These two victims to the offended laws of their country terminated their mortal career upon the scaffold, on Saturday, as we intimated in our last. Their behaviour up to the fatal moment was strictly in unison with that contrition and repentance which they had manifested from the time of condemnation, an interval which they devoted almost exclusively to the duties of religion. They made a full confession of their crimes, acknowledged the justice of the fate they were about to undergo, and, as the best proof of the proper state to which they had subdued their minds, repeatedly expressed their forgiveness of the accomplice whose testimony had led to their conviction. With Mills particularly the latter feeling was predominant, and he frequently intimated a wish to have a friendly interview with his brother before he suffered. This however did not take place, as Thomas Mills could not be induced again to face his miserable brother and associate. On the day previous to his execution, Mills took a final leave of his wretched parents. The old man was dreadfully affected, but the mother did not manifest a similar degree of feeling. On Saturday morning both culprits attended in the chapel, where, after the usual service, the sacrament was administered to them. They afterwards again made confession of their offences, and about half-past twelve o'clock were ushered to the fatal beam, where their earthly sufferings were terminated in the presence of an immense concourse of spectators. After hanging the usual time, the bodies were taken down and delivered to their friends for interment.

Of the other cases brought before these Assizes, one turned out to be a sequel to a case which had been heard the previous Spring, with the return of Ann Hicks who, it will be remembered, had been robbed of the then very considerable sum of 200 guineas, but was also robbed of the satisfaction, at that previous hearing, of seeing those accused of the crime found guilty. Since then, the thief-catchers had apparently managed to light on three new suspects, whom they took into custody, to replace those acquitted at the earlier trial.

From the Gloucester Journal, 12 August 1826:

SINGULAR CHARGE OF HIGHWAY ROBBERY – *Arthur Britton*, aged 18, *Samuel Crow*, aged 18, and *William Crow*, aged 19, were severally indicted for assaulting Ann Hicks, spinster, on the King's highway, in the parish of St. George, putting her in fear, and taking from her person and against her will, 200 pieces of the current gold coin of this realm, called guineas, value 210*l.*, and other monies, and also a linen pocket, and other articles, her property, on the night of 5th Sept. last.

Mr. Twiss, who conducted the prosecution, examined the prosecutrix, who stated her name to be Ann Brain – Mr. Baron Garrow: "How is that? you were a spinster the last time we met; you remember we met here last Assizes, and your name was Ann Hicks?" – Mr. Twiss: "My Lord, she has since been married to a man named Brain".

The prosecutrix then proceeded with her story, Brain being ordered out of Court during her examination. She related nearly the same account of the alleged robbery that she did at the last Assizes, when two girls named Barrett were tried and acquitted as participators in the offence. She said that, between ten and eleven o'clock, or later, on the night of the 5th Sept., she was returning from Bristol fair, whither she had gone the same afternoon in company with Wm. Brain, a young man whom she had since married, and by whom, at that time, she was pregnant; and while they were going quietly and soberly along the high road homewards, the prisoners, together with the two women of the name of Barrett, and one Gribble, overtook them, when the prisoner Samuel Crow said, "Bill Brain, thou shalt have enough of it tonight", striking and knocking him down at the same instant. She screamed, and they knocked her down also, and, while on the ground, Wm. Crow tore off her pocket, in which she had ten score of guineas, besides the silver money, and he bore off all with him. She had never seen her money since. She spoke positively to the prisoners

being of the party, as she and Brain knew them all well.

In her cross-examination by Mr. Watson, she said that this money was bequeathed or given to her by her deceased mother, four years ago. She at first had deposited it in her box in her mother's house. There were nine in family, brothers and sisters; but the rest only got 5*l.* a piece on their mother's death. At first, she put this money, for safety, into a hole, under a stone in the kitchen; every body could cross this hole, as well as go into the room where her box was kept; but she had never informed any body that she was in possession of this cash; even Brain, by whom she had had a child born last March, that died six weeks after, was ignorant of it! Her mother had made a will, but it contained no allusion to this property of hers. Her sisters and brothers were all labouring people; she kept the secret from them.

In answer to questions from the Court, she said that nobody was privy to having such a treasure; therefore nobody could expect to find it upon her person, though there might have been rumours that her mother had given her money. She took the money out, for the first time to this fair, and Brain knew nothing of it. She thought it would be safer to carry it in her pocket, than to leave it in the box, in the house where Brain's mother was.

Wm. Brain was next called; and he exactly corroborated her statement of the assault, the identity of the parties, and her having said as they went home afterwards that she had lost all she had got in the world, then, for the first time, apprising him of her wealth. That notwithstanding this disclosure, they pursued their pace homewards and went to bed, without making any public alarm about it.

This was the case for the prosecution.

Mr. Baron Garrow said that, as it had been part of his practice through life to observe the expression of features, he thought he caught that the Jury were of opinion with him that this evidence was far too insecure for the maintenance of so serious a charge. Let them just see for one moment what they would have to believe, before they could convict on this evidence. First, that the mother of this woman had left her this money, to the exclusion of her other children – a sum of money exceeding 200*l.* – an immense amount for people in their walk of life. Then, that she kept this money, unknown to any one, under some stone, and being about to go to Bristol, she took the whole of this valuable treasure with her in her side-pocket, as the best and safest place it could be in. That she was, on her return home, attacked by men and women, all of whom were very

well known to her; and that they aimed at and tore off this pocket from her person, altho' they could have had no reason in the world to believe it contained one farthing; and then that she and Brain went home together, without making the least communication of the robbery on their arrival. Were they prepared, on evidence of this sort, to leave these three men to his discretion, to be left for execution? For, undoubtedly, if the Jury were satisfied of their guilt, the offence was heinous, and the culprits ought to be hanged. Did the Jury wish him, upon the evidence which they had just heard, to call upon the prisoners for their defence; or were they of opinion that the statement of the prosecutrix was altogether too unsafe to move with? It was an awful and momentous question, to say that six people (for there were three others besides the prisoners, if this story be true) ought to be hanged, for an offence only sustained as this prosecution had been.

The Jury declared their concurrence with his Lordship, and said that they had heard enough to guide them to a verdict of *Not Guilty*.

Mr. Baron Garrow said that, last Assizes, another Jury had acted in precisely the same manner. All these people had been at Bristol fair, which was a hot-bed of crime. They had quarrelled coming home. He would not say that the story was trumped up, or that the woman had not lost her money, if she ever had any; but the case was very doubtful as it was developed before them – indeed the story was quite incredible. Then, addressing the prisoners, his Lordship added in conclusion – "Prisoners, I believe you are bad and dangerous characters, and some like you have gone on for years with impunity, until they were caught at last, and the gallows, round which they had been so long playing, had at length made close acquaintance with them. Fellows of this stamp were now overtaken in the calendar of this very Assizes".

BASE COIN – *Wm. Compton*, aged 17, was convicted of uttering two counterfeit sovereigns, on Saturday, 27th May, to W. Jones, in the parish of Bibury.

TUESDAY, August 8

The Court directed the above prisoner to be brought up for judgment, when he was addressed in the following terms:

Mr. Baron Garrow – "Prisoner at the bar, you have been convicted of uttering base money, not according to the ancient practice of exercising that calling, by beginning with sixpences and shillings, going on to half sovereigns, and finally to sovereigns; but by at once commencing with the last, and dealing wholesale in the higher sort of gold coin. Your crime is a

serious one. A poor woman takes to the market the produce of her little potatoe ground, where she might sit for the whole of a long day, before she could realize 20s. out of the sale of her little property; and you, and fellows like you, go with your base sovereigns to buy 5d. worth of her goods, and receive from her in good change 19s. 7d. This course you and your fellows pursue, until you have passed the bag of base money which one of you bears to the market. I have no hesitation in expressing my regret that the law limits by statute in the sentence which I can inflict upon you. I say this by way of apology, for the too lenient punishment to which I am to consign you. When I give utterance to this expression of my feelings, it is unusual with me, but I do sincerely regret that I can only sentence you to twelve months' imprisonment, and hard labour, and that afterwards you give your own surety in the sum of £20 for your good behaviour for the next ensuing two years. And I will just add this, by way of advice to you, though God knows what effect it will have, not to go and fill your bag again, when you leave prison, after enduring this punishment. This is, I know, the usual course pursued by fellows of your kind, and it eventually leads them to their proper exit – the gallows. And if you happen to be again convicted, rely upon it that will be your most deserved fate".

An application had been made both by the committing Magistrates and the prosecutor, to the Mint, to prosecute this prisoner, which was refused; the prosecutor had therefore to conduct it, at an expence of 40l.

CHARGE OF MANSLAUGHTER – *Jos. Pugh* and *Wm. Davis* were indicted for killing and slaying Josiah Dee, in the parish of Oxenhall, in this county, on Monday, the 24th of April last.

Mr. Phillpotts stated the case for the prosecution. He said that the affair out of which this prosecution had grown was one of the many lamentable proofs that dreadful results arose out of the habit of frequenting public-houses on the Sabbath day. The prisoners had been in a public-house at Newent, when some altercation arose, which led to a challenge from the deceased to fight Pugh, one of the prisoners. The latter, it was right for him to say, had on this occasion manifested no eagerness for the combat, but, on the contrary avoided it while in the public-house on this Sabbath night. The quarrel, however, which commenced within, was afterwards revived without; and, in the end, these parties came into collision on the Monday morning, when Dee met his death from the injuries which he received from the prisoner and his companion, who was an aider and

abettor on the occasion. He was not instructed to press the case hard against the prisoners, but it was right and proper that a full inquiry should be instituted.

Samuel Lewellyn – I live in the parish of Newent, and was at the Red Lion public-house there on Sunday, 23rd April, at ten o'clock at night. I saw the late Josiah Dee there, and the prisoners, with others. Dee several times challenged the prisoner, Joseph Pugh, who declined; but Dee said, if he would not fight then, he should make him do so at another time. Pugh replied he would not then, nor again. They all came out of the public-house together; another altercation took place; Dee knocked Pugh down, gave another man a black eye, and a row took place, when two of the parties agreed to fight on the next morning for 1l. a piece. I went out with the others to see the fight, but we did not cross into the field, for those who were there said that the fight would come to nothing. We went away and, soon returning, found not the two men that we expected, but Joseph Pugh and deceased, having some rounds. I saw deceased fall upon his back, and not rise again. It appeared to me to be a very fair fight.

John Constable was present at the fight, and agreed in the account of it which was given by the last witness. The battle lasted an hour, and was very fair. Pugh, after the 14th round, wanted to shake hands with deceased, but the latter would not, neither would his brother consent, for he said, "Go at him like a brick!"

Crockwell said, I was present; saw them shake hands, and then go to work at once; and after some rounds Pugh wished to shake hands and fight good-humouredly.

Mr. Hollister, a surgeon at Newent, saw deceased in a dying state. He had been previously bled; after death, he opened his head, and found a great quantity of extravasated blood, which was caused by either a blow or the concussion of a fall, in this battle.

This gentleman and some other witnesses gave both the prisoners a good character.

Mr. Baron Garrow – "Gentlemen of the Jury, we see nothing in this case resembling these pitched battles, in which one parcel of ruffians turn out another upon a stage, to fight for their base gratification, for money. If any of such a class should come before me, whether the instigators or the boxers, I shall most assuredly know how to deal with them. Here we have only the quarrel of two men, who, in the heat of personal altercation, contend with each other, and one of them loses his life evidently. The prisoner does not appear to have sought, but rather to have avoided this

quarrel. If, however, the deceased had met his death by the prisoners' hands, as would seem from the evidence, then the Jury were bound to find the prisoners, one or both, guilty of manslaughter".

The Jury, after a few minutes' consideration, acquitted the prisoners; and the Learned Baron smiled at the verdict, at the same time ordering Pugh and Davis to be discharged.

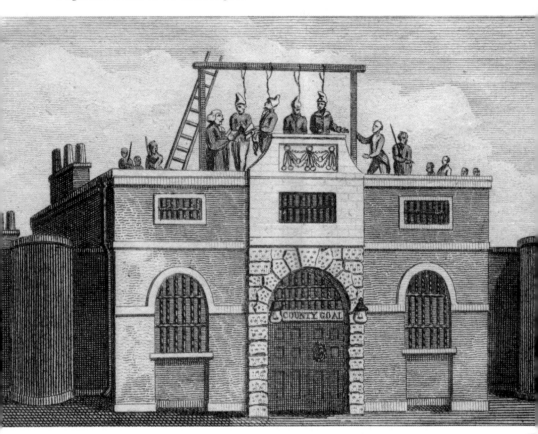

This execution scene is not dissimilar from that frequently enacted at Gloucester Gaol.

1827

The 26 April saw the opening of the Gloucester and Berkeley Canal (which we now call the Sharpness Canal), attended by much jubilation. There was good reason for celebration, for its achievement had been far from swift. It had been as long ago as 1794 that, at Gloucester, the first sods had been turned, with the digging reaching Hardwicke by 1799. There it stopped dead for twenty years, while quarrels, dismissals and arguments about its ultimate route engendered much heat, but little effect. At last, with all these problems solved, it had been finished, ending at Sharpness rather than Berkeley as originally intended, and two days later the *Gloucester Journal* signalled its approval by devoting well over a whole column to the event:

Never has it fallen to our lot to announce an event so pregnant with importance to the commercial interests of this city and neighbourhood, as now devolves upon us, in noticing the completion and opening of this stupendous undertaking. When we have, at former times, indulged in pleasing anticipations of the arrival of this long-wished for occurrence at no very distant period, some untoward circumstance or other has generally intervened to destroy our hope; and the recollection of previous disappointments has tended to embitter future prospects. But our feelings, upon this gratifying occasion, are unmixed with any such alloy – we have seen the Canal completed, and its utility proved to demonstration by the arrival in the basin, in this city, of two merchantmen, one of them of a class and burthen never before witnessed so high up the Severn by many miles. Thus, also, by the ease with which these vessels were introduced into the Lock at Sharpness Point, has a direct negative been given to the statements of those who have made it their business to assert, that such an attempt would be at all times dangerous, if not impossible. Even

Gloucester Docks in 1826, with the stern shape of the County Gaol looming in the background.

in the worst state of the wind and tide, we are induced to place every reliance upon the judicious arrangements, careful management, and active exertions of Capt. Clegram, the Gentleman to whom this particular duty is assigned.

In the progress of forming this Canal, it has been necessary to apply for six Acts of Parliament, the first of which was obtained in the Session of 1792-3, and in the latter year the works were commenced. But the expence of carrying on a design of such magnitude so tremendously exceeded the estimate, that the original capital was speedily swallowed up, and by the time the locks and basin had been formed, and about five miles of the Canal excavated at this end, the difficulties appeared so formidable, that the design was abandoned in despair; and, for upwards of twenty years, the concern assumed no better an appearance than a great mass of stagnant water, utterly useless for any extensive commercial purposes. About twelve years ago, however, the undertaking attracted the attention of Mr. Pearman, of Coventry, who was accidentally staying in this city,

and was at once convinced of its importance, if completed. Through his representations, in connection with several other Gentlemen of activity, enterprise, and capital, the design was again taken up; and on the first of September, 1817, the works were resumed. Since that period, immense sums of money have been expended, and various has been the success with which the Proprietors have been struggling on; nor would the plan have been at last carried into effect, had not the aid of Government been repeatedly afforded, through the medium of the Exchequer Loan Commissioners. Some opinion of the immensity of the works may be formed, when we state, that the expenditure, to the present time, has exceeded the sum of 450,000*l.*

The original design was to have carried the Canal from hence to Berkeley Pill; but it was subsequently resolved that it should terminate at Sharpness Point. The length of the line is 16¼ miles; and there are fifteen swing bridges over it, exclusive of those over the locks at each end. It is upon one entire level and when full is from 70 to 90 feet wide, and 18 feet deep, with a spacious basin at each end, for the reception of shipping; and, at Gloucester, a second basin upon a reduced scale, for the accomodation of barges and smaller craft. At Sharpness, there are two locks from the basin into the Canal, one for large and the other for small vessels, by which means an unnecessary waste of water is avoided.

The *Journal* continued at some length to describe the progress along the Canal of the two ships, the *Meredith* (happily carrying a cargo of brandy from France) and the *Anne*, with colours flying, accompanied by the playing of the inevitable band and the firing of many guns, whilst cheered on by a vast crowd which lined the banks. There followed the triumphant entry of the two vessels into Gloucester Basin itself, to the sound of more gunfire.

At five o'clock some hundred people sat down to a celebratory dinner at the King's Head (6 shillings per person), which seems to have gone very well; once the food had been fully consumed, it was time for the speeches and the toasts. The President for the evening, Mr George Talbot, of Guiting, set the ball rolling; the first toast was to the Canal itself, followed by one to the Duke of Gloucester. The local MP, Colonel Webb, then toasted Mr. Talbot and was himself toasted in return. The evening proceeded with the exchange of numerous expressions of mutual regard, while the number of toasts proposed and drunk mounted steadily. When no further subjects could be discovered for honouring with a libation,

'the party broke up at a late hour', to quote the *Journal* once more, 'not more exhilarated by the conviviality of the table than by the preceding events of the day'.

Away from the pleasurable celebration of these useful and progressive events, crime and its perpetrators had been continuing on their usual courses:

Gloucester Lent Assizes

From the Gloucester Journal, 14 April 1827:

On Monday last, their Lordships having finished the business at Monmouth, took their departure for this city. On arriving at Over, they were met by the High Sheriff of the county, George Bragge Prowse Prian, Esq. by whom they were escorted to our Shire Hall, with the usual cavalcade, and the Commission was formally opened. On Tuesday morning their Lordships attended divine service at the Cathedral, where a sermon appropriate to the occasion was preached by the High Sheriff's Chaplain, the Rev. R. Williams.

Soon after one o'clock, their Lordships proceeded to the Hall for the commencement of business, Mr. Serjeant Bosanquet, who officiated in the absence of Mr. Baron Garrow through indisposition, took his seat in the *Nisi Prius* Court, where there were 47 causes entered for trial, six of which were Special Juries. Of these, 31 had been decided when the Court broke up last night; and it is rather singular that, in every case, except one which was referred, a verdict was given for the plaintiff. The Special Jury Causes are fixed to commence on Monday morning at nine o'clock.

In the Crown Court, Mr. Baron Vaughan presided; and after the Magistrates had been called over, and the respective Grand Juries sworn in, with the customary preliminaries, the Learned Baron delivered his Charge, of which, with other proceedings, an ample report will be found on our 4th page.

ATROCIOUS BURGLARY – Thursday, *Jos. Ray*, aged 19, *Jas. Jones*, aged 20, and *Wm. Leach*, aged 18, were tried for burglariously breaking into the house of Edw. Shearman, of Horfield, and stealing thereout about 30*l.* This robbery was accompanied by circumstances of great cruelty and outrage; but as our limits will not admit of a full detail of the evidence,

we must confine ourselves to an outline of the case as proved in Court. The prosecutor and his wife were an aged couple, who had realized some property by the sale of milk, and resided on St. James's Back, Bristol. On the 10th of Feb. last, James Jones, one of the prisoners, who lived within a door or two of Shearman's, went to John Stephens, chief constable of the night-watch of that district, and informed him of a plan that had been entered into by himself and others, to break into the house and rob the old man, and that he was afraid murder would be committed. That they knew the old man had plenty of money, because when the Banks were breaking, Shearman, who could not read or write, took a quantity of notes to a person to ask if they were good, and that this person had informed the thieves of it, saying he had property to the amount of some hundreds, which he kept in a box under his bed. Jones said that they had been to the spot several times to carry their purpose into effect, but that he had been conscience struck; and felt as if he had lost the use of his limbs. The old man's house was not more than fifty yards from the watch-house; and Jones gave Stephens a caution to take care of himself, for the party had provided themselves with *jemmies* (crowbars) that if the old woman screamed out, they would give her a smack on the head; and if the alarm should reach the watch, and Stephens and his party should come to the door, that one was to give him "a smack on the head with a *jemmy*", while the other two fought their way out. Stephens repeated this information to Mr. Evans, the keeper of the Bridewell, who accompanied him to the old man's, and told him of the diabolical plot that was formed against him; and Shearman was in consequence so much alarmed that he disposed of his house and business as soon as he could, and removed to another residence at Horfield, about three quarters of a mile off.

On the night of the 13th of March, about a fortnight after Shearman had removed to Horfield, his wife went to bed about eight o'clock, previous to which he fastened the doors and windows, and himself retired to rest about ten, and both went to sleep. The old woman was first awakened by the light of a candle, which came through the door at the foot of the stairs, by which she saw four men below, who had what she called a large big stick each in their hands. They came upstairs, and she recognized the faces of Ray and Jones, whom she had known for years, but she would not swear positively to Leach. Jones, she said, held her husband, while Ray cut his head with a stick. They ransacked the boxes in the room, and flung the contents upon the old woman, whom they pushed down as often as she attempted to rise. They struck her likewise on the arm,

and bruised it black, and she was, as may well be supposed, extremely frightened. The old man said, when he awoke he saw by the light of a candle, three men standing round him. He stood up in the bed, when they pulled his shoulders down, and struck him very violently three or four times with an iron bar, or something of that sort, over his head. His head was much cut, and he bled till the morn, in his own words, "it was like a butcher's slaughter-house." They then pushed him violently across another bedstead in the room where he lay and watched their proceedings. One held the candle, while the others searched the boxes. He knew them to be the prisoners. He had known Ray and Jones for twelve years, as they had both lived near him on St. James's Back, and he knew Leach's person. He saw them ransack the boxes, they took ten sovereigns in gold, and about 20*l.* in silver, after which they went away. As soon as they were gone he crept off the bed, and, going to the door at the foot of the stairs, cried out "murder" and called for a neighbour, named Prosser, to come to his aid. Jones immediately came back and said, "Here I be, my good man, open the door", and kept driving forcibly at the door. He knew his voice well. With a view to frighten them away, the old man then said, "here's Prosser and another coming, we shall soon have 'em now", upon which they immediately started off. The old man then held fast the door, till he "heard the birds whistle" when, thinking he was safe, he tried to go out, but found it was fastened outside. A man named Clark, who was employed on the prosecutor's premises, going to his work at half-past six in the morning, found the two first doors forced open by means of a crowbar, and the door at the stairs nailed on the outside, under the latch. He broke it open with a bar, and found Shearman lying on the floor, wallowing in his blood, and the old woman on the bed, but not much hurt. There was a deep cut on the prosecutor's head, about four inches long, which appeared to have been inflicted by the edge of an iron bar. He took the old man to the Infirmary to have his head dressed. Clark also swore that he saw the three prisoners, in company with another person, pass by the premises about five o'clock on the previous evening.

On the apprehension of the prisoners, Ray offered to tell all the particulars of the burglary, if he was admitted King's evidence; but the other two denied participating in the robbery. In their trial, when called upon for their defence, Ray confessed his share in the affair, giving the names of three other persons as being connected with him, and denying that the other two prisoners were there. Jones and Leach protested their innocence, and brought forward witnesses to prove an *alibi*.

Mr. Baron Vaughan summed up with great care, and, after a quarter of an hour's deliberation, the Jury returned a verdict of *Guilty* against all three prisoners, but recommended them to mercy.

The three wretched culprits, when called upon to receive sentence, fell upon their knees in the most abject manner, praying for mercy, and were at first obliged to be held up by force to hear the address of the Judge, who passed the awful sentence of death in the most impressive manner, dwelling in emphatic terms upon the dreadful enormity of their crime, beseeching them to reject all idea of the possibility of mercy being extended to them on this side of the grave, and entreating them to employ their remaining time in endeavouring to make their peace with an offended God. The prisoners were then removed from the bar in a dreadfully agitated state.

The 'Wickwar Gang', whom we met last summer, had been broken up and scattered. At such times, when villains find themselves in difficulties, the quality of loyalty can become a little strained. Thus it was during this episode, when one of the gang purchased his freedom by giving evidence against his former friends. This perfidy naturally excited a certain indignation in at least two of them who, unfortunately for the traitor, had been acquitted and were therefore at large and free to seek their vengeance.

From the Gloucester Journal, 21 April 1827:

SHOOTING WITH INTENT TO MURDER

Mark Dyer and *John Dyer* were indicted for feloniously shooting Thos. Mills, with intent to murder him, or to do him some grievous bodily harm. It will be recollected that Thos. Mills, at our last Assizes, appeared in the Court as King's evidence, against a great number of depredators, who had for a length of time carried on an extensive system of robbery, in the neighbourhood of Yate and Sodbury.

Mr. Ludlow, as Counsel for the prosecution, gave a statement of the facts of the case, as afterwards proved in evidence.

Thos. White deposed as follows: I live at Yate, I was charged by the constable, previous to the last Assizes, to aid and assist. Mark Dyer was in custody, I accompanied him to Wickwar. He told me Wm. Mills and Thos. Mills ought to be hanged and ought to be shot; and he would shoot them if ever he could see the chance, as soon as he would a sparrow! He

heard that he was charged with others with cutting Mr. Cox's trees, and fainted away; it was said that Wm. Mills had given the information. Thos. Mills was in custody at the same time, and had been so for some days; the Dyers were also in custody, but they were kept in separate houses. John Dyer was not present at this conversation.

Thos. Mills – I live at Wickwar. I was in custody in the summer of last year at Wickwar. John and Mark Dyer were in custody at the same time. Before that time, I was engaged in transactions with the two prisoners. I was a witness against both prisoners; they were tried in this Court, and were acquitted. On 24th Oct. last, I went from Wickwar to Yate in company with Wm. Coventry, to my father's house; we parted company about 300 yards from my father's, as Coventry's clock struck seven. I proceeded immediately to my father's house. My father, mother, brother Job, sister Susan, and my wife Sarah were in the room there was no shutter to the room, there were two candles on the table, a round table was put against the window. My father was sitting with his right arm towards the window; my brother Job was sitting opposite my father; I was sitting by my father on a low stool, my head being about level with the top of my father's chair. My wife was sitting about two yards from the fire-place, which is on the left as you enter the room. I was about a yard and a half from my wife. About ten minutes after I got in, a gun was fired through the window, on the same side my father was sitting. A curtain was drawn on one side of the window, and stuffed into a broken pane of glass; all the glass up to the broken pane was broken by the shot, and the curtain was singed. The lower part of the window was about three feet and a half from the ground. The upper rail of the chair my father was sitting in was struck by large slugs; my head was about level with the rail, and about two feet from the end of it, towards the fire-place. The instant I heard the gun fired, I jumped up, and ran to the door, which was ajar. When I got outside the door, I came to a little wall; I stooped a little and I saw two men. The door opens into the garden, into which the window opens. I did not observe any smoke outside, but there was both smoke and fire inside upon the discharge. Each of the two men had a gun in his hand. One had a low crowned hat on, and the other a cap without braid. It was not a very light evening. The men were standing about four yards and a half from the window. I knew the person of one of them; that was Mark Dyer; he had the hat on. I am certain Mark Dyer was one of the men. I have no doubt at all, upon my solemn oath, that he was one of the men. I saw both their faces. I believed the other to be John, from his dress; he had a cap on, and

a light fustian jacket. I heard a cry of "murder" from the house, and I said to the men, "you have done something now". They were both looking towards the window, and were stooping down. I don't think they saw me till I spoke, when they turned round and gave me a better opportunity of observing them. They were about three yards from me. The light from the window fell upon the men. They ran away, and in about three or four yards one of them fell down. They were in the garden, and had to get over the hedge. I heard John say to the other, "Give me thy hand, give me thy hand". I knew his voice, and am certain it was John Dyer. I then turned back to the house, where I found my father and brother with my wife in their arms; the blood was running down her legs, and her shoe was full of blood. The side on which she was wounded was that which was next the window. She had fainted away. There were four wounds on her arm. We carried her up stairs and put her to bed. We pulled the bed off the bedstead, and laid it in the corner by the door, for fear they should come again. The next morning, I observed the marks of foorsteps in the garden, between the house and the shard in the hedge; one of them had on one shoe the half of an iron heel tip, and the other half was filled up with the marks of little iron nails; the sole part was plain. The other footsteps had the marks of hob-nails, on the fore part. I was in the county gaol with the Dyers before the last Assizes.

Cross-examined by Mr. Twiss – It was seven o'clock when I parted from Coventry. It was not five minutes before I got to my father's, where I sat down. I did nothing from the time I got in till the gun was fired. I will swear I had not been in a quarter of an hour. The garden extends about 30 yards from the window. The men might have got off the premises by a shorter way, but then they must have come towards me. There was some light thrown from the door, but there was a high settle between the door and the fire. They could not see me come out, in the way they were standing.

By the Judge – I had no doubt, when I returned into the house, who the two persons were; I knew the one by person, and the other by his voice.

I would have pursued them when I was out of the house, if it had not been for the guns. When I got in my wife would not let me go out again after them. There was only one report. Thos. Downes and his son came to our assistance; they live about 100 yards off. I did not hear my father or brother say it might be Frank Mills who had fired the gun. When I got in, I mentioned who the men were. My mother cried "murder!" five or six times from the window, which brought Downes to us. I think it

was my mother who said it might be Frank Mills. When this was said, I did not say "it was very likely, and I would have the whole gang taken tomorrow". I have heard that the Dyers had said they would be revenged upon me. Thos. White told me; no one else ever told me so. White told me of this after the prisoners were committed for this offence. I did not think I was in any danger from these men. People have told me to be aware of them, but I was not in fear of them. The reason the people assigned was that a brother of the Dyers was off, and if they could get rid of me, he might come back again. I had only seen one of the prisoners, John Dyer, once since the last Assizes. They live nine miles from where I reside. I gave information at the last Assizes of a number of criminal offences in which I had been concerned.

Sarah Mills – I am wife of the last witness. My husband came in about seven o'clock. I was sitting opposite the fire. Something flew out, I thought it was from the fire, and wounded me on the arm and left side. The moment this happened, my husband went out; I fainted away.

Cross-examined – I don't think it was so much as a quarter of an hour after my husband came in.

Mr. Henry Percival – I am a surgeon at Chipping Sodbury. I was called in about eight o'clock in the morning of 25th Oct. Mrs. Mills was lying on a bed on the floor in an upper room. The thigh was very much wounded and bruised, and also the left elbow. The wounds were caused by shot of a large description. She was very severely wounded, and continued ill a long time. Three shots had penetrated the skin, which was much lacerated. No shots were extracted. There were thirteen places where the shot had struck; it appeared to have come in an oblique direction, and to have been caused by large irregular shot, not by shot cast in a mould. From what I have seen of the chair and situation, I have no doubt the injury proceeded from a gun fired through the window. The obstruction and resistance of the window and chair might have caused the irregularity of the shot. Had it come in a direct line, the effect might have been fatal.

Job. Mills, jun. – I am brother of Thos. Mills. The chair I produce was that on which my father was sitting. The marks upon the chair were produced by the firing of the gun, on the evening of 24th Oct. My brother's head was about level with the top of the chair.

Cross-examined – I was acquitted at the last Assizes.

Wm. Coventry – I came with Thomas Mills from Wickwar on the evening of 24th Oct. The clock struck seven as we parted. I went out on hearing "murder" cried, nearly half an hour after. Mills's is about 300

yards from my brother's.

Sampson Townsend – I live at Iron Acton. I was near John Dyer's house on 24th Oct. I saw John Dyer that evening about half-past six. He had a cap on his head. He was going towards his own house. It was such a cap as soldiers wear; it had no brim to it.

Benjamin Cooke – I am a special constable. I went to Job. Mills's house on 25th Oct. There were three panes of glass broken at the lower part of the window. There were marks of powder on the curtain, and the marks of seven shots upon a table, at the opposite side of the room to the window, one of which I took out and produce. I measured the depth from the sill of the window to the ground; the depth was two feet nine inches outside, and three feet one inch on the inside. The seat of Thos. Mills was five feet from the window. The shots on the table seemed to have been skirted, as if driven in that direction by first striking the chair. Judging from the marks, and the line from the window to the table, I should suppose the aim was taken through the window directly for Thos. Mills's head. I searched Mark Dyer's house on 26th Oct. and found a gun; it had no lock upon it; I observed the marks of fresh oil, and other marks, as if the lock had recently been taken off. From the smell of the gun, I should say it had been recently discharged; it was not then loaded. I then went to John Dyer's house, where I also found a gun. It was loaded with the shot I now produce.

Cross-examined – Mark Dyer's gun appeared as if it had been fired some time within a week.

Chas. Barter – I accompanied the last witness to Mark Dyer. His gun appeared to have been fired out within forty-eight hours.

John Neale – I am constable of Yate. I saw Thos. Mills at seven o'clock in the morning of 25th Oct. at the Lion at Yate. Apprehended the prisoners upon his information. Mark Dyer had nailed shoes and large hob-nails on the front part of the shoe. John had no nails on the fore part of his shoes, but I think there was part of a tip, if not a metal tip, on the heel of one shoe. I produce six shots which were delivered to me by Thos. Mills. They were picked up in his father's kitchen the next morning.

Cross-examined – I found Mark Dyer in his own house, dressed in his pit clothes; he told me he had been employed in the pit all night. I found John Dyer putting in wheat in his garden.

Thos. White recalled – I did not tell Mills of Mark Dyer's threats, till after they were committed for the present offence.

This closed the evidence for the prosecution.

Mark Dyer, being called upon for his defence, said that he was in a coal pit at work at the time, he was there all night, and had witnesses to prove it. He was quite innocent of the charge.

John Dyer said that he was at the house of Tamar Holbrook, from half-past six till nine o'clock on the night in question.

The following witnesses were then called. Thos. Downes – I heard the report of the gun and the cry of "murder!". I went there. The door was shut. Sarah Mills was on the floor; she was lifted up. I know Frank Mills. Job Mills said, "I believe it was Frank Mills that shot the gun off", and his wife said she believed it was. Thomas Mills also said it was likely it was. He said, "I'll have all the gang taken up tomorrow, and Francis Mills too".

Cross-examined – I did not shake when he talked of the gang. I did not belong to the gang. There was a man of the name of Downes taken up at the same time with the gang. I was that man. My house was searched at the time.

Re-examined – I was not brought to trial; there was no charge exhibited against me.

Mary Frape – My son works in the mines with Mark Dyer. I remember the evening Mrs. Mills was shot. I saw Mark Dyer at my house that evening at severn o'clock. It could not have been earlier, because I was going to hear a funeral sermon and I heard the clock of a neighbour named Short strike seven when I was talking to Mark Dyer. I counted the clock. The sermon was to be preached at half-past six, and I was too late, and did not go. Mark Dyer came to ask for my son, who keeps the engine; he wanted him to put him down. My son was not at home; he was at a neighbour's. Dyer staid about five minutes, and then went away. He was in his working clothes.

Cross-examined – It is about a mile and a half or two miles from my house to Mills's.

James Frape keeps the engine of Bendall and Co. Mark Dyer works in the pit. The men are put down at all hours. The night Mrs. Mills was shot, I had directions to put Mark Dyer and others down into the pit; they were to be put down between seven and eight. The engine is a mile or a mile and a quarter from Mills's. I was at a neighbour's, Jas. Lacey's, near the engine, that evening. I thought it was time to go to the engine and, looking at the clock, I found it was ten minutes past seven. While I was looking at the clock, Mark Dyer came and called me. I sent him on, and in three or four minutes I followed, and found him sitting on the engine, eating some

bread. He staid while I got the engine ready, and then got his tools, and I let him down. Another person let him up in the morning.

Cross-examined – Other persons were let down at the same time, James Short and three boys. It is my duty to go half an hour before the rest, to get the engine ready. It might be nearly eight o'clock when I let them down. I had been at Lacey's two or three hours. I had not looked at the clock before. Mark Dyer had a low-crowned hat without any braids to it. I went to a second engine afterwards. I got there about nine o'clock. It might be twenty minutes after eight when I left the first engine. Shorts is about fifty or sixty yards from my mother's; we can hear the clock strike sometimes. Mr. Steele asked next morning what time I put Mark Dyer into the pit, and I told him it might be eight or a quarter past eight o'clock I can't exactly say which. Dyer had his pit dress on.

John Rathbone – I am foreman of the works of Bendall and Co. The last witness is employed under me. I was at the engine at eight o'clock on 24th Oct. Mark Dyer, Jas. Short, and three boys were let down. I saw them drawn up again next morning. Most of the men wear low-crowned hats, from the nature of their work; some have brims, and some have not. It is a mile or more from the engine to Mills's. Dyer had his pit dress on.

Tamar Holbrook – John Dyer lives about forty yards from my house. I remember the night Mrs. Mills was shot, because they came and took the young man up next morning. John Dyer came to my house at half-past six that night, and staid till a quarter to nine; he smoked his pipe. My house is two miles or three from Mills's. I looked at my husband's watch, which was hanging over the fire-place.

Cross-examined – I never heard before I came to Gloucester, at what time the gun was fired. I looked at the watch when he came and when he went away.

No other witnesses were called, and Mr. Baron Vaughan commenced summing up to the Jury. His Lordship set out with explaining the nature of the indictment, and the statute under which it was framed, giving a very clear exposition of the provisions of Lord Ellenborough's Act, and impressing the Jury with the necessity of mature consideration of the case, from the extreme severity of the punishment attached to the offence. The lives of the prisoners at the bar were in their hands, because, if found guilty, the law must undoubtedly take its course. He commented on the bad and suspicious character of Mills, the principal witness; but still it was for them to weigh the circumstances in their own minds, and to say what degree of credit was due to his testimony. After some other preliminary

remarks, his Lordship proceeded, with great minuteness and perspicuity, to read over the evidence, pointing out and dwelling upon those features which bore most strongly upon the case; and particularly investigating the different contradictory statements which had been adduced. In conclusion he called upon them to discharge their duty fearlessly and their country had a right to expect it at their hands. The statement of Thos. Mills ought to be examined and sifted with the utmost care and jealousy but still it was his duty to call their attention to the various points of confirmatory evidence by which his testimony was borne out. He then recapitulated these various features. The question of the *alibi* would depend entirely upon the degree of credit which they might attach to the parties; and he was quite satisfied that they would come to that decision which the justice of the case required, and which their own conscience would dictate.

The Jury then retired to their room, and, after an absence of an hour and a half, returned with a verdict of *Guilty* against both prisoners, but recommending them strongly to his Lordship's mercy. In this recommendation Mr. Ludlow, on the part of the prosecutor, concurred, and expressed a hope that the justice of the case would be satisfied by their being sent out of the country.

His Lordship said that he always felt pleasure in attending to the recommendation of a jury, but in this case it was out of his power. He would, however, certainly forward the recommendation to the only quarter from whence mercy could be extended, but, as far as he was concerned, he must leave the law to take its course.

A general buzz here pervaded the Court; and Mr. Tomes, addressing the prisoners severally, asked what they had to say, why they should not suffer death, according to law.

Mark Dyer said, "I am as innocent as a child unborn, my Lord" and *John Dyer* said, "I am as innocent as the child unborn my Lord, and I know nothing about it".

Mr. Baron Vaughan put on the fatal coif, in order to pass sentence of death; and the usual proclamation being made, his Lordship addressed the prisoners in the manner following:

"*Mark Dyer, John Dyer,* you stand severally convicted after a most patient and painful investigation of the circumstances of your heavy offence, that of having unlawfully, willingly and maliciously shot at Thomas Mills with an intent to murder him, or to do him some grievous bodily harm. To this atrocious offence the law of the country has annexed the penalty of death; and it is my painful duty to inform you that the

circumstances of your case are such as to leave no hope that the penalty of death will not be executed. Indeed, with respect to you, Mark Dyer, you have made declarations which shew that you had engendered a most deadly malice against this unfortunate prosecutor, in consequence of his having preferred some information against you, and it appears that you, Mark Dyer, had declared that he ought to be hanged, and that you would shoot him as soon as you would a sparrow, that you would send him to his great account with all his crimes unrepented on his head; and it now becomes my painful – it now becomes my most melancholy duty to tell you that, though I shall forward to the quarter to which it is addressed the recommendation of the Jury, and the generous suggestion of the Counsel against you, I cannot give you a hope that such a recommendation will be attended to. You are convicted of an offence, by which you would have satiated your revenge by shedding the prosecutor's blood, and you must atone for that crime with your own blood! I have only, therefore, to entreat you to consider the awful change which you must so shortly undergo. Your days are numbered and your course is run! And I implore you, therefore, to take and bid a long, long farewell to all the concerns of this world; and I implore you, if you value your immortal souls, that you will, on bended knee, and with penitent and contrite hearts, supplicate at the throne of grace for that mercy which I feel cannot be extended to you here! Therefore it remains only for me to pronounce the awful sentence of the law upon you, which is that you Mark Dyer, and you, John Dyer, be severally taken from hence to the place from which you came, and thence to a place of execution, where you shall be severally hanged by the neck, until you are dead; and may the God of Mercies speak peace and pardon to your souls!".

Here his Lordship was deeply affected.

The prisoner Mark Dyer: – "My Lord, let me say a few words – please to have mercy on me! My brother's son, who worked along with me, told me my brother was to try to shoot the prosecutor; but I never know'd how it was done. My brother's son were telling me as he was going to shoot him; but how he did not know".

Here the prisoners were removed.

SINGULAR CHARGE OF HIGHWAY ROBBERY

The King v. Mr. John Morgan – This was an indictment against the
defendant for a highway robbery. Mr. Horace Twiss and Mr. Justice
appeared for the prosecution. Mr. Ludlow and Mr. Cross were for the
defence.

The indictment charged that, near the city of Bristol, on the night of the
11th of March, the defendant put the prosecutor in fear, and took from his
person and against his will a sum of 50*l.*

The facts of the case are comprised in a very short compass. It appeared
that the prosecutor, who is a farmer, on the day stated in the indictment,
had sold some beasts, for which he received the money in the notes of which
it was alleged that he had been robbed. He repaired from Bristol market to
a public-house, where he met with a friend, who was to accompany him
home; and after they had separated, for the purpose of looking after the
objects of their respective business, the prosecutor met a prostitute. He
also met some sailors at the door of the gin-shop, where he was going to
treat his female companion; and after having left the shop, and the female,
he proceeded towards the place where his horse stood at bait. On his road,
he thought it prudent to turn up a lane, to count the notes he had in his
pocket-book, and to fix them in his fob. While in this act, some one ran at
him, seized the notes from his hand, and made off. The defendant at that
time was engaged, unfortunately, in illicit intercourse with some female
in the same lane; and the prosecutor came towards him, and seizing him
by the collar, charged him with a highway robbery. The defendant had a
bull-terrier dog with him; and the dog, faithful to his master, barked and,
in the scuffle, got between the prosecutor's legs, and threw him down. The
prisoner ran to a neighbouring public-house, to which he got access, after
losing his hat, and where he was subsequently searched; but no notes of
the prosecutor's were found upon him.

The trial occupied many hours, but it terminated in such a manner as
to leave no doubt that the prosecutor was mistaken as to the identity of
the real robber. We subjoin a *verbatim* copy of the manner in which the
case terminated; in as much as the person accused is a most respectable
silversmith, of Bristol.

After the evidence was gone through on both sides, some parts of which
are neither delicate nor entertaining, Mr. Baron Vaughan addressed the
Jury in the manner following:

"Gentlemen of the Jury – This is an offence, the probability of the

commission of which is entirely a matter for your consideration. You will consider whether there is any probability that this defendant could have committed the crime which is here imputed to him; but before I sum up the evidence (and you must be the best judges whether it is necessary to sum up the evidence at large or not), I must state to you that almost a whole host of witnesses have been called to character, who have attested that which has been asserted; and it appears most clearly that this gentleman is a man of the greatest respectability – a man who has lived a life quite unimpeached; and we must take it for granted that, until the present trial, Gentlemen, he bore the most unexceptional character; and in any case, if doubt could at all arise in its consideration by a Jury, and where the prisoner bore an excellent character, this is just the case of all others which ought to turn the scale, if you have any doubt (though you must mind, I don't want to spare myself the trouble of summing up the evidence in this case to you); but you are aware that it is a most serious charge, affecting his life. This man, who appears to be a watch and clock-maker of great respectability, and known by all his neighbours during a course of many years, is now standing in deliverance before you on a charge of highway robbery; and, Gentlemen, it is imputed to him that he took 50l. or 60l. from the prosecutor. By highway robbery is meant, putting a person in fear, and taking from them by violence and against their will, the money stated in the indictment. If the money is not so taken with violence and force, the offence becomes larceny, and cannot be highway robbery. But in this case, Gentlemen, I do not think it is necessary you should stay to enquire upon the legal distinctions, whether it is larceny, or whether it is the crime of highway robbery, because, in this case, if an offence has been committed by any body (and it is clear an offence has been committed by some one), that offence is the offence of highway robbery; but, nevertheless, there is not that evidence of identity in so serious a case, as would warrant a Jury in coming directly to a plain, pure conviction of the prisoner's guilt. There is doubt; and with that preliminary remark, I beg leave to say to you that this is a case in which, clearly, there has been the greatest doubt as to identity; and, like all other cases which hang in doubt, you know as well as I do that the benefit of such doubt ought to be given to a prisoner".

Mr. H. Twiss – My Lord, the prosecutor has heard the excellent character given to the prisoner; he has heard the eloquent observations your Lordship has made; he begins to hope he has been mistaken as to the identity of the prisoner; and he therefore begs that your Lordship will have the goodness not to go any further.

Mr Baron Vaughan – "That is the most handsome thing that could possibly be done; and I have no doubt this course has been suggested to the prosecutor by the excellent advice of his Counsel. It is quite clear that on that night the prosecutor was in that state that, under a misimpression of his intellects, for certainly it is quite clear that he was affected by liquor, and there was a person who robbed him – it is quite clear that he was robbed. Who the person was who committed that robbery, it is impossible to ascertain; but it is clear, after what has been said, that that person could not be the prisoner, and it would be an idle waste of your time to go through the detail of the evidence, and one only has to lament that, by a transitory indiscretion, the prisoner has brought himself into great difficulty and inconvenience. We can say no more but that one regrets, so far as this charge is concerned, that he has suffered such painful inconvenience; and I hope that, when he is dismissed out of this Court, he will be discharged without the slightest shadow of doubt remaining on his character or on his credit. I hope, when he goes forth to the world, every body will suppose that he is purely and perfectly innocent; because, if a person is acquitted on doubtful evidence, the ill-natured part of mankind are often willing to suppose that a man only gets off upon a quibble, without satisfactory proof of his innocence; and therefore I do take this opportunity of saying that this is a case in which there is great and substantial doubt of the defendant's guilt. He is a person who has lived with credit and with character, among that rank of society who are most respectable in this country – I mean the higher orders of our tradesmen – and therefore you ought to give him the advantage of that character which such a host of witnesses have testified. Gentlemen: therefore, although I feel clearly that the prosecutor has been perfectly persuaded he was not under any mistake, and that this prosecution was undertaken under an honest and conscientious motive, still, however honest his motives might be, it is clear that, beyond all doubt, the prosecutor must have been mistaken. If that is your honest impression, you must say the prisoner is not guilty; and it does the prosecutor great credit to state, after what he has heard, that he now believes he might be mistaken".

Here the Jury consulted, and the Foreman said, *Not Guilty*.

Mr. H. Twiss – "My client, my Lord, had under-rated the quantity of liquor he had drank".

Mr. Baron Vaughan – "Oh! a man cannot be supposed to be able to judge what he has drank".

Mr. Justice – " No, my Lord; and I have generally seen it may be observed

as a standard maxim that, when a man is under the influence of liquor, he always thinks himself sober and every one else drunk".

Mr. Baron Vaughan – "I am exceeding glad, Mr. Cross (the prisoner's Counsel), that we have gone through this case, and that we have gone through all its details. The prisoner is perfectly exonerated from all blame".

Mr. Cross – He feels much indebted to your Lordship, for the expression of your sentiments. He now returns to his friends with his character perfectly cleared up, and probably your Lordship will order that he should be forthwith discharged".

Mr. Baron Vaughan – Oh! certainly – let him be discharged immediately" – Here Mr Morgan was discharged, and a manifestation of some applause took place in Court.

Two years had now passed since the troubles between the weavers and their employers, but still the waves caused by that disturbance had not quite died down. In the following case, however, it was one of the unfortunate victims who found himself the defendant in the resulting civil action:

From the Gloucester Journal, 21 April 1827:

NISI PRIUS COURT

Pegler v. Colston – This was an action brought by the plaintiff, to recover from the defendant a compensation in damages for a malicious prosecution and for accusing the plaintiff, without any probable cause, that he, with divers other persons, had assembled in a tumultuous manner, and had thrown him (the defendant) into a pond. Other counts in the indictment averred that the defendant spoke certain malicious words of the plaintiff.

Mr. Taunton stated the case to the Jury. In the month of June 1825, some unhappy differences existed in this county, in the neighbourhood of Stroud, which is the centre of the manufacturing district, between the master weavers and their workmen. It was not the business of the Jury to enquire what gave rise to these unhappy quarrels; but they did arise, and a tumultuous mob assembled, who went through the country committing various unlawful acts and outrages. All those matters concerning the tumultuous riot which was created on that occasion ought to be buried in oblivion. It was, however, necessary to explain the facts of the case,

by stating the peculiar circumstances attaching to the plaintiff and to the defendant. The defendant happened to be an object of the mob's rage and he was seized, plunged into a pond, and ducked. While he was in that situation, he called to a person whom he knew, named Reuben, and asked him to assist him out. Reuben, however, proved to be a false friend; and though he reached out his hand towards the defendant, he only did so for the purpose of pushing him back into the water! This was most unjustifiable; but the defendant subsequently, and from an old grudge, attributed this treatment to the plaintiff, who had just as much to do with the matter as any of the Gentlemen of the Jury. The plaintiff was apprehended under a warrant; he was taken to the gaol at Horsley; he was detained there for several days, until he could be bailed, and finally he was discharged on finding bail. The defendant, however, did not let the matter drop there, but indicted the plaintiff at the Sessions, where he was tried and acquitted. It was for this improper treatment that the present action was brought; and it would be for the Jury to say what compensation in damages the defendant ought to pay, for having inflicted so serious an injury on the plaintiff.

Henry Burgh, Esq. stated that he was a Magistrate in the county of Gloucester, residing near Stroud. On the 7th of June, 1825, there were disturbances in that part, arising from disputes between the master clothiers and their workmen. Witness saw the defendant after he had been ducked, and took him to a public-house to prevent his being ducked again, and at that public-house the witness was obliged to read the Riot Act. On the 5th of August the defendant laid an information before the witness on which the plaintiff was apprehended and sent to Horsley prison, where he remained four days in default of bail.

Mr. Matthew Windey, the Governor and Keeper of Horsley prison, proved that the plaintiff was committed to his custody on the 5th of August, and was not discharged until the 8th, when he was liberated on finding bail.

The indictment was put in, which shewed that the defendant was the only witness against the plaintiff, and also recorded an acquittal.

Mr. Phillips addressed the Jury for the defendant. He said it was his duty to offer a few observations in justification of his much injured client, who, though humble, was yet respectable, and to whom character was of the greatest consequence. His Learned Friend had said that it was much better the riots of 1825 should be forgotten; but he, Mr. Phillips, thought otherwise, and was of opinion it was much better mobs should be

taught that the arm of the law was too strong for them. The unfortunate defendant, who had been so cruelly outraged, had confided too much to his own representation of his wrongs, when he indicted the plaintiff at the Sessions; and to the circumstance of no other witness being called, the plaintiff owed his acquittal; but the Learned Counsel would show that the plaintiff was the ring-leader of the mob that assembled on the 7th of June, and certainly assisted in the attack on the defendant.

Thomas Hogg stated that he knew the plaintiff, Pegler. He remembered the day that Colston was ducked; that was the 7th of June. He saw Pegler that morning going towards Stroud. Pegler passed the witness's garden, and an old man of the name of Knowles passed at the same time. Knowles told Pegler that he had better bide quiet, but he said, "No; he would sooner fight up to his knees in blood!"

Mr. Taunton – Now, how came you to listen to this? Witness: Why, Sir, I leave it to you, if you was standing in your garden, and you heard such talk pass, wouldn't you take notice of it? *(Laughter)*. Mr. Taunton – Why, if you ask me the question, I tell you I should not, because I know an old story about listeners. Witness: I shall say no more to you, good Sir. [Here the witness turned around, and was going to leave the box.]

Mr. Taunton afterwards elicited that he knew there were *combustibles* that day in Stroud, and that the Dragoons were called out.

Other witnesses were then called, who proved that Pegler was seen going into a shop to buy blue ribbons; but no one of them proved that he took any part in the attack upon the defendant.

Mr. Taunton replied. He contended that, though his Learned Friend had been strong enough in hard words, there was not the least substance or fabric in the defence.

Mr. Serjeant Bosanquet, in charging the Jury, told them that he was bound by law to give them his opinion, whether there was any probable cause in the prosecution against the plaintiff, and he was clearly of opinion that there was not. It was, however, for the Jury to say whether the plaintiff had taken any part in the attack upon the defendant; and if they thought he had not, it would be for them to say what compensation the plaintiff ought to receive in damages.

The Jury consulted for some minutes, and then found a verdict for the plaintiff. – Damages £25.

The following case, although minor in character, is a first episode in the tale of a ne'er-do-well son and an exasperated father, which will find its sequel at the next Summer Assizes:

From the Gloucester Journal, 21 April 1827:

Thos. Gyde was charged with stealing five pigs, the property of Samuel Gyde. This prosecution was instituted by a father against his own son, whom he had made every effort to reclaim, but without success, and he had taken the present proceeding from a fear that something worse might occur.

S. Gyde, a respectable farmer, said: I am 60 years of age, the prisoner is my son. I made him a weekly allowance of 8s. for some time, but I had been forced to send him entirely away. I had five pigs in my sty on 9th Dec. I went to Gloucester market; and on my return home, at about six o'clock, I missed them all. I found three of my pigs on the following Tuesday in the hands of Mr. Frankis and Mr. Gardner. I saw another of the remaining number in Stroud market, in the possession of my son. My son had bought them for me, and had marked them. I had given my son no authority to take the pigs; but on the contrary I had told him that for what he had done he should never touch a thing of mine again.

Examined by the Learned Baron – I did not complain to any Magistrate till 7th March. I never had any words with him since the month of December. He was saucy when I told him I must be severe with him.

Cross-examined by the prisoner – Your wife gave me a pound note, part of the money the pigs sold for, but did not say for what. I kept the note. You have had hundreds of pounds of mine.

S. Gardner said – I bought two pigs of the prisoner on 9th Dec. for which I paid him 1l. 17s. 6d. I did not then know that he had left his father's service; but I had known him buy and sell pigs for his father before.

H. Frankis said – I bought a pig of the prisoner, which was subsequently claimed by his father. Neither Mr. Gardner nor I have delivered up the pigs to the prosecutor.

The prisoner said he had sold the pigs for his father, and intended to have paid him over the money.

Mr. Baron Vaughan left it to the Jury to say whether the prisoner meant to steal his father's pigs, or whether he took them under any supposed authority to deal with the pigs as he had done when in his father's service. – Verdict, *Not Guilty.*

Mr. Baron Vaughan – I hope this will be a warning to you. If you ever appear here again, where you are no stranger, you will meet with no mitigation of the punishment for the offence of which you may be guilty.

From the Gloucester Journal, 28 April 1827:

SHOOTING WITH INTENT TO MURDER

On Saturday morning, at seven o'clock, *Robt. Matthews* and *Wm. Birt* were indicted for feloniously, wilfully, maliciously, and unlawfully shooting at Wm. Howard, at Woodchester, on the 13th of Oct. last, with a pistol, loaded with powder and ball, with intent to murder him, or to do him some grievous bodily harm.

Mr. Justice, in stating the case for the prosecution, observed that the laborious duties of the Jury were about to be brought to a close by a case of a most anxious nature, because, if it was proved to their satisfaction, the lives of the unhappy men at the bar would inevitably be sacrificed to the offended laws of the country! The crime they were about to investigate differed only from that of murder, inasmuch as the party was alive – the punishment was the same. He would not state to them the motives which could lead to this outrage, but would leave it to them to draw their own conclusion. He wished cautiously to abstain from any remarks which might have the effect of leading the minds of the Jury; but the only way of judging of the motives of men, was from the means they used and the acts they did. He then entered into a moderate and guarded statement of the facts, as more minutely detailed in the following evidence.

Wm. Howard examined – I live at Woodchester. I had been contractor for the management of the roads several years. I employed a number of men, whom I paid by the week. The pay amounted to from 15*l.* to 20*l.* a week. I gave up at Michaelmas. There was a Meeting of Trustees on 11th of Oct. to balance my account. I was to have received between 200*l.* and 300*l.* which was paid on the 12th. The prisoner Birt lived at the upper part of Bospin-lane, about 500 yards from my house. Matthews resided in the Coombend-road, about the same distance from my house. My household consists of one daughter, of weak intellect, between thirty and forty, and a housekeeper between fifty and sixty. I had known the prisoners. Birt was bred and born there, and had worked for me as a labourer four years ago. I knew Matthews by sight for years. On the evening of Friday, the 13th Oct. about a quarter before nine, some one knocked at my door. I went to the door and found Birt there. He had a bludgeon in his left hand. He

said he wanted work. I told him I had not got any work. He said I had. I told him I had given up business and had no work. He said I was going to build a row of houses in the ground here, and then walked thro' the gate leading into the ground. The gate is about six yards from my door. I followed him, to shut the gate after him. Birt was about four feet off, when I shut the gate. I turned round to go back to the house, and on advancing two yards from the gate I observed Matthews, at the corner of the house, outside the pales. He advanced towards the end of the gate with a pistol in his two hands, which he kept below the top of the pales. I saw the pistol, but could not exactly tell what size it was. I could see the muzzle and the butt end of it, as he sprung from the end of the house. I could not tell the length of the pistol. I was two yards from the gate when Matthews got there. As soon as he got there, Birt said, "Now's the time"; and at the same moment Matthews raised the pistol above the pales, and presented it towards me. I immediately turned my head from him, a little leaning to the right; and, as I was turning, the contents of the pistol struck me on the left side of the head. The instant I found myself wounded, and the blood springing over my clothes, I put my hand to my head, and turned round towards the prisoners, and said, "That's what you want, is it?" I saw them both standing upright before my face. They were about four feet from the gate. I saw Birt with the same stick in his hand. I stepped towards them, and they both ran away as fast as they could. Matthews went down the hill into the village, and Birt ran in a contrary direction up my ground. Matthews was dressed in a light jacket and a round fur cap. Birt had a brown coat and a slouched hat. I went to the gate, and leant upon it for about two minutes. It was an extremely moonlight night. The moon came to the full on the Sunday after. I never saw the moon shine more bright. The blood was flowing down my clothes. I went in, and sent for a friend, Mr. Tiley, who came in a few minutes. I did not go before the Magistrates till that day week, when Birt was apprehended, and Matthews was taken the same night. I did not go before the Magistrates because I was so extremely unwell and exhausted, and for fear of mischief. I did not send for a surgeon at first. Eight or nine days after, my head continuing very bad, from my exertions before the Magistrates, I sent for a doctor. I am in my 69th year. I am quite sure the prisoners are the two men. I have no doubt of it.

Cross-examined by Mr. Watson – I did not say, when Birt came to the door, "I have no work, you are a great scoundrel, and I think you want to rob me." He did not say he was very badly off, nor did he ask for a glass

of beer. There was a bludgeon found where Matthews stood at the end of the house, about eight feet from where the shot was fired. I will swear it was a pistol Matthews had in his hand. I heard the report of the pistol distinctly. The shot was heard in Woodchester. My head was dressed, and I found there was no fracture of the skull. There was a wound where the ball had grazed, about an inch in length. No man on the outside could have reached me with a bludgeon, Matthews had no bludgeon in his hand. I was six feet from the pales. The ball was searched for, and not found.

Wm. Tiley – I am a butcher. I was sent for to Mr. Howard's, about nine o'clock. I live about 70 yards off. I found him in his kitchen, holding a cloth to his head, which was bleeding. I examined his head. The skin was broken very much behind the left ear. The wound was about an inch long and not quite so wide. The skin was jagged. The wound was rather deeper in the middle. It was down to the skull. I went out to get some Friar's Balsam to apply to the wound. I should think the wound was occasioned by the ball of a pistol. About ten minutes past nine, as I was going to Bospin-lane from Mr. Howard's, I saw Robert Matthews standing at a gate opposite John Smith's. He had a waistcoat on with a black or blue body and white sleeves, light corduroy trousers, and a fur cap. He spoke to me as I got over the gate, saying, "You will be shot if you get over that gate". I did not answer, or say a word to him then. When I returned from Smith's, he said, "What is the matter?" I said, either that "Mr. Howard was shot" or "it wasn't much", I can't tell which. He was talking to Maria Browning. I examined the ground next morning. There was blood nearly two yards from the gate.

Cross-examined – The bone of the skull was a little rough. I had no suspicion that Matthews was the man who had fired the shot, when I saw him in Bospin-lane. Mr. Howard did not mention any name that night, but he thought he knew the person who called him out of doors. He bled a good deal, and seemed very much frightened. Matthews staid a day or two in the village, and then went to his father's at Chalford. I saw Birt at work on the Tuesday following. I have no doubt he remained in the village till he was taken up. When I went to Howard's first, he said some person had shot him. I am sure he said he had been *shot*, but I don't remember that he mentioned the instrument. When the housekeeper came for me, she said she heard a noise, and she thought it was like a gun. It was a very fine calm night. I did not hear any report of fire-arms myself. I was in doors sitting by the fire. I cannot say that I was awake at the time.

Thos. Dutton – I heard of the affair, and went to Mr. Howard's, about a

quarter after nine. I am not in any business now; in early life I was some years with a surgeon. I examined his head. It was bleeding profusely. It was a wound about an inch long and half an inch wide, and the flesh and skin very much scattered. The edges of the wound were very rough. I did not perceive any lump or swelling. I cannot say if it went to the bone. In my judgment, I should have supposed the wound was occasioned by a shot, because the flesh was so much scattered. I do not think it had the appearance of being caused by a bludgeon.

Cross-examined – I heard before I came that Mr. Howard had been shot. Next morning, a stick was shewn me which was found on the premises. I don't think it could have made a wound of that appearance. I have seen many wounds from pistol balls.

Walter Leighton, jun. – On the evening of 13th Oct., I saw Robt. Matthews, about eight o'clock, at the Cross, Woodchester. He had on corduroy trousers, dark waistcoat, with light fustian sleeves, and a fur cap. I saw him again, rather more than a quarter before nine; he then had on a short light fustian coat, and a round fur cap. Wm. Birt was then with him. Birt came up as if from the Ram Inn. He called Matthews, and they went together up Bospin-lane. Birt had on a long dark coat, and hat.

Jas. Reeves – On the evening in question, when coming down Bospin-lane at half-past eight, I met Wm. Birt. After some conversation we parted. I went home and staid there about twenty minutes, and then went to bed. As I was going to bed, I heard the report of firearms. It was a few minutes before nine. I live about 200 yards from Mr. Howard's.

Cross-examined – I only heard one firing. Lord Ducie's wood is about a quarter of a mile from my house. I heard the shot very plain. The shot was in the direction of Mr. Howard's. There is no house between Mr. Howard's and mine. I thought some one was shooting quists[7].

Walter Leighton, jun. recalled – While I was talking afterwards with Comfort Merrett, in Woodchester-street, Matthews passed by, walking as fast as he was able towards his own home, from Mr. Howard's. He spoke to me, but I don't know what he said. He had on a light fustian coat.

Comfort Merrett – I live in Woodchester-street, about 50 yards from Mr. Howard's. I was standing at my door on the night in question. About ten minutes before nine o'clock, I heard the report of a gun or pistol. In three or four minutes after, Matthews passed by, as if from Mr. Howard's, to his own house. He had on a light fustian jacket and a fur cap. He was walking a smart pace.

George Buckingham – I was at the Ram on the evening of 13th Oct. it

is about 50 yards from Bospin-lane. The prisoners were there about eight o'clock. I was at the apprehending of both prisoners. Birt was taken on the 20th and Matthews on the 21st. I took Birt in the Venn Wood, at work in the ordinary way, and Matthews at Chalford. Nothing was said by way of threat or persuasion, to induce Matthews to say anything. The turnkey said to him, "You are the chap that was along with the girl in the lane", upon which he burst into tears. Birt was not present. Matthews then said, "If he had not been drunk, he should not have done it". He said that some one and him had been in the bower for a quarter of an hour, waiting to see Mr. Howard; and some one desired a stone to be marked, to frill up, to see which should knock at the door. It fell to Matthews' lot to go to the door, but he objected. The other said he would break a stick, and get the old man to come out. The other went and knocked at the door. I don't recollect that he said any more. I saw this stick lying at the gable-end of the house, some time after nine o'clock. I had this stick in my hand when I conducted Matthews to gaol. He owned the stick, and said that some one cut it for him. I said, "Matthews, I am very sorry for this; I little thought of this when I saw you at the public-house". He said, "This stick, and the pick lay under a boundary wall whilst we went to the public-house to have the beer". This is all I heard him say about the pick. Up to this time, I had always considered Matthews to be a very good, hard-working lad, particularly so.

Mr. Howard recalled – I compared this stick, produced by last witness, with the stump of a tree I planted myself in my orchard behind my house, and it fitted exactly. I saw that stick growing the afternoon before, and I missed it the morning after my accident. It fitted the stump exactly.

Cross-examined by Mr. Watson – That stick has been in my custody ever since, and I have kept it by my bed-side, and always will as long as I live.

Re-examined by Mr. Justice – I saw Matthews's lodging searched, and we found this cap (produced), and it is like the cap Matthews had on that night.

Walter Leighton – I went with the prisoners to gaol. Nothing was said to induce either of them to say any thing. Matthews said that some one had said to him, "If you will be true to me to-night, I will put 100*l.* in your pocket".

Mr. Bassett, Clerk to the Magistrate, produced the examination of Matthews, taken before the Rev. Mr. Hawker. It was put in and read as follows: "The prisoner, Robert Matthews, being asked by me, whether he chose to say any thing in reply to the above charge, says, 'I was drinking

on the night in question with *another person*[8], at Samuel Clark's bower; and the other person said he would make me as long as I lived, if I would go with him that night; and he said he would put 100*l.* in my pocket. We went together to Mr. Howard's house, and we stayed there a quarter of an hour before Mr. Howard came out. Before Howard came out, he said he would kill him; and he said he was a mind to break a stick, and he asked me to go to the door. He then took a stone, and marked it with a cross, and threw it up, and said I was to go there. Mr. Howard was not shot at, but hit with a pick'".

This was the case on the part of the prosecution.

The prisoners were then severally asked whether they had anything to say in their defence; but they both said they would leave their case to their Counsel.

Mr. Watson then called the following witnesses.

John Matthews said, I am a tailor. I reside at Woodchester. I remember the night this attack was made upon Mr. Howard. A person called about nine o'clock that night on me, to tell me of it. I live from Mr. Howard's house about fifty yards. I know Lord Ducie's park. I have often heard shots in the night time there. I heard a shot that night, a quarter of an hour after I heard of Mr. Howard's business, in the direction of Lord Ducie's wood. I heard no shot before. I have known the prisoner Matthews eleven years. His general character has been good, I believe, for honesty and humanity. He lived with me for some time; he was always a very steady civil young man, and strictly honest.

Cross-examined by Mr. Justice – I don't know which way the wind blew that evening.

Samuel Webb – I am a millman at Stroud. I have known Matthews the last six years. His general character for humanity has been very good indeed.

William Merrett – I live at Stroud. I have known Matthews from his infancy. He has always borne an excellent character, and I have come from home at my own expence purposely to give him a character.

Mr. Baron Vaughan then summed up the evidence, and concluded in the manner following: "Gentlemen, We have now travelled to the end of this most important case, so interesting to the public, and of such serious consequence to the accused; and we have now arrived at the time when it will be your duty to pass a temperate and dispassionate verdict, upon the guilt or innocence of the prisoners at the bar. I have already stated the nature of the charge contained in this indictment. You are to find, before

you can convict the prisoners, that they, or either of them, did wilfully and maliciously shoot at the person of Mr. Howard, the prosecutor, with a pistol loaded with powder and ball, and so loaded that it might produce death, maim, or do some grievous bodily harm; and you must find it was fired under such circumstances that, if death had ensued, it would have been murder. You must be satisfied of these ingredients; for malice is the essence of the charge. But wherever the act committed produces those consequences which shew a reason to apprehend that malice was the incentive, there the law will presume malice; and where a man uses an instrument so dangerous as a loaded pistol, and does so deliberately, and advisedly, the presumption of the law is that he intends to do that which might be the natural consequences of his act. Therefore, if you should be of opinion that the weapon used by the prisoners, or either of them, was a pistol loaded with powder and ball, and that it was aimed and fired at the person of the prosecutor, the law presumes the intentions to be such as the means were calculated to accomplish. That which is passing in the mind of a man is known only to himself; and the Jury are to judge of the intent of an act, and to draw their inference from the circumstances accompanying it. It certainly appears in this case that there was no quarrel; that there was no grudge that could have created offence in the minds of these prisoners, against the prosecutor. It is easy to conjecture a motive; but such motives cannot always be proved; but no man commits an act, and especially an atrocious act, of this description, without a motive. I have made these remarks before, and it is unnecessary to repeat them again. You must be convinced that the pistol was loaded with powder and ball, at the time it was fired; because there is a solemn decision, that though a person loads a deadly instrument with powder and ball, if the ball had dropped out, and the firing could not produce death, or any of the grievous consequences stated in the indictment, that case is not within the meaning of the Act of Parliament. If you can entertain any doubt – that is, any reasonable doubt – as to any of the ingredients I have stated, which constitute this offence, you will of course give the prisoners the benefit of that doubt; but if your minds are clearly and deliberately brought to a conviction as to the motive entertained, and the means employed to accomplish them, you cannot but come to the conclusion that death, or some other fatal injury, was intended to the prosecutor. I repeat again, that it is of no consequence by which hand the fatal weapon was fired, when two persons concert together for any of the objects enumerated by the Act. The case is now, Gentlemen, entirely in your hands; and I have no doubt but that you will find such a

verdict as will be satisfactory to the law, to the justice of the country, and to your own consciences".

The Jury consulted together for a few minutes, when their Foreman stated to his Lordship that it would be necessary they should retire. They therefore retired at a quarter past two o'clock, and returned into Court five minutes after three; when the Foreman pronounced a verdict, finding both prisoners *Guilty.*

The prisoner, Robert Matthews, being asked what he had to say, why he should not suffer death according to law, replied, "Nothing, my Lord". During almost all the period of the trial, and more especially during the absence of the Jury, this prisoner was suffused in tears, and was in constant conversation with some friend close to the dock, who appeared to be endeavouring to console him. When the verdict was found, he seemed to have obtained the greatest firmness; but, shortly after, relapsed into a paroxysm of grief.

The prisoner, Birt, being asked what he had to say, why he should not suffer death, according to law, said, "My Lord, it was not the pistol; it was the pick".

Mr. Baron Vaughan passed sentence of death in the following words: "Robert Matthews and William Birt – You stand severally convicted, after a most dispassionate investigation of the circumstances of this atrocious case, of the horrible crime of wilfully and maliciously firing a pistol loaded with gunpowder and a leaden bullet at Wm. Howard, with intent to murder him! It is impossible to have heard this case examined, without being perfectly persuaded of that guilt which the Jury, by their verdict, have ascribed to you. It is not for me to vindicate the policy of the law from the imputation of excessive severity; because this crime is, in a moral sense, equal to the consummation of your guilt, had murder been actually perpetrated. I cannot hold out to you, or encourage you with the delusive hope that any mercy can be extended to you on this side of the grave; for be assured, the gates of death are opening for you, and all mercy on earth is excluded. I have only affectionately to implore you, by the worth of your eternal souls, to lose no time in preparing for the awful change that so speedily awaits you; for you are only now retiring from the presence of an Earthly, soon to appear before a Heavenly Judge! And I implore you that, with earnest contrition, you will supplicate at the Throne of Grace for pardon for your sins; and may that great atoning Sacrifice we have so lately commemorated be profitable to your souls. It remains for me, the Organ of the Law (for it is the law which condemns you), to declare your

sentence; and it is indeed painful and melancholy to see two fellow-men in the prime of their life cut off from all their connexions in this world. I have only to pronounce the awful and dreadful sentence of the law, which is that you, Robert Matthews, and you, William Birt, be taken hence to the place from whence you came, and from thence to the place of execution, and that you be there hanged by the neck until you are dead; and God have mercy on your souls!"

GLOUCESTER ASSIZES – The trials in the Crown Court were not finished till three o'clock on Saturday afternoon, when the business closed with the conviction of *Robert Matthews* and *John Birt* [sic], for shooting at Mr. Howard, of Woodchester, a full report of whose interesting trial will be found on our 4th page. Both these unhappy men were condemned and, together with *Jas. Ray*, for the burglary at Horfield, and *Mark Dyer* and *John Dyer* (brothers), for shooting at Thos. Mills, will this day suffer their awful sentence at the usual hour and place. Four of the above wretched culprits, we understand, have behaved with much propriety since their condemnation; but we are sorry to hear that the reprobate conduct of *Matthews* has been such as to be quite shocking to contemplate.

Jas. Jones and *Wm. Leach*, who were condemned with Ray above-mentioned, have had their sentences commuted to transportation for life, as have also twenty-six others, against whom sentence of death was recorded.

Gloucester Summer Assizes

Before these Assizes had even opened, no less a person than one of the Circuit Judges found himself, for a change, embroiled in the sort of *fracas* which he would normally expect to be contemplating from the Olympian detachment of the Bench:

From the Gloucester Journal, 8 September 1827:

A very unpleasant affair occurred to Mr. Justice Littlemore, on his way from Monmouth to Gloucester. From a scarcity of post-horses, his Lordship obtained the horses to take his carriage from Monmouth to Ross, at the King's Head at Monmouth; and when the post-boys arrived at Ross, they drove past the Swan Inn, to which his Lordship usually posted, to the King's Head, which is a rival house. Before any inquiry could be made why

the carriage was not taken to the usual place, fresh horses from the King's Head, and also others from the Swan, were brought out to be attached to his Lordship's carriage; and the two sets of horses being brought out from the rival inns, the post-boys, ostlers, &c. came out of the yards of both, which are situated close to each other, and a very serious conflict ensued, each party trying by force to get possession of his Lordship's carriage. The Learned Judge seemed very much annoyed at the interruption, and his Lordship's coachman descended from the box, in the hope of quelling the disturbance, but he, as is common with peace-makers, received some blows at the hands of both the parties to the conflict; however, at length, the Learned Judge being very peremptory in his orders that his carriage should be horsed from the Swan, as usual, the post-boys of that inn put to their horses, and proceeded with the carriage to Gloucester, without further interruption.

CROWN COURT

FRIDAY – *John Somers*, aged 14, and *Thos. Face*, aged 12, were indicted for stealing 1s. 6d., the property of Thos. Fawkes. The Jury found the prisoners *Guilty*, and Mr. Baron Vaughan, passing sentence, observed to Somers, that as he was an old offender, he should make a difference in the punishment, as he feared that he had been the means of leading Face into this offence, and the punishment he had formerly received seemed to have failed to have the desired effect. The sentence of the Court, therefore, was that Somers should be transported for seven years; and Face be imprisoned and kept to hard labour for six months.

Mary Ann Chaplin stood charged with breaking into the house of Mrs. Whitehead, at Rodmarton, in the day-time, no person being therein, and stealing therefrom about 5l. in silver monies. The prisoner confessed that she had taken the key of the house from its hiding-place, in the absence of the prosecutrix, and stolen the property mentioned, and that afterwards she flung the key into a pond; but she added that she had been compelled to do so by her husband, who had threatened to murder her if she did not. She was acquitted on the ground of having acted under the coercion of her husband. Mr. Baron Vaughan, observing the beauty of the infant in the prisoner's arms, inquired how many more children she had. The prisoner answered that she had but that one. – Mr. Baron Vaughan: How long have you been married? – The prisoner: Not more than six months, please you, my Lordship.

SATURDAY – *Edwin Drew* and *Saml. Domney* were indicted for having

'*Romps in the Hay Field*' – or the version of the incident as Thomas Gyde would like the Court to see it.

stolen and taken away, from a waggon passing along the high road, about 1 cwt. of coals, the property of Chas. Marklove. The prosecutor was a coal-merchant, at Berkeley, and the prisoners were coal-halliers. In consequence of some suspicions, the witness concealed himself on the road, and saw the prisoners in the act of removing coal from Drew's waggon to Domney's cart. The prisoners in their defence said that Drew was carrying some of Domney's coals up the hill to ease Domney's horse, and they were in the act of returning them to Domney's cart, when they were seen by Mr. Marklove. Several witnesses were then called, who gave the prisoners a good character; and Mr. Baron Vaughan having summed up, the Jury found the prisoners *Guilty*. His Lordship in addressing the prisoners on the impropriety of their conduct in robbing their employers, and setting up such a defence, said it was altogether a dark business; and sentenced them to be imprisoned and kept to hard labour for one year.

We have met the following defendant before, at the Spring Assizes, when he was portrayed as the wayward son of an estranged father. This time he could be in more serious trouble, but – was it a serious and debauched assault upon a defenceless woman that we have to contemplate, or just rustic frolics in the hay at harvest-time?

MONDAY – *Thos. Gyde*, a well-looking man of 25 years of age, was charged with an assault upon Hannah West. Mr. Justice stated that the prisoner was a married man, with five children, and that the prosecutrix was 54 years of age. The parties were at work on a corn-rick when the prisoner committed the outrage. There were some persons near who heard the cries of the prosecutrix, and would not go to her assistance; however, one of her own sex did also hear her cries, and she, much to her credit, went up the ladder to the top of the rick, and from that circumstance an important corroboration would be brought into the case.

Hannah West, a decent-looking woman, but possessing no particular personal attractions, said, I was, in August last, working for Mr. Gyde, the prisoner's father, on a corn rick. The prisoner was to build the rick, and I put the sheaves towards him. I never was married. The prisoner was then a married man with five children, but he had a sixth born only a week ago. There was no one but me and the prisoner on the rick, when he made an attack on me. (The witness detailed the acts as they occurred). I screamed very loud, and said, "Lord, have mercy upon us, and forgive us our trespasses as we forgive them that trespass against us". Sarah Sprowle came up the ladder to the top of the rick, and the prisoner said, "D—n her, I will kick her down". She then jumped off the ladder, and the prisoner raised me up. Sarah Sprowle was waiting for me at the rick, and I told her what had happened.

The prisoner said that he had been told that the prosecutrix had received 5s. from a man who owed him a grudge, for the purpose of prosecuting him; but this was denied by the prosecutrix.

Sarah Sprowle confirmed the testimony of Hannah West, who, when she came off the rick, was much alarmed, and the tears ran down her face in streams.

Hannah Organ said she lived 136 yards from Mr. Gyde's rick. She heard cries of Mercy, or Murder, or something of that sort, which lasted for twenty minutes.

The prisoner said, in his defence, that he had found the prosecutrix taking some corn, and that, to prevent his telling his father, she made advances to him; and that, when upon the rick, they had "a smartish hustle together, but nothing at all *unprudent* happened"; and the prisoner further stated that the woman only complained of her bonnet being crumpled till the people came up, and that then she began to cry Murder.

Mr. Baron Vaughan summed up the case, and the Jury returned a verdict – *Guilty*. His Lordship said that he recollected trying the prisoner at the

last Assizes; and he was sorry to learn that that was not the only time the prisoner had been in a Court of Justice; the case, therefore, could not be looked upon as any but one of the greatest aggravation. If the prisoner had been convicted of the capital charge, he must certainly have been left for execution. It was quite horrible that persons should have been (as was stated) close to the place, and yet have rendered no assistance. The sentence of the Court was that the prisoner, for this most aggravated misdemeanour, should be imprisoned in the Penitentiary for two years, and be kept to hard labour.

Sarah Racey, a very pretty young woman, was charged with stealing a silver watch, three gold seals, a gown, a silk shawl, a gold ring, a chased gold ear-ring, and a variety of other articles, the property of Job Powell. Judith Powell said she lived near Bristol, and had taken the prisoner out of charity, to assist when she was ill. She went to take her husband his breakfast, and on her return, found her room door locked. She felt surprised at this, and broke the door open with a poker, when she discovered that a great deal of her husband's property was gone.

The prisoner was taken at Bath, on her way to London. On her person was found the whole of the property except the watch, which was discovered at a pawnbroker's, where it had been pledged for 2*l*. Verdict, *Guilty* – Mr. Baron Vaughan said that this came so near the case of a servant robbing her mistress that the prisoner might rely on being sent out of the country.

Elizabeth Showell, alias *Edwards*, was charged with stealing from the person of Jas. Godwin Davis five bills of exchange, for 100*l*. each, two 1*l*. notes, and a silk handkerchief.

Mr. J. G. Davis, a middle-aged man, of very gentlemanly appearance, said, I am a draper, residing at Cheltenham. On 23rd Aug. last, I went out for a walk. I had a pocket book, containing five bills of exchange of 100*l*. each, and two 1*l*. notes. On my return I missed my handkerchief. I missed nothing else that night. I returned before ten at night. Next morning I missed my memorandum book.

Mr. Edm. Lloyd, clerk to Messrs. Lechmere and Co. bankers, Tewkesbury, said that on 24th Aug. a bill for 100*l*. was presented at our bank by the prisoner, who stated that she had found it on Shutongar Common, and that she did not know what it was, but on her showing it to a man, he advised her to bring it to a bank. I sent information to Messrs. Pitt's bank.

G. Russell, police-officer, said, I apprehended the prisoner, two days after the loss, at Tewkesbury. She said she had slept at Mrs. Jones's, in Cheltenham, which I have since found to be correct. The house of Philip Owen was searched, and we there found the prosecutor's silk handkerchief. Philip Owen married the sister of the prisoner.

Mr. J. D. Kelly said, I was accidentally in Court today. I had dined with the prosecutor on the day in question, but had left early. The next morning he came to my office, and asked if I had taken his pocket-book. I told him I would not do such a thing, but he said he thought I might have taken it in a joke.

Mr. Baron Vaughan summed up the evidence, and commented upon the imprudence of the prosecutor carrying his money about with him under such circumstances.

The Jury, after a short deliberation, found the prisoner *Not Guilty*. Mr. Baron Vaughan: Prisoner, the Jury have taken a very merciful view of your case. They have done quite right in acquitting you; but let this be a warning to you in future. The prosecutor must have his property restored, but I shan't allow him his expences.

Aggravated Case of Manslaughter. Jas. Galavin stood indicted for the manslaughter of James Butt, one of the constables of the parish of Cheltenham. It appears that on 15th August, the prisoner and another man were seen in the streets of Cheltenham, and were insulting and pushing about every person they passed. Several constables, in consequence, were sent after them, who, after watching them some time, and seeing them most grossly insult various persons, took them into custody. Castles and the deceased took hold of the prisoner, who went with them for about one hundred and fifty yards, tolerably quiet, when he made a sudden spring, and said, "he would be d—d if he went any further". The deceased still retained his hold, and the prisoner seized him by the neckcloth, and pressed his knuckles against his windpipe, and so held him for nearly a minute and a half. On the prisoner being disengaged by another constable, the deceased staggered to a paling, and there stood with his head leaning over the palings. He afterwards recovered a little, and by supporting himself against the back of the prisoner, contrived to keep up with them about 100 yards, and then fell down on his back. His comrades took him up, and conveyed him to an adjoining house, where in four minutes afterwards he breathed his last.

Cheltenham High Street around about 1800.

Mr. Henry Fowler, surgeon, who had examined the body of the deceased shortly after his death, gave it as his opinion that death was produced by apoplexy, and that the apoplexy was induced not by the pressure on the throat, but by the excitement of passion.

Mr. Baron Vaughan expressed great astonishment at this opinion, but the witness persisted in maintaining it. He admitted, however, that he had not opened the body.

The Learned Baron summed up, and after expressing his own belief that the cause of death was different from that stated by the medical gentleman, left it for the Jury to say whether, as men of common sense, they could believe that death was produced otherwise than by the violence of the prisoner.

The Jury instantly found him *Guilty* – the Learned Baron said no one could doubt the propriety of their verdict, and, had the prisoner been indicted for murder he should not have hesitated to have left him for execution. His case was a most aggravated one; and the sentence of the Court upon him was that he be transported for life.

1828

The preceding year, 1827, had seen no less than three Prime Ministers, beginning when the long administration of Lord Liverpool was brought to an end by the latter's incapacitation due to a stroke. In January 1828, a degree of political stability returned once more when the hero of Waterloo, the Duke of Wellington, performed the far from easy feat of putting together a Cabinet which won the approval of a sufficient proportion of the Lords and Commons to stand a chance of surviving. Peel who had retired to his country house, being unwilling to serve under the previous incumbent, Canning, returned to the Home Office and continued with his reforms and improvements.

Gloucester Lent Assizes

In so many of the cases whose records are reproduced in these pages, the perpetrators seem to have committed their crimes, at least partly because, lacking much in the way of education, their actions were born more of instinctive animal reactions than any considered and carefully conceived plan. Such could not be said of the next accused, who appears to have planned her misdeed with some forethought and attention to detail. It is certainly a tangled tale!

From the Gloucester Journal, 12 April 1828:

CROWN COURT – Before Mr. Baron VAUGHAN
TUESDAY, APRIL 8

Ann Hammerton was indicted for stealing, on 16th Nov, a 10*l.* Bank of England note, and divers articles of wearing apparel, the property of Mary Davis. The prisoner, on being placed at the bar, pleaded, in a firm

impressive tone, Not Guilty. She had just before surrendered to take her trial (having been admitted to bail), and seemed to view the preliminary proceedings with great composure. She was not handsome; but with quick intelligent dark eyes, a genteel appearance, and being well dressed, her *tout ensemble* was extremely interesting.

Mr. *Carwood*, for the prosecution, said that the prisoner was indicted for larceny. She had surrendered to take her trial, and, generally speaking, that was a mark of innocence; but it was his duty to lay before the jury a case of such a singular nature, that they would do well to attend closely to the evidence, which, on the part of the prisoner, was mixed up, with great art, with transactions wholly foreign to the present enquiry. The prisoner was a milliner, residing in Albion-street, Cheltenham. The prosecutrix was an old maiden lady of small income, who, having advanced some money to the prisoner, in order to get payment went to reside at her house. The prisoner and her lodger slept in the same room, and eat at the same table. Part of the property of this old lady consisted of an annuity of 20*l.* per annum allowed her by her nephew, who resided at Merthyr-Tydvill, in South Wales. On 15th Nov. last, she received a letter from him, enclosing a 10*l.* Bank of England note; and such were the habits of intimacy on which the prosecutrix and prisoner resided together, that it was impossible for such an occurrence to take place without the prisoner becoming acquainted with it. On the evening of the next day, the 16th, it appeared that the prosecutrix and the prisoner were together in the kitchen. The prisoner observed that, as she did not expect any one, she should not light a fire in the parlour; to which the prosecutrix assented; and shortly after, the prisoner going up stairs, found a bolster lying in the back-yard, and perceived a pillow hanging from her bed-room window. She immediately gave the alarm that the house had been robbed; and on going up stairs it was found that a trunk belonging to the prosecutrix, containing the 10*l.* note she had received, together with the different articles described in the indictment, was gone. The prisoner also, it appeared, had lost something; some dirty clothes and a bed. At this time another person, who also lodged in the prisoner's house, came in, accompanied by her brother, who, on examining the back-yard, although it was a wet night, could discover no foot-tracks; and some scarlet beans, which were trained against a wall, the only place from which the thieves could escape, were uninjured. It appeared, therefore, that the thief did not come from without. However, the old lady entertained no suspicion of the prisoner; indeed, so far from it that, at her instigation, she was very near searching several people's

houses for the stolen property. At last, by chance she discovered, concealed between the feather-bed and sacking of one of the beds, a flannel petticoat which had been in her trunk at the time of the robbery; and, on looking into the prisoner's reticule, found a steel purse which she knew to be hers, and also to have been in the trunk she had lost. In consequence of those discoveries, she left the prisoner's house; but it was not till some time after that she procured a search-warrant; and on searching it, found several more small articles which she knew to be her property. On that charge, the prisoner was apprehended, and, after some examination, discharged. He (the Learned Counsel) must now recall the attention of the jury to the period immediately after the robbery. The old lady, on that event taking place, wrote to her nephew to send her the number of the 10*l.* note, which he accordingly did. On the receipt of the letter, she communicated its contents to the prisoner, who immediately offered to go to the Banks in Cheltenham, to give the requisite notice to have it stopped. She went out for that purpose; and she returned, and told the prosecutrix she had been to the Banks, though in fact she never had. Shortly after the prosecutrix left the prisoner's house, she received a parcel, containing some of the things she had lost, and a note written in a disguised hand, urging her to search certain houses for her property. He (Mr. C.) should prove that that note was written by the prisoner. He should prove that she had written a letter to the nephew of the prosecutrix, urging him to say that his aunt was not right in her mind, and that that letter was sealed with a seal which had belonged to the old woman, and had been in her trunk when it was lost; and in addition to these facts, he should prove that the prisoner had written a letter to the old woman in a disguised hand, as if it came from an accomplice with her in robbing the prisoner's house; and the prisoner having received this letter, by directing it to her own house, caused it to be opened, and made it the alleged ground for charging the prosecutrix with the robbery! And on that charge she was apprehended and detained in custody for three weeks, before the charge was finally dismissed!

Mr. Watson stated that he appeared as Counsel for prisoner.

Mary Davis, the prosecutrix, was then called, and related the circumstances of her residence with the prisoner, of the robbery, and of her discovering her purse, petticoat, and other articles, as detailed by the Learned Counsel. The different articles were then produced and identified by her. The note and letters were also shewn to her, and she declared them to be in the hand-writing of the prisoner. The impression on the seal of the letter to her nephew, she said, was made from a seal of hers that was

in her trunk at the time of the robbery.

The device was described to be the Devil shaving a Pig! and occasioned some laughter. The letters and notes were then read by an Officer of the Court.

On cross-examination, the witness said she did not know any one of the name of Obediah, the signature affixed to the letter charging her with the robbery. That letter, she said, although addressed to her, had never come to her hands. Miss Hammerton had taken it. She knew that there was a tailor lodging in the prisoner's house, who left it at the time of the robbery; but she did not think Miss Hammerton lost any thing. The witness owed her 5s. at the time she left her house.

Wm. Pitt, jun, Esq. said that his father is a Banker at Cheltenham. Miss Hammerton never came to him to get the note stopped, as she had mentioned.

Wm. Shortall, the person whose sister lodged in the prisoner's house at the time of the robbery, said he examined the yard, and could find no foot marks, and did not think any one could have got over the wall without disturbing the scarlet runners. – Cross-examined: The other side the garden-wall is the yard of the Lamb public-house. No one could have got at the prisoner's bed-room but by a long ladder.

George Russell, the chief of the Police at Cheltenham, proved that the prisoner brought him a letter addressed to Miss Davis, the prosecutrix; she said she had peeped into it, and discovered something about the robbery. The witness in consequence opened it, conceiving he was justified in so doing, if it threw any light on the transaction. The prosecutrix was in consequence apprehended, and committed for fourteen days, to compel her to produce the writer. – Cross-examined: Miss Davis came to me about ten minutes after the robbery; and I went to the house immediately. From what I saw, the things appeared to me to have been taken out of the window, over into the Lamb yard. It could not well have been done without a ladder. Miss Davis told me at the time *that the prisoner and her had been sitting together the whole of the evening.* I remember, when Miss Hammerton was before the Magistrates, a key was produced, which Miss Davis said was hers. Miss Hammerton said she had been destroying an old box that morning, and the key belonged to it. On sending to her house, we found the pieces of the box, which I now produce, and the lock which the key belongs to; it did not belong to Miss Davis.

Mrs. Sparks said she had washed for Miss Hammerton. She had seen a slip with her that belonged to Miss Davis. Miss Hammerton said she had

changed with her, giving her some lace-work for it. The slip was one of the articles claimed by the prosecutrix, and stated to be in her trunk at the time of the robbery.

Mrs. Styles was called to speak to some of the articles being the property of Miss Davis. – On cross-examination, she said the prisoner tried to make mischief between her and her husband. The witness had never threatened to do for the prisoner. The prosecutrix had been in the employ of the prisoner, and used to make the beds and the fires.

The prisoner, on being called on for her defence, in a clear, audible voice, addressed the Court at considerable length, explaining the various circumstances of the case, by entering into a history of the whole transaction. She spoke with great fluency, and concluded by a declaration of her innocence of the charge imputed to her.

Mr. Watson then called Mr. Tovey.

Mr. Curwood questioned the witness, as to whether he had not made a bet respecting the result of the trial.

Mr. Tovey said he believed he had betted a bottle of wine that the prisoner would come off triumphantly.

Mr. Baron Vaughan said it was not worth mentioning; and the examination then proceeded.

The witness said that he takes care of the Masonic Hall, Cheltenham. He knew the prisoner and Mrs. Styles. On returning from the Magistrates, when Miss Hammerton was examined respecting the things found in her possession, Mrs. Styles said she would "take care and do whatever she could against Miss Hammerton, as she had made some insinuations against her character". The witness told her he should mention that expression. He has been a Collector of Taxes at Cheltenham for six years, and had known Miss Hammerton during that period. She bore the "*most brightest character of women*".

Mrs. Tovey, the wife of the last witness, confirmed the testimony of Russell, respecting Miss Davis having said that, during the time of the robbery, *the prisoner had been with her all the time.*

Mr. Baron Vaughan having recapitulated the whole of the evidence, the jury, after a short consultation, returned a verdict of *Guilty.*

The Learned Judge then addressed the prisoner, and said that she had been convicted on the clearest evidence, which left no doubt in his mind of her guilt; and he therefore felt it his duty to inflict the heaviest punishment allowed by law. The sentence of the Court was that she be transported for seven years. The unfortunate girl, when the verdict was returned and the

sentence pronounced, maintained her fortitude and self-possession in an extraordinary degree.

But the affair was not to end in the manner ordained. The same edition of the *Journal* carried a paragraph headed 'Melancholy Suicide' which, after referring the reader to the above trial, of 'a young woman of respectable connexions . . . very genteelly and fashionably dressed', went on to describe the subsequent events:

Her presence of mind did not seem to forsake her on hearing either the verdict or the sentence; and on being conducted to prison, she calmly averred her innocence to the officer who had charge of her. On reaching the County Gaol, she was consigned to a sleeping cell for the night, and locked up. At eight the following morning, the wife of one of the turnkeys went into the cell, to give her the usual allowance of provision, and to tell her to be in readiness for her removal to the Penitentiary; when she found her sitting up upon the bed, with all her clothes on, and the coverlid about her. The attendant, after putting down the allowance, left her, and returned in about an hour. On opening the door of the cell, seeing the prisoner on her knees in the corner of the room, she supposed she was at her prayers; but, on going up to her, saw she was dead, and suspended from the iron grating of the window! Altho' dreadfully alarmed, the woman instantly cut her down, and the Surgeon of the prison was immediately in attendance, but the vital spark had fled. She had effected her purpose by means of a light silk handkerchief and two pieces of ribband, and so bent was she upon her own destruction, that she had evidently strangled herself whilst her knees were in contact with, and resting upon, the stone step beneath the window. It is a singular circumstance that the handkerchief was not tight about her neck; so that it would appear that the strangulation was effected by the voluntary muscular exertions of the body. An inquest was held, the same day, before John Cooke, Esq. Coroner; when a verdict of *Temporary Insanity* was returned. The remains of the unfortunate creature were conveyed to her friends at Tewkesbury, where they were interred yesterday afternoon.

Trial of three Poachers for Murder!

On Thursday morning, *Richd. Whithorne, Jacob Perry*, and *Wm. Smith*, were placed at the bar, charged with the murder of Robert Rounce, gamekeeper to Harry Edm. Waller, Esq., by beating him with bludgeons, at the parish of Turksdean, in this county, on the 26th of November last, of which beating he died on the 16th of December following.

Mr. Justice (with whom was *Mr. Maclean*), in stating the case for the prosecution, said that from the silence which prevailed throughout the Court, he felt that the subject of this present enquiry was ushered in with that seriousness that it merited; and he was sure that, as it advanced, it would claim from the Jury their most anxious attention, because they were called upon to investigate the circumstances of the death of a fellow-creature, and the offence which the prisoners at the bar were accused of combined a charge of no less than wilful murder. That accusation arose out of a breach of the laws for the preservation of game. With the game laws, however unpopular they might be, they had nothing to do; that those laws existed was sufficient for their present purpose. If men went out with the object of committing an illegal act, and in the commission of that act were opposed by persons authorised to oppose them, and the life of a fellow-creature was sacrificed, that was sufficient to constitute the crime of murder. In this case, much of the evidence consisted of a positive, and much of a circumstantial description. He meant by circumstantial evidence, evidence in itself incomplete, but which, coupled with other facts, was sufficient to stamp the guilt of the parties – evidence which, from the combination of small circumstances, it was impossible to invent, and which, in the present instance, would be supported, not only by other testimony, but by the evidence of an accomplice, whom they would watch narrowly. He (Mr. Justice) was here to represent Mr. Waller, he was not here to eulogise him; but for him, and for himself, he entreated the Jury to watch during the progress of this trial, not more carefully the interests of society, than every circumstance which would operate in favour of the prisoners. The Learned Counsel then proceeded to relate the facts of the case, as subsequently given in evidence.

Robert Cook said, I am employed by Mr. Waller as keeper. On the evening of 26th Nov. about nine o'clock, I went out with Geo. Curtis, and met Robert Rounce, Stephen Curtis, and Edm. Strong, at a barley-rick in a field belonging to Mr. Stone, in the parish of Turksdean, on Mr. Waller's estate; we went in consequence of some poachers having been there. We had each a stick, but no fire-arms. Rounce was under-keeper

at Farmington. We lay down in the corner of a ploughed field, under a wall near a gate leading to a wheat field. There was a good deal of game on that spot. About an hour and a half afterwards, whilst laying down, I heard the stones moved on the wall over my head; and, on looking up, saw a man turn from the other side of the wall. I jumped up and got on the wall, which gave way with me; saw two men about ten yards from us; they had a dark brindled dog, like a bull-terrier, with them. We went towards them, Rounce a little before me, the other keepers behind. Saw Rounce lay hold of the first man, and I laid hold of the second. Rounce and his man had some words; I heard Rounce tell him to drop his stick; they had blows. The man I held was very quiet. Saw them scuffling, and then saw that Rounce had loosed the other man. I loosed the man I had hold of, as he was standing quiet, and did not attempt to strike, and I seized the man Rounce had been scuffling with, in order to stop the blows. On my laying hold of him no more blows passed till another man appeared; the first man I had hold of called, "forward, forward" in a loud voice; he was standing; no one had hold of him. Soon after a man appeared running; he came up to me with some sort of a weapon which he used with both hands, and gave me a violent blow across the head with it. I had done nothing to him, but had been quite quiet up to that time. I fell senseless; when I came to, I was laying on the ground near to where I had been standing. Did not hear the man speak at all. Found I had several blows and wounds on my head, one across my right shoulder, and one on my left arm. Saw Geo. Curtis kneeling down, not far from me; Stephen Curtis and Strong were walking about; the men were gone. Looked for Rounce, but could not find him. Went for home at Hazleton; the two Curtis's went with me; after going a little way Stephen Curtis and Strong went back to look for Rounce, and I did not see them again that night. Met Rounce about an hour after in Hazleton village, a mile and a half from the wheat field, Robt. Cook was with him; his face was all covered with blood, his head appeared to be beaten badly, and was bleeding very much. The first man I laid hold of had a short smock-frock and a hat on. The moon was about a quarter old, and not very clear that night. Did not know any of the men. Believe the third man had also a short smock-frock, and a leathern cap; he appeared a tall man. Kept my bed for five weeks and two days, from the effects of the blows.

Cross-examined – Don't remember one of the keepers crying out during the scuffle, "Come on, we are ready for you", or any words to that effect. I was standing nearly facing the gate, the man was coming towards me;

he appeared to be running; he had some sort of weapon, longer than a common walking-stick. Blows passed between Rounce and his man; Rounce had a stick with him, he pulled it out of the hedge; it was not a large stake, but an old stick. Did not hear the man Rounce struck cry out for mercy; heard him say he thought his arm was broke. Did not say, "Bob, don't hit the man any more, you've broke his arm". Did not hear the other man say he had hit him too much. Heard Geo. Curtis say, "Tell the rest of them to come on"; this was when Rounce and the other man were scuffling; he did not speak very loud. After this the man came and gave me the blow. There was nothing like a challenge on our part for the poachers to come on and fight. Did not see who struck the first blow.

Stephen Curtis – I went with Rounce, Strong, R. Cook, and G. Curtis on the 26th Nov. I was assistant keeper to Cook; we lay down in the field about ten o'clock, and waited nearly an hour before we heard any thing. Two men came to the wall. Cook and Rounce got over after them, and I saw them catch hold of them. The men had a stick each, and when I got up to them were quiet. Saw no blows. The men halloed, cried "forward", and whistled. Soon after I saw some one running down the wheat field to the gate; he had a stick; he got over the gate and, putting the stick over his shoulder, said to Cook, "D—n your eyes, loose the man", and struck him, but I cannot tell which was first, the word or the blow. Cook was knocked down, and the two men who had been at the gate tried to hit the keepers. A scuffle then ensued, and Rounce was knocked down by the tallest man. When about to rise, the man hit him again. As soon as that blow was struck, my four companions were lying on the ground. I was struck a violent blow across the left arm, but cannot tell by whom. We were forced to retreat, and I was followed a little way by the tallest man, and another. The tallest man struck a blow at me as I was retreating, but missed me. I got 40 or 50 yards from them; they then turned from me, and I saw them no more. I now went to look for my companions; saw Cook, Strong, and G. Curtis; the blood was running from their heads. As I was retreating, saw Rounce go away, staggering and reeling, through a little gate; never saw him more. Went with the other three men part of the way to Hazleton. I assisted Cook and G. Curtis to walk; they afterwards recovered a little, and I went back with Strong, who appeared to be hurt very bad. I went with him to Turksdean, and then I went home. There was no path in the wheat field.

Cross-examined – Saw only two blows given to Rounce, who had a stick with him about a yard long; a straight stick, without a knob at the end,

as large as a smallish stake, one he had cut out of the hedge; he walked with it. Recollects one of our party calling out "no fighting". Saw no blows pass before I got up. Did not hear any one say, "tell the rest of them to come down". Saw the man knock Cook down; three or four minutes elapsed between that and his retreating.

By the *Judge* – Had seen two of the men (Perry and Smith) before; did not know either of them that night. Richard Whithorne was the man who came down the wheat field, and struck Rounce.

Edmond Strong – I went out with the former witnesses, Rounce and G. Curtis. After describing their lying down, the approach of the men, and the scuffle, the witness said, I was knocked down with a blow across the head, my arm was hit, and I was deprived of my senses for a little while. I received a blow after I was down. When I came to, Cook, G. Curtis, and myself were on the bank together. When the men went away, they said it was to let us know they were pretty good fellows. Cook and Curtis were bleeding, and I got up by myself; they went for Hazleton. Saw nothing of Rounce after I was struck. Heard no provocation given by any of our party.

Cross-examined – Did not hear any one say, "let them come on". From five to ten minutes elapsed between the halloeing and the approach of the men. There was nothing to prevent our going off. Heard nothing about an arm being broken.

George Curtis – I was assistant-keeper, and went out on the night of 26th Nov. We lay in wait an hour. Rounce and Cook were over the wall before me. When I got over saw two men by the gate, a dark coloured dog with them, and they had each a stick. Rounce took hold of one man, and Cook the other. Had seen the men before, they were Wm. Smith and Jacob Perry. Jacob had worked for me, and I had known Smith for years. Cook had hold of Smith, Rounce of Perry. Rounce had caught hold of Perry's stick and was twisting him about; Rounce said, "Loose it"; Perry said, "d—m me, you'll break my arm". Don't recollect saying one word. Cook let Smith loose, and went down to the other. I stood by Smith; he was moving about with his stick; he halloed something like "forward", more than once. I had got my stick on his arm; he was swinging about, and hit at me, but missed me; I hit at him, and we then laid on as hard as we could. Before the scuffle, I saw a man coming down the wheat field; Smith then said, "forward" and began with me. I received a blow on the back of my head, which knocked me down; I attempted to rise, when Smith hit me on the right leg, from which I am now lame, and I could not get up for a

long time; my head was bleeding. Just as I got up, Smith and Perry passed me; a third man was with them, and all three got over the gate. One said, "We have let them know we are d—d good boys or fellows". We went to Cook's house, about a mile; Rounce was sitting in the kitchen there, and there was blood all down him, running from his head.

Job Perry – I live at Rowell, in this county. Jacob Perry is my brother. I know Rd. Whithorne and Wm. Smith, the prisoners at the bar. I met them about eight o'clock in the evening of 26th Nov. at Halling, about five miles from the wheat field. We set out together to go poaching. We had three nets and a dark coloured terrier, with a little white on his breast. Whithorne had a stick in his hand about a yard long, with an iron socket at the end, for the purpose of setting the nets, I believe it was a crab stick, as large as a flail, or a good sized walking stick. I had a stick to set the nets. Smith and Jacob Perry had sticks. There were as many as nine sticks altogether. Before we got to Mr. Waller's wheat field we caught four hares. Smith and Perry took the hollow, and Whithorne and myself took the hill; we were in the wheat field. We began to set the nets on the top of the wheat field. I heard a man halloo; I can't say if it was my brother; the voice came from the hollow. Whithorne ran down with a stick in his hand. I remained where I was.

Cross-examined – It was with my net the four hares spoke of were caught. My brother was with me when the first was caught, and Whithorne when the others were taken. Smith and Perry were then gone to set a net in another place. We afterwards met together. It was nothing like half an hour after we had separated when I heard the halloo.

W. Wood – I live at Northleach. Rob. Rounce lodged at my house. He came home on the 27th Nov. at ten in the morning. He walked in, and went up stairs to bed directly. He was much wounded about the head. I attended him till he died, which was on the 16th Dec.

Mr. Chas. Lamley, Surgeon, of Northleach – I was called in to the deceased about one o'clock in the morning of the 27th Nov. at Cook's at Hazleton. He had three severe wounds; one about two inches long upon the suture of the frontal and parietal bones. Another smaller one on the left side of the head. I saw him at Northleach, next day. The wounds were not particularly inflamed. I did not examine to see if there was any fracture of the skull. I wished to do so, but he would not let me. He was very irritable. That irritability might be occasioned by the injuries he had received. There was a degree of levity about him which at first induced me to think he was intoxicated. I made several attempts to examine his

head, but he would never let me. He varied a little, sometimes better and sometimes worse. About the ninth day I enlarged the wound, and a discharge of blood flowed, which appeared to relieve him. Mr. Pytt, of Burford, examined him next day; he was then insensible. We found the skull fractured, and the bone depressed. We then trepanned him, and found the dura-mater lacerated, part of the inner lamina of the skull splintered and driven thro' the membrane into the brain, occasioning great inflammation and suppuration. I attended him during some days after, and then he died. I then opened the skull, and found a quantity of matter under the wound. If I had not seen it I could not have supposed any man could have lived so long under such circumstances. I have no doubt whatever that the death was occasioned by this fracture. Such an instrument as the stick described would have produced the wounds. I very much doubt, if he had been trepanned immediately, whether his life could have been saved with such an injury. There might have been a chance, but I doubt it.

R. H. Pytt, Surgeon, of Burford – I saw deceased on 29th Nov., he was labouring under violent irritation of the brain. I examined his head as far as he would allow it, but could not examine him satisfactorily, he was so violent. On the 12th Dec. I did examine him. I found the skull fractured to a very small extent, apparently without any depression, on the left side of the superior part of the head. On trepanning we found the inner table of the skull driven into the substance of the brain. A small portion of the brain had kept oozing out from the fracture. The instrument which has been described would be a very fit one to inflict such a wound. The wound was undoubtedly the cause of his death.

Wm. Betteridge – I am ostler at King's Arms, Prestbury. I recollect two men coming in on a Tuesday. I had met them between eight and nine in the morning. They were then going towards Cheltenham. They were Whithorne and Perry. They had a small bag. They came to the house about one, Gibberson was with them. Perry hit his hand on the table and said, "he shouldn't be satisfied till he had had another good fight or spree". I turned my head, and Whithorne said, "d—n your blood, ostler, don't you split, if you don't no one else will". They were talking about game amongst themselves.

James Gibberson – I am a tailor at Cheltenham. On 27th Nov. I saw Whithorne and Perry at my house, in Cheltenham, about eleven. They had three hares with them. They said they had had a row the night before. Perry showed me his arm, and said he had very nearly got his arm broke, by one of the keepers on the hills. They went away, I saw them in two

hours after. We went to Prestbury together, to the King's Arms. Perry told me he was taken, and he halloed, and the keeper struck him three different times. One of the keepers told the other not to beat the man as he was in custody, and the keeper answered he would cut his bloody brains out if he halloed any more. Whithorne said, as soon as he heard Perry halloo he came down, jumped the gate, and met one of the keepers, who ordered him to give himself up. He told him he didn't think he should, neither did he think he should keep the men he had got. That the keeper seemed preparing himself for fighting; and that he, Whithorne, kicked him up, and hit him as he was getting up again. That he struck that man no more, and ran to the assistance of Jacob Perry. He got Perry loose from the two men who were holding him, and ran after two men that ran away. When he came back, Jacob Perry was beating the man that he, Whithorne, had knocked down first. Whithorne caught Perry by the collar, and pulled him away, saying, "don't beat that man any more, I think you have given him enough; don't let's have murder, if we can help it". Whithorne then asked the men that were down, if they were satisfied; if they were not, if they would get up, he would meet them man to man. There was no more fighting after that, and they went away. I saw Whithorne again at Sandiwell on the day Rounce died; and I asked him if that was the man they had beat; and he said it was not, but expected they should be taken up on suspicion. I saw him again the day before he was apprehended, when he again denied that Rounce was the man.

Jos. Stone – I am a tenant of Mr. Waller's, and occupy the farm at Turksdean, where this conflict took place. On 27th Nov. I picked up these fragments, just thro' the gate in the hollow.

The witness here produced three pieces of stick and an iron ferrule, which together formed just such an instrument as that described in the evidence.

Wm. Newton, keeper of Northleach Bridewell – Jacob Perry was in my custody. He sent for me, and I went to him next morning. I held out no threat or inducement. He wished to disclose the whole affair. I told him he had better not make any confession, I was sure Mr. Waller would not listen to anything he had got to say, his character was so bad. He still persisted in wishing to disclose it; and I told him I would not listen to him; that there was sufficient evidence without it, and he would convict himself. He said he did not care; that he knew he was guilty. He then said himself and three others were concerned; that he and another were in custody of the keepers, and upon a halloo a third man came down, and made some

expression, and a blow at the same time, and struck the man on the head, and he fell down dead. That the man never rose any more whilst they were on the ground. That he had a net and a hare in a wallett. He was tying the dog to the gate when the keepers came up. They had large sticks with them, with the ends let into iron sockets or ferrules. That the sticks had afterwards been chopped up and burnt, and the spikes thrown into a privy. In consequence of this, I went with a search warrant to a house at Halling, and in the privy found two spikes, the wood of which had been chopped off. [The spikes were here produced].

Robert Burge – I live at Halling. Whithorne's father lives next house to me. There is another cottage adjoining, and one privy in common to the three. [It was in this privy the spikes were found].

Wm. Fardon – I am a blacksmith at Halling. Whithorne came to my shop in Oct. and asked me to make some spikes with a socket and a joint, to hold a stick bigger than one's thumb. I made either two, three, or four. [The witness identified one of the spikes produced as one of those he had manufactured].

Mr. Thos. Griffiths, Clerk to the Magistrates at Cheltenham, proved the confession of Jacob Perry, which was put in then and read.

Mr. Phillpotts, on the part of the prisoners, objected that they were indicted on a charge of murder. That altho' the keepers were authorised under the 37 Geo. 3d. to apprehend persons found trespassing against the provisions of that statute, yet, in this instance, the prisoners were not apprised of the keepers' authority; and the keepers having exceeded the proper bounds of that authority, by ill-treating the prisoners, the offence which had been committed by the resistance offered did not amount to murder. With reference to the death of the party, he begged leave to refer his Lordship to Lord Hale, where it was stated that if a wound was given which in itself was not mortal, but the party died in consequence of the wound, being improperly treated, that would not be homicide. He confessed that the first point appeared to him to be the strongest.

Mr. Baron Vaughan – The men were found in the commission of an illegal act. There was nothing said in the statute respecting a warrant, or the object of it would be defeated; and as far as the law went, he had no hesitation in saying that the seizure of the prisoners was a legal apprehension.

Mr. Phillpotts then offered some further objections respecting the wording of the indictment, as regarded the principals in the second degree. They were charged as being accessory to the commission of a felony on

the 26th of November; whereas the previous part of the indictment, and the evidence adduced, tended to shew that the felony was not completed till the day of the death of the party, namely, the 16th of December. His Lordship, however, over-ruled the objections.

The prisoners being now called upon for their defence, merely asserted, generally, that they did not intend to do harm to any one. After which several witnesses were called to character, who spoke very favourably, particularly with reference to Smith.

His Lordship then commenced summing up; and, during two hours, with great patience and perspicuity, read over and commented upon the evidence, pointing out the different bearings of the testimony, and fully explaining the law as applicable to the case.

At a quarter past five, the jury retired to their room; and after nearly two hours consultation, returned into Court with a verdict of *Not Guilty* against all three of the prisoners! The verdict was heard with great surprise by almost every individual present, and apparently by none more so than by the prisoners themselves, who had evidently anticipated a very different result, and his Lordship told them they had had "a most extraordinary escape".

The trial occupied about eleven hours, and the Court was intensely crowded during the whole time.

Well, we must share the Courtroom's surprise! Unfortunately, we shall never know why the Jury remained unpersuaded by what seems to have been, taken altogether, pretty damning evidence.

Gloucester Summer Assizes

From the Gloucester Journal, 16 August 1828:

On Wednesday afternoon, at little before four o'clock, the two Judges, Mr. Justice Gaselee and Mr. Baron Vaughan, arrived in this city. They were met at Over, by the High Sheriff, Fiennes Trotman, Esq., and escorted into the city with the usual ceremonies; and having alighted at the Shire-Hall, the Commission was duly opened.

On Thursday morning their lordships attended the performance of Divine Service at the Cathedral, where an excellent Sermon was preached upon the occasion by the High Sheriff's Chaplain, the Rev. Fras. Pelly,

from *Hebrews* iii. 12, 13; and shortly afterwards the Learned Judges proceeded to their seats in their respective Courts.

There was to be a sequel to the conviction and tragic suicide of Ann Hammerton, during the previous Assizes. It will be recalled that the elderly lady, Mary Davis, for the theft of whose property the former had been found guilty, had, by Ann Hammerton's cunning machinations, at first herself been accused of the theft and had spent three weeks in prison before being cleared. She therefore brought an action at the present Assizes against the High Constable, George Russell, and his colleagues, for false imprisonment. The justice in those days seems, by our standards, to have been a bit rough!

From the Gloucester Journal, 23 August 1828:

FALSE IMPRISONMENT – *Davis v. Russell and others* – Mr. *Curwood* (with whom was Mr. *Carrington*) stated that this was an action brought against the defendants for a wrongful imprisonment of the plaintiff. The case was in its circumstances more singular than he had ever met with in his rather long experience. The plaintiff was a female advanced beyond the middle period of life, and had been housekeeper to Sir Arthur Faulkner, jnr which situation she had conducted herself in such a way that Lady Faulkner had an extremely high opinion of her. The plaintiff had had the misfortune to become acquainted with a Miss Ann Hammerton, a young woman of great personal attractions, and of much address, but unfortunately of no very strict moral character. To this person the plaintiff had lent a sum of money, and, being on intimate terms with her, the plaintiff, who had for some time lodged in her house, very unguardedly made her acquainted with the fact of her having received a 10*l*. note, that being the half-yearly payment of a small annuity that the plaintiff possessed. This awakened the cupidity of Miss Hammerton, and on 15th Nov. Miss Hammerton amused the plaintiff, while one of her confererates robbed the house. The plaintiff lost all her clothes and her 10*l*. note. At first the plaintiff did not suspect her friend, and it was not till a number of circumstances occurred, that the plaintiff accused Miss Hammerton before a Magistrate. In consequence of this Miss Hammerton was sent for, and the Magistrate, influenced by her specious manner, admitted Miss Hammerton to bail, and she had the effrontery to appear and take her trial before Mr. Baron Vaughan at the last Gloucester Assizes, where

she was on the clearest evidence convicted of robbing this unfortunate plaintiff; and the learned Baron before whom she was tried, considered her case as so heinous a one, that he sentenced her to the highest penalty of the law, which was transportation for seven years; and what made the case more melancholy was that Miss Hammerton, overcome with the ill-success of her artifices, actually committed suicide in the gaol, on the very night on which she was convicted. However, as soon as Miss Hammerton had been liberated on bail, as he had before stated, she wrote a letter in a feigned name, which imputed that Miss Davis had robbed her, and she took this letter (as if it had been intercepted) to the defendant Russell, who thereupon, without any warrant, went to the lodgings of the plaintiff, on a Sunday night, at about eleven o'clock, and took her away to prison, where he kept her till the next day. For this he asked a liberal compensation in damages, quite sure that the Jury would not suffer the liberty of the subject to be violated with impunity.

Miss Mary Ann Hall said – In January last I lived with my father, in Malvern-place, Cheltenham. Miss Davis lodged in our house. I remember the night the defendants came. It was between ten and eleven o'clock on a Sunday night. Miss Davis was in bed, and my sister and I were going to bed. There was a violent knocking at the door. The door was not opened directly, and the persons said that if the door was not opened, they would break it open in two minutes. The door was then opened. I remained in my bed-room. I heard Miss Davis ask what is the matter. Russell said to her, "Some of your villainy is come out". Miss Davis asked repeatedly what was the matter, but they would not tell her. They took her out of the house to the prison. I went to the defendant, Russell, the next day, to see if I could get her released, and he said that, from what he then knew, it could not be done; but that, if we could throw any light upon the robbery, she could be brought back any day. The Cheltenham prison is a mile off, and Miss Davis walked there. Russell said she had been committed for further examination. Russell is high constable of Cheltenham and Pearce, another of the defendants, is one of the petty constables. I did not see Miss Davis afterwards, till she was brought before the Magistrates. Miss Hammerton was there, and Russell. Miss Davis was discharged, and the things Russell took away were given up.

Mr. Collier, the attorney for the plaintiff, said – I was at the trial of Ann Hammerton in the other Court, before Mr. Baron Vaughan. I heard Russell examined as a witness. Mr. Baron Vaughan said to Russell, I hope you had a warrant for all this that you did to Miss Davis. Russell said he

had not, for he thought the end justified the means.

Mr. *Taunton*, for the defendants, said that the question was, whether the constables had fair and reasonable grounds for suspecting that Miss Davis had been concerned in the commission of a robbery of which Ann Hammerton had complained; for, if constables and Magistrates were not protected, it would cripple the effect of the laws, and impede the administration of justice. And if, in every case where a party was acquitted, such person was entitled to "a liberal compensation in damages", prosecutors would never come forward, Magistrates would never act, and constables would be remiss in their duty. Miss Hammerton, in the month of November, complained of having been robbed of wearing apparel, and there was also another charge made by Mary Davis. And Miss Hammerton, tho' afterwards convicted of felony, was then a person in credit, and the constables could not be blamed for attending to the charges that she had made against Miss Davis.

Mr. Griffith said – I am clerk to the Magistrates at Cheltenham. I took the examination of Ann Hammerton; at that time Mary Davis was present, and Russell produced some articles (I believe trinkets), which were shown to Miss Hammerton, and Miss Davis was committed for further examination. [This deposition of Miss Hammerton charged Mary Davis with stealing a great number of articles from her.] It was said that a tailor had lived at the house, who had absconded either the day of the robbery or the day after.

T. Tovey said – I remember the house of Miss Hammerton being robbed. I went to the house. I saw the counterpane in the garden. Miss Davis said that she was the last person in the room from which the things were stolen. She said that Miss Hammerton was in the kitchen below stairs, while the robbery occurred. In January last, Miss Hammerton had a letter with her. I went with her to the defendant Russell. She said she had opened the ends of the second letter, and saw enough to convince her that Miss Davis was a party concerned in the robbery. Miss Hammerton expressed a suspicion against Miss Davis, and said that Russell should take her into custody.

The letter was read; it purported to have been sent to Miss Davis by some person who had been concerned with her in robbing Miss Hammerton. It was ill written, and worse spelt, and bore the signature of Obadiah.

Mr. *Curwood*, in reply, contended that there was nothing in the information Russell had received which could in any way warrant the proceedings against Miss Davis, without the authority of a warrant; and it was evident the charge had been exhibited against Miss Davis, in order

to get rid of the accusation which she had made against Miss Hammerton. Under these circumstances he was satisfied that the Jury would feel it their duty to protect the liberty of the subject, by giving ample damages.

Mr. Justice Gaselee, in summing up, left it to the Jury to determine whether there had not been such a reasonable cause on the part of the constable as would justify the course he had pursued, and which was now perfectly in conformity with the law. It was, however, quite manifest that Miss Davis was an innocent person; but still, if the constables acted on fair grounds, they were justified in what they did. Verdict for the defendants.

Mary Davis also brought an action against the Magistrate with the same complaint, but, the jury having failed to agree on a verdict after trying to do so for twenty-four hours, it was thrown out by the Judge. So, in the end, the poor victim got little redress for the double affront she had suffered.

1829

This year saw the passing at Westminister of the Catholic Emancipation Bill which, by allowing for the first time members of the Catholic Faith to take their seats in the nation's Parliament, redressed a long-standing injustice. Although this momentous concession represented in particular a watershed in Anglo-Irish affairs, it would prove to be entirely inadequate in terms of solving the grievances of the people of Ireland and of dealing with the well-nigh intractable differences which divided the two islands.

As for the Assizes, there was confusion lying in wait for the court officials and any others concerned in its administration, when the two Learned Judges who turned up to sit at the next Assizes proved to have names which, as the extract below shows, were almost identical. The difficulty was lessened to some extent, when a wag was found who dubbed the senior of the pair, reputedly highly religious, 'St James's Park' and the other, a relative newcomer, 'Green Park'.

Gloucester Spring Assizes

From the Gloucester Journal, 4 April 1829:

> On Wednesday afternoon, Sir James Parke, Knight, was met at Over, near this city, by the High Sheriff, Wm. Blathwayt, Esq., of Dyrham Park, and having been escorted with the usual formalities to the Shire-Hall, the Commission was duly opened. The other Learned Judge, Sir James Allan Park, Knight, arrived here very shortly after. On the following morning their Lordships attended Divine Service at the Cathedral, where a truly appropriate Sermon was preached by the Rev. Mr. Robinson, the High Sheriff's Chaplain.

'The Highway Robbery': a vivid depiction of too many such incidents in those times, including the assault on Farmer Kearsey by the Pinnell brothers.

From the Gloucester Journal, 11 April 1829:

DESPERATE HIGHWAY ROBBERY – *Matthew Pinnell*, aged 36, and *Henry Pinnell*, aged 28 (brothers), were indicted for feloniously assaulting James Kearsey, on the King's highway, in the parish of Rodmarton, on 17th Dec. last, and stealing from his person a watch, a pocket-book containing 60*l.* in notes, a quantity of silver, and a key. Mr. Phillpotts stated the case, which was clearly proved by the following evidence:

Jas. Kearsey, a farmer, residing at Rodmarton, said, I left Tetbury market about eight o'clock in the evening of 17th Dec. I was sober. After turning towards Rodmarton, about a quarter of a mile from the turnpike-road, two men moved towards me. The tall man crossed my horse's head and took the bridle with his right hand. The short man struck me on the head with a stick. After I had received many other blows on my head, arms,

and hands, I fell off my horse. The stick had a knob at the end of it. The tall man, after I had received many blows, said, "Stop and deliver". While on the ground, the short man beat me on the head with the same stick. I got on my legs and begged him not to murder me, as I had a wife and large family. The tall man said, "I won't murder you, if you will give us what you have quietly; if not there is this for you", showing me the muzzle of a small gun or a large pistol. I unbuttoned my top coat, and the short man took my watch from my fob, my pocket-book from my side-pocket, containing four 5*l*. notes of the Tetbury Bank, forty notes of 1*l*. and some memorandums. The tall man took some silver and a key. They then ran away. It was a very moonlight night; and I had an opportunity of seeing the persons. The prisoners at the bar are the men. Had seen both before.

Chas. Warner, surgeon, of Cirencester. I was sent for on 17th Dec. to attend Mr. Kearsey. He had three or four severe wounds on his head, apparently inflicted by a stick or blunt instrument.

Henry Tilling. I live at Jackament's Inn, about 5½ miles from Tetbury. The road for Rodmarton branches off between them. I saw the prisoners on 17th Dec. at Jackament's, in the morning. They went towards Trouble-house.

Zebulon Harewell. I live at Trouble-house. I saw the prisoners on 17th Dec. between one and two o'clock. They remained at my house till past three. I had seen the tall man before. I saw Mr. Kearsey go by towards Tetbury market. Mr. George also went by. The tall man said, "It would be no sin to take a little from some of these great farmers". I observed a swelling on the right cheek of the short prisoner.

Thomas Cornwall. I live at Wotton-Underedge, and know both the prisoners. I saw them on 18th Dec. last. They came to me between four and five in the afternoon, and asked me to have some beer. They are labouring men. I went with them. Matthew showed me a 5*l*. note of the Tetbury Bank. Henry showed five or six 1*l*. notes of the same Bank. They asked me what notes they were, and I told them.

Thos. Hobbs. I keep the Bell, at Salisbury. On 24th Dec. I saw the prisoners there. They slept at my house one night. I am sure they are the men. On 27th, in consequence of some information, I went to look after them, and found them together in the street. I told Henry there was a person at my house wanted him. He went a little way willingly; he then said he doubted my word, and would go no further. I then took him by the collar, and we had a scuffle. I took him home, and gave him up to two persons who were in pursuit. When I took Henry, the other prisoner ran

away. Henry was searched. Silver, gold, and notes were found upon him. A watch was also found upon him, which I now produce.

Robert Bruton. I am a constable of Salisbury. I searched Henry Pinnell, and found the silver, gold, and notes upon him which I now produce: 7*l.* 16*s.* 6*d.* in silver, 4*l.* gold, 12*l.* notes, and a pocket-book.

Chas. Cogwell. I am a constable at Wotton-Underedge. I went to Salisbury in search of the prisoners. I went to Hobbs's. I heard a row in the street, and saw Mr. Hobbs bring in Henry Pinnell in custody. Matthew had ran away. I found him concealed behind a door in a court. I collared him and brought him out. Henry refused being searched. I drew the watch out of his pocket and said, this is the watch which the person was robbed of.

Wm. Beech. I was at Salisbury when the prisoners were taken. I searched Matthew, and found 9*l.* silver, five sovereigns, and three half-sovereigns.

Mr. Kearsey identified the watch.

His Lordship then proceeded to sum up, and the jury instantly returned a verdict of *Guilty.* The usual proclamation was then made, and the learned Judge having put on the fatal emblem of their doom, addressed the prisoners in very impressive and feeling language, and exhorting them to entertain no hopes of mercy on this side of the grave, passed sentence of death upon them in the usual terms. When about finally to retire from the bar, the younger prisoner requested as a last favour from his Lordship, that his body might be given up to his friends.

From the Gloucester Journal, 25 April 1829:

EXECUTION – On Saturday last, the two brothers, *Matthew* and *Henry Pinnell*, who, as our readers will recollect, were convicted at our late Assizes of a highway robbery upon Mr. Kearsey, of Rodmarton, accompanied with circumstances of great violence, expiated their offence upon the scaffold. Even before trial the culprits seemed to be aware of the hopeless nature of their case, and anticipated little else than that a long career of guilt would be fatally and ignominiously terminated. Their behaviour in prison, therefore, evinced a very proper sense of their melancholy condition, and subsequent to their conviction they manifested great penitence, and eagerly availed themselves of the religious consolations which were unceasingly offered to them by the Chaplain. They relieved their consciences by a full confession of their crimes, acknowledged the justice of their doom, and expressed great gratitude for

the attention that was paid to them. The day before their execution they took leave of their friends, and the parting interview between Matthew and his wife, and Henry and a young woman to whom he was shortly about to be married, was very distressing. On Saturday morning they attended chapel, and after the performance of the service, bid adieu to their fellow-prisoners, many of whom were affected to tears. The holy sacrament was afterwards administered to them which they received with great devotion. The unfortunate brothers took an affectionate leave of each other in the chapel, soon after which they resigned themselves into the hands of the executioner by whom the necessary preparations were made. Just before twelve o'clock, the melancholy procession was formed, and the unhappy men, with tolerable firmness, but in perfect silence, walked to the new entrance lodge, upon which the scaffold was erected. They were assisted up the steps, and having been tied to the fatal beam, the bolt was withdrawn, and the world closed upon them for ever. The eldest, Matthew, aged 36, was a powerful man of six feet in height, and his sufferings were but of momentary duration, but the convulsions of the younger, who was much shorter but very muscular, were considerably protracted by the knot slipping to the back of his neck. After hanging the usual time, their bodies were delivered to their friends for interment. The crowd collected on the occasion was immense, and we regret to say that a very large proportion of it consisted of females. It has been said that a pickpocket was detected following his vocation in the crowd, but such is not the fact.

From the Gloucester Journal, 18 April 1829:

ATROCIOUS ROBBERY AT LADY BANTRY'S, AT CLIFTON
John Dwyer was indicted for having, on the night of 7th Jan, burglariously broken and entered the house of the Countess of Bantry, at Clifton, and stolen fifteen sovereigns, &c.

Mr. Serjeant Ludlow, in stating the case, as subsequently detailed in evidence, said there was but too much reason to believe that the prisoner had been admitted by one of the servants in her Ladyship's service.

The Countess of Bantry said that, in January last, she resided at No. 11, Freeland Place, Clifton. Her family consisted of two female servants, who slept in the house, and a coachman, who slept out. On the night of 7th Jan, she went to bed between ten and eleven o'clock, and had desired her servants also to retire to bed. About three o'clock in the morning she

was awakened by the opening of her room door; and a man entering, he immediately went up to her bed-side, and forced the bed-clothes over her head, so that she was almost smothered. He desired her to be quiet, and said, they did not intend to murder her, or do her any harm, if she would give them her money and her plate. He said, there were plenty of men at the door, and asked her for her pocket. She replied, she had none. He said, he knew better, and immediately began to search about the room but could not find it. By that time, she had got on part of her dress, and got out of bed, and, having found her pocket, took out a bank-note and gave it to him. He said, he would have nothing to do with paper, he would have nothing but gold, and asked for her purse. She then gave him fifteen sovereigns, and he put back the window-blind to look at them. He said, what use is this amongst so many? He thought they were shillings; but she told him they were all gold. He then asked for the key of the apartment where she kept her plate; and she went into her dressing-room, and gave him a bunch of keys; but he took only the one that opened the plate-closet. He then left the room, and she got into bed, and rang the bell violently. The bell communicated with the kitchen. The same man came into the room, and said, "You have rung the bell to give an alarm, and I will strangle you!" and immediately put his hands round her neck, and squeezed it so violently, that she lost her sight. On recovering her sight, she saw the man stooping down to pick up the money which appeared to have dropped from his hand. There was a gas lamp nearly opposite the house; it gave a very strong light into the room; and when he went to the window, and put aside the blind, she distinctly saw his face, as well as when he was picking up the sovereigns from the floor. The prisoner at the bar was the person who committed the robbery. She described him to Col. Græme, and recognised him immediately on seeing him in Bristol gaol. He was an hour in the room altogether. He said to her, "probably you have a valuable watch". She said she had, and gave it to him immediately, but he said he would not deprive her of it. He said he did not know what the people up stairs had got, but that if she would give them 20l. they would return all the plate.

On cross-examination, Lady Bantry said, she was greatly alarmed at the time, but not so much so as to prevent her being certain that the prisoner was the man; she recognized his voice as well as his features.

John Kennedy, her Ladyship's coachman, had seen the prisoner at her Ladyship's house, in the kitchen, with the cook, Letitia Dixon.

Col. Græme, a Magistrate, said that, in consequence of the description

given by her Ladyship, the prisoner was apprehended. His features did not appear to him so strongly marked as described, but his walk corresponded with the account given of him.

Wm. Taylor keeps the Hot-wells Tavern, and had seen the prisoner in company with Letitia Dixon twice, in his tap-room.

Henry Reed, the constable of Clifton, was sent for to Lady Bantry's the day after the robbery. He examined the premises, and found the moulding of the pantry-window broken; but none of the outward fastenings had been broken. There was no opening by which any one could enter the house; there was some mould in a little yard at the back of Lady Bantry's house, and the mark of a small female foot-step in it, towards the wall of the yard of the next house. The next day he received the crow-bar which he produced and which had been picked up in the yard of the next house.

Thomas Been said he lived in the Hotwells Road, and the prisoner occupied two rooms in his house. He saw the prisoner return home about eight o'clock in the evening of 7th Jan; and the witness locked the door at a quarter past ten that night. Next morning he got up at half-past five, as his wife was ill, and he saw the prisoner go out between six and seven.

Mr. Justice James Parke having summed up the whole of the evidence, the Jury returned a verdict of *Not Guilty*.

Letitia Dixon was indicted for having stolen one gold bracelet-clasp, the property of the Countess of Bantry.

Fanny Oatridge, wife to the Keeper of the House of Correction at Lawford's Gate, said it was her duty to search the female prisoners brought to that prison. On searching the prisoner, she found the gold clasp which she produced, suspended from her neck.

The Countess of Bantry identified the clasp and miniature. The prisoner had been in her service from Oct. to Jan. last.

A confession that the prisoner made on being apprehended was then put in and read. It stated that she had nothing to say but that she was guilty of the robbery of the house; and on being now called on for her defence, she said was innocent of every thing.

The Jury having returned a verdict of *Guilty*, *Mr. Justice James Parke* instantly sentenced her to transportation for seven years, observing that in all cases where servants were convicted of robbing their employers, the law would be carried into effect to its fullest extent.

So, in what appears to have been an 'inside job', the main perpetrator seems to have got away with it, while his foolish accomplice inside the house finds herself bound for Botany Bay.

However, in this case, the Arm of the Law was ready to stretch a little further, with the story set to continue, perhaps at the next Assizes:

From the Gloucester Journal, 25 April 1829:

> In our last, we gave an account of the trial, at our late Assizes, of a man named *Dwyer*, for a robbery at Lady Bantry's, at Clifton. The man was acquitted in consequence of the positive swearing of a witness, that the prisoner was in his house the whole of the night in question. Since his acquittal, *Dwyer* has been apprehended in Walcot parish, Bath, for having in his possession some of the plate stolen from the Countess; and, from subsequent information, there is but little doubt that the witness adverted to was guilty of the most wilful and corrupt perjury in his evidence upon the trial. With *Dwyer* was apprehended another Irishman, named *Michael Hickey*, who, it is supposed, was concerned in the same robbery.

Meanwhile, we have another example of the ever-mischievous Cupid casting another of his pebbles to disturb the placid waters inhabited by the gentry:

From the Gloucester Journal, 11 April 1829:

NISI PRIUS COURT – CRIM. CON.

SATURDAY – *Wallis, Esq. v. Birket, Esq.* – *Mr. Taunton* (with whom was *Mr. C. Phillips* and *Mr. Phillpotts*) said, that he should state, as briefly as possible, the circumstances that compelled the plaintiff to come into a Court of Justice. The plaintiff was a gentleman who had resided for about five years at Tibberton Court, near Gloucester, a Magistrate of that county, and beloved by all who knew him. In early life Mr. Wallis had been in the Navy, and had had the honour to be Secretary to Lord Nelson; he had served at Copenhagen; and having been promoted to the rank of a purser, he was ultimately appointed prize-agent at Java, where he amassed so much property as to enable him to come home at the time of the peace, and live in a state of affluence. On his return to England he became acquainted with the family of Lady Bolton, who had two daughters, one of whom Mr. Wallis married in the year 1816. Mr.

Wallis was then 38 years of age, Miss Bolton being 18. She was young, beautiful, and accomplished and, what was more than all, she was virtuous. From 1816 to 1818, they lived at an estate of Mrs. Wallis's, called Tutt's hill, near Chepstow; and, during this time, and even down to the cause of the present action, it would be proved by friends who visited them, and by servants who were domesticated with them, that nothing could exceed the harmony upon which they lived together, and that nothing could surpass the affection of Mr. Wallis, nor the way in which that affection was repaid by his wife. They lived in this way till October 1828. However, it was proper to observe that, in the autumn of 1826, they had been at Aberystwith, where they had become acquainted with Mr. and Mrs. Goldsmidt, who, in consequence of the intimacy that then existed between them, were invited to make a visit at Tibberton Court. The defendant was the brother of Mrs. Goldsmidt; and in consequence of that, he was invited with his brother-in-law and sister to Tibberton, where he enjoyed the hospitality of Mr. Wallis's house, and the pleasure of sporting over his estate; and it was a remarkable feature in this case, that Mrs. Wallis was a person least of all likely to have taken the step that she had; for it would appear that, so far from having the slightest levity in her conduct, she appeared to strangers to be rather cold and repulsive. Indeed, during a period of two years, there was nothing to lead to the slightest suspicion of any improper intimacy subsisting between Mrs. Wallis and the defendant; and the plaintiff defied the other side to show that there ever was any deficiency of attention in Mr. Wallis towards his wife, or that there ever was the slightest negligence on his part. In the autumn of 1828, Mr. and Mrs. Wallis contemplated taking a tour on the Continent; and with that view Mr. Wallis disposed of his house at Tibberton Court, and proceeded with his wife to Cheltenham, to stay till they went on their tour abroad. There they met Mr. Birket, and Mr. and Mrs. Goldsmidt. However, before he stated what occurred at Cheltenham he ought to inform the Jury that Mrs. Wallis had some separate property of her own, which, by the marriage settlement, she had the power of disposing of by will. Now, he was in a condition to lay before them her will, dated so lately as the year 1825, by which she left the whole of this property to her husband for his life, and after his decease to any children he might have by a second wife. At Cheltenham it would appear that Mr. Birket was only once alone in company with Mrs. Wallis, and that that was when Mrs. Wallis rode out on horseback on one occasion, attended by her groom, and nothing occurred to excite suspicion till 14th October.

On that day the Quarter Sessions at Gloucester were held; and Mr. Wallis being a Magistrate, came to Gloucester to attend these Sessions. He made an arrangement to dine at home, and had actually invited this very defendant to dine with him, and partake of his hospitality. The invitation was accepted; but it would be proved that at ten o'clock on the morning of that day, Mr. Birket, who kept two carriages, set out in one of them towards the Evesham road; and that, when he got beyond the new church at Cheltenham, he overtook Mrs. Wallis. On coming up to her, the defendant got out of the carriage and said, "My dear, no time must be delayed"; to which, after bursting into a flood of tears, she replied, or rather, she sobbed out the words "I can't go – I can't leave". This was the last gasp of conjugal affection; for the defendant handed her into the carriage, and they proceeded to Evesham, thro' Alcester to Leamington, where they took up their residence for five days, passing as man and wife, under the assumed name of Mr. and Mrs. Vernon. However, at the end of the five days, Mr. Chadborn, accompanied by a police-officer, proceeded thither to conduct Mrs. Wallis back – not to her offended husband, but to the protection of her mother, Lady Bolton. She was brought back, and it was impossible to account for estrangements such as these; but they would hardly believe, that such was the perverseness of this lady's mind, that she went away again, and was now in company with Mr. Birket. These were the facts of the case, without the slightest circumstance of alleviation; for in this case, they found friendship betrayed, hospitality violated, and innocence seduced! These were topics upon which it was only necessary to touch; and if there were any deficiencies in his statement, the good sense of the Jury would, he was sure, supply them. The plaintiff came forward with every possible claim for redress, while the defendant had not one single topic of mitigation to urge. Ample compensation the plaintiff never could have, as no compensation could repay him for the anguish he had undergone; but still such recompense as he could have, he was quite sure the Jury would give him.

Mr. John Chadborn was the first witness called. He produced the register of marriage, at Mary-le-Bone Church, on 30th March, 1816, by banns. He had been acquainted with Mr. and Mrs. Wallis for five years, and dined with them frequently.

Sir Alexander Wilson, a Magistrate of the county, knew Mr. and Mrs. Wallis, and visited them both at Tutts-hill and Tibberton Court. They appeared to him to live together in perfect harmony. Mr. Wallis behaved to his wife with much affection; and Mrs. W. was always correct, without

the slightest approach to levity in her conduct – quite the contrary.

The Rev. Wm. Bushell, Rector of Tibberton, had known Mr. and Mrs. Wallis for five years. He visited them, and they had every appearance of harmony. Mrs. Wallis was very regular in attending Divine Service on Sundays, and she also received the Sacrament frequently. Never saw her in any thing like levity of conduct.

Mr. Campbell – I don't mean to say she had. I have no defence of that kind, and I may save your Lordship some little trouble.

Mr. Justice Park – I must hear how this really was. If this person was a woman of levity of conduct, that will abate the damages; but if she is proved to be a woman of very exemplary conduct, manifesting much of conjugal affection, and having at least the show of very religious habits, that will vary the case materially.

Miss Key, a lady of fortune, visited Mr. and Mrs. Wallis, and never knew a pair who appeared to be living on better terms. Mr. Wallis was a mild, good-tempered man.

Mr. Rd. Lovesey, surgeon, had known Mr. and Mrs. Wallis upwards of 20 years. He visited Mr. and Mrs. W. as a friend, and attended them professionally. From constant opportunities of observing their conduct, he considered them a very happy couple.

Cross-examined – I never heard of any conversation of Mr. Wallis that I disapproved of. I saw Mr. Wallis after this occurred; he appeared almost distracted.

Examined by the Learned Judge – I have attended Mrs. Wallis in illness, and at those times her husband always appeared to be very attentive to her, and he seemed anxious about her.

Rd. Bridgeland had lived nine years in the family as coachman. Mr. and Mrs. Wallis kept a good deal of company. They appeared to live happily; he was a very kind husband, and she was a very meek, good-tempered woman – indeed both of them were very good-tempered. In 1826 they went to Aberystwith where they became acquainted with Major and Mrs. Goldsmidt, who returned with them on a short visit to Tibberton. The Major and his lady then went to Cheltenham, where Mr. and Mrs. Wallis returned the visit; here they became acquainted with Mr. Birket, the brother of Mrs. Goldsmidt, and he and all the family afterwards visited at Tibberton. Mrs. Wallis never either walked or rode out with Mr. Birket alone. During the nine years I lived with Mr. Wallis, I never witnessed the slightest impropriety in his behaviour.

Cross-examined – Mrs. Wallis never had any family. About six years

ago, Mr. and Mrs. Wallis went to Paris, where they remained about nine months, during which time Mr. Wallis was absent in England for six weeks on business; Mrs. Wallis was left with her friend Miss Steed, and her maid Sarah Rose. Mrs. Wallis's brother-in-law Mr. Prince and her sister were there.

Examined by the Learned Judge – I never observed that Mr. Wallis became less attentive to his wife after he came from Paris.

Sarah Rose, lady's-maid and housekeeper at Tibberton the whole time the family were there, had opportunities of seeing their conduct. Mr. Wallis was always kind to Mrs. Wallis; and witness once heard her say that if any one was ever blessed with a good husband she was. Had seen Mr. Birket often, but never saw him alone with her mistress, and saw no more attention paid by her to him than a well-bred lady would pay to her husband's friend.

Rd. Hughes, a post-boy at the George, Cheltenham, knew Mr. Birket, and took his carriage and horses to his residence on 14th Oct. at eleven in the forenoon, to go to Evesham. When we started there was no one in the carriage but Mr. Birket, and a servant on the box. When we got to the new church I observed a lady, standing near the hedge. I was ordered to stop, when Mr. Birket got out of the carriage and went to the lady. They were in conversation a few minutes. He took her by the hand. She was crying, and had a handkerchief before her face, and she said, "I can't go. I can't leave". He took her by the arm and kissed her twice, as they stood at the road side, and then handed her into the carriage, saying, "There is no time to be lost, my dear". He then got into the carriage himself, and I drove them to Evesham, a distance of 16 miles. She had no luggage.

Cross-examined – The lady appeared to be waiting for us.

Other post-boys then proved having driven the parties from Evesham to Alcester, Stratford, and Leamington, starting on the first stage under pretence of going to Worcester. The last of these witnesses stated that, on 18th Oct. he saw the parties in the carriage, in the street of Leamington, going out for a drive; when they were stopped by Mr. Chadborn, and Mr. Marsh, a police-officer. The lady was taken out of the carriage to the Crown Inn, and was afterwards put into a post-chaise, and accompanied by Mr. Chadborn inside the carriage, and Mr. Marsh outside. They drove away with her towards Warwick.

Cross-examined – They were stopped five yards from the inn. The lady was taken out of the carriage in the street. They might have driven under the inn door. I did not see any constable's staff, but there was a great crowd.

Mrs. Woodhouse, of the Union Parade, Leamington, said that, on 14th Oct. a gentleman and lady came in a carriage to that house, and took lodgings. In consequence of some suspicions, witness went into the bed-room, and found a pair of stockings marked "A. Wallis".

Mr. Chadborn, recalled, said – On 15th Oct. I was sent for by Mr. Wallis to go to Tibberton Court. I saw Mr. Wallis; he appeared in great distress. I went to Leamington, where I found Mrs. Wallis, and I brought her back. She appeared greatly distressed. I produce Mrs. Wallis's will. It was executed in 1825. When I brought Mrs. Wallis back, I brought her to my own house at Gloucester, and I afterwards consigned her to the care of her mother, Lady Bolton, who took her to Hereford.

Cross-examined – Mr. Wallis knew that I was going to Leamington, and that I was to take Marsh, the police-officer, with me. I had an authority in writing from Mr. Wallis.

Re-examined – Mr. Wallis's directions to me were, to bring Mrs. Wallis back, and place her in the charge of her mother, Lady Bolton.

Examined by the Learned Judge – At the time I saw Mrs. Wallis in Leamington, Mr. Birket was in the carriage with her.

The will of Mrs. Wallis was read. It covered twelve closely-written sheets of paper, reciting a very long marriage settlement, and what the lawyers call a power of appointment; and it also recited several other title-deeds relating to Mrs. Wallis's property, and then proceeded to bequeath all her property to Mr. Wallis, and to any children he might have by any future wife. The reading occupied nearly twenty minutes, during the whole of which time nearly every body in Court was profoundly attentive.

Mr. Chadborn, being recalled, said that he understood Mrs. Wallis's property comprised in this will was worth between 1000*l.* and 2000*l.* a year; but that she was not entitled to any part of it till Lady Bolton's death.

Mr. Campbell, for the defendant, said that the evidence tended to show that the plaintiff was a much-injured man, and he was bound to admit it, and indeed, his client deeply regretted what had passed. He felt quite sure that his client would not do any thing to aggravate what he had done. He had no instructions to impeach the character of Mr. Wallis, who appeared to have been a highly respectable and estimable man. However, letting it be supposed that his conduct was free from reproach, still the question here was, what had been the injury he had sustained by the conduct of the defendant. There was no account of Mr. Birket's fortune, connections, or family; and no evidence had been given that he was at all able to pay

any damages that might be awarded against him. All that was proved was this – that Mr. Birket was not 24, and Mrs. Wallis something over 30. Now, though Mr. Birket had offended against the laws of God and man, yet, was it, as Mr. Taunton had said, a case loaded with aggravation, and without a single mitigatory topic? Was the defendant a hoary seducer? Was he a man trying to obtain a name as a profligate? No; all that they had heard was, that he was a young man of 24; had become acquainted with Mr. and Mrs. Wallis; and that the defendant and Mrs. Wallis had formed an improper intimacy together, which intercourse had continued; and it was a fact not a little to be remarked, that no member of the family was called to prove the very romantic affection, which they were taught to believe had existed between these parties. There were only occasional visitors called, with the addition of some of the servants. If it was to be said, that Lady Bolton was too near a relation to be called as a witness, still why was not Miss Wallis called? Again, there were Miss Crawley, Miss Sampieri, and Miss Bernard, each of whom were for months in the house; but none of them had been examined; and he did not think that there could hardly be that enthusiastic affection subsisting between the parties; for it should be recollected Mr. W. was twenty years older than his wife. He left her at an hotel at Paris for some months, with no one to take care of her but servants. It was said that there was a great breach of friendship; but what did that amount to? Did Mr. Wallis and Mr. Birket go to school together? No. Were they college friends? No. Mr. Wallis was near 30 years older than Mr. Birket, and their acquaintance had not begun till the year 1826, and then Mr. Birket was only a casual visitor at Tibberton Court, and had come occasionally to dine there. These were some of the aggravations; but there were some matters of mitigation to be attended to on the other side. Were there any letters from the wife to the husband, to show the state of her affections? Not one – but instead of them, they had Mrs. Wallis's will brought forward, by a Gloucester attorney, in which she called Mr. Wallis her dear husband. However, that proved very little of affection; for the words "dear husband" were copied out of Mr. Richard Preston's "Precedents in Conveyancing"; and as Mr. Wallis knew of this will, he acted rather an indelicate part in allowing his young wife to settle her property, not only upon him, but upon the children he was to have by another wife, after she was in her grave, without leaving any thing either to her mother, her sister, or any of her own relations. Indeed, in the same taste in which that will was produced, they might have had Mr. Morgan, the actuary, called before them, to

say what was the value of Mr. Willis's interest in this property, which he would have taken under the will. Another topic of mitigation was that there was no adulterous intercourse under the roof of her husband; and, so far from that being proved, it did not even appear that, while Mrs. Wallis was in her husband's house, an improper familiarity had passed between these parties. There was no child to mourn Mrs. Wallis's loss – no child to remind Mr. Wallis of his misfortune. Under these circumstances, why should a Jury award exemplary damages? Was it because Mr. Birket remained still kind to Mrs. Wallis, and that, after she had once left him, he brought her back and afforded her an asylum? That, he submitted, was a circumstance in his favour. Did this in any way inflict additional injury on Mr. Wallis? He could not take her back; and, as she had lost her station in society, Mr. Birket did quite right to afford her his protection. The damages, he submitted, ought not to be exemplary; they should be temperate, and such as should show that the Jury thought that Mr. Birket had not acted dishonourably, or in a manner unbecoming a gentleman. The character of Mr. Wallis had been established; and the verdict would enable him to have recourse to a remedy, by which the ties that united him to Mrs. Wallis would be for ever dissolved. That was all he could want, as his fortune was ample; and, if the Jury should award heavy damages, the verdict would operate upon the defendant as a sentence of perpetual imprisonment, as he was in no situation to pay them.

Mr. Justice Park said that the facts of the case being clearly made out, the question was merely what ought to be the amount of damages the plaintiff was entitled to recover. In considering this question, the conduct of the husband and wife, before the latter fell in the trap of this seducer, was most material. The Learned Counsel for the defendant had said that there was no evidence of the property of the defendant. There certainly was not; but it had always been laid down as a rule, that those who could not pay in their purses should pay in their persons and, if this defendant could not pay, let him go to gaol. Was it to be endured, that this person should go about with his open carriage and his two footmen, seducing men's wives, and then say, "Oh, pray let me off, for I have no money to pay damages"? Then it was said that the lady was 31, and this young gentleman only 23. If she had been the seducer, it would be a great mitigation; and if this were the case of a lascivious woman, who had by her acts seduced a mere boy – and it is very difficult to withstand the arts of an artful woman – small damages would suffice; but then look at the evidence – was she the seducer? The evidence of Rd. Hughes showed

that she was crying, and did not like to leave, but that the defendant was persuading her to go. However, there was but one thing that made it seem that Mr. Wallis did not live so well with his wife, which was this – that he left his wife in France by herself for a short time. I, said the Learned Judge, should not have done such a thing for all the world; however, I am sorry to say that a great many foolish people, of late years, keep running abroad, and taking their wives and families with them, spending their money there, which they had much better have spent in their own country. But then this was six years ago; and since that time, they had it proved that Mrs. Wallis had made a will in favour of her husband. These were some of the points urged in the defence. Then, how did the case stand? It was proved that two years ago the defendant became acquainted with the plaintiff; that he was received at his house, and visited there from time to time, till the affections of this lady, who had, up to that time, been a virtuous woman, were entirely estranged from her husband. This was the case; and the damages were matter entirely for the consideration of the jury.

Verdict for the plaintiff – Damages *Two Thousand Pounds*.

Gloucester Summer Assizes

As foreshadowed at the time of the Spring Assizes, there was a third person to be brought to book in the affair of Lady Bantry's silver. He was tracked down by the long arm of the law, in time for these Assizes, though not without a little help from another erstwhile comrade who 'turned King's Evidence':

From the Gloucester Journal, 5 September 1829:

CROWN SIDE – Before Mr. SERGEANT TADDY

Simon Hickey was indicted for having, on 7th Jan. last, burglariously broken and entered the house of the Right Hon. the Countess of Bantry, and stolen therefrom a silver tea-pot, ten silver table-spoons, seven silver dessert-spoons, two silver butter-boats and covers, and several other articles of plate, the property of the Earl of Bantry.

Mr. Sergeant Ludlow stated that the case against the prisoner would depend chiefly on the evidence of an accomplice of the name of Dwyer, who had been tried at the last Assizes for the same offence and acquitted.

John Dwyer, the accomplice, said he knew the prisoner for 23 or 24 years. He is an Irishman. The witness lived at Clifton, near Bristol, and worked for Counsellor Powell. He was acquainted with Letitia Dixon, a servant of Lady Bantry's. He believed she is now transported. Before 7th Jan. last, he plotted with the prisoner to break into her Ladyship's house, and agreed that they should go on the Wednesday night. He mentioned their intention to Letitia Dixon, and told her they were to be there between twelve and one o'clock. He went with the prisoner at one o'clock, and got in at the back of her Ladyship's house. A quarter of an hour after, Letitia Dixon came down and opened the door to them. The prisoner had a crow-bar, and said they should make some signs of having broken in, that it might not appear that they had been let in by any one inside. He then made some marks with the crow-bar on the side of the door and window. They then went into the house, the witness went first, and the prisoner followed. Letitia Dixon, after getting the keys of the store-room, went up stairs and brought them down a large basket of plate, with which they left the house. They went off towards the Downs, where they then hid the plate, between the observatory and the turnpike. Witness, on last Thursday, pointed out the spot where the plate was hid, to Mr. Oatridge, the Governor of the House of Correction, at Lawford's Gate. On 13th April last, the prisoner went with the witness to the spot where the plate was concealed, and took out a tea-pot. He carried it in his apron to another part of the Downs, and cut it to pieces. The prisoner then went to Bath with the witness to try to sell it. They went to Mr. Lawrence's, the silversmith's, in the evening, and the next morning they were taken up. Letitia Dixon was transported at the last Assizes. Cross-examined – I was tried at the last Spring Assizes for this offence, and acquitted. The plate was taken to Bath after the Assizes. The prisoner, as he knew where it was, might have removed it immediately, but he did not so. I did not employ the prisoner to carry those things to Bath to sell for me.

G. Lawrence, a silversmith at Bath, said the prisoner and the last witness came to his house on 13th April last. The last witness brought with him about 3½ ounces of broken silver to sell. The prisoner waited outside the window. Witness did not see him. Dwyer asked the witness what he would give for the broken plate. Witness replied 13s. Dwyer then went out and consulted the prisoner, and then came in and agreed to take the 13s. The prisoner then came in, and Dwyer asked the witness if he would buy any more. The witness knew it must have been stolen; and, in order to have them apprehended, said he would buy the rest. He then paid them

13s. and directed Hawkins, a police-officer, to be in waiting by the time the prisoner and the last witness came the next morning, which they had agreed to do, and bring some more plate.

Mr. Oatridge went with the witness (Dwyer) to Clifton Downs, last Thursday, and under a furze bush, which he pointed out, found the plate which he now produced.

The Countess of Bantry said that in January last she occupied a house at Clifton, and Letitia Dixon was one of her servants. Her Ladyship proceeded to describe the circumstances of the robbery.

Mr. Oatridge apprehended Hickey a few days after the robbery, and he made a most violent resistance.

The prisoner on being called on for his defence, said he had been employed by the witness Dwyer to carry the silver to Bath; that he had nothing to do with the offence with which he was charged, and had been told Lady Bantry did not intend to prosecute.

Mr. Sergeant Taddy having summed up the evidence, the Jury found the prisoner *Guilty* – Judgment postponed.

In accordance with the criminal law, Hickey was condemned to hang, but his punishment was subsequently reduced to transportation for life. Thus, of the two ruffians and their female accomplice who were involved in the robbery, two received their deserved punishment, while the third, by dint first of finding a friend to provide a false alibi and then of turning King's Evidence, seems to have got off scot-free.

Surely, if ever there was a tale fit to induce salt tears, the following case is such a one. The two principal actors, a man and his wife, lost deep in a rustic backwater in the Forest of Dean, came from a world which was a far cry from the indulgent comforts and polished manners of Cheltenham Spa. Blessed only with the meanest of possessions to furnish their comfortless hovel and scratching a bare existence at the very lowest level of society, their lot was one to which they could have had no hope or prospect of finding any improvement.

If the husband treated his spouse abominably and deserved his end, it cannot be denied that he was granted the poorest of starts in life, which can have allowed him little or no instruction in the humanity with which one being ought to treat another.

From the Gloucester Journal, 5 September 1829:

MURDER OF A WIFE! – *William Salewell* was indicted, charged with the wilful murder of his wife Sarah Salewell, at Ruspedge Meon, in the hundred of St. Briavels.

Mr. Justice (with whom was Mr. Watson) said, in addressing the Jury, that the silence and anxiety which prevailed throughout that crowded Court indicated the deep interest excited by the important investigation which was now to employ their attention – an investigation, not only important as it respected the inquiry into the death of a fellow-creature, but important, as it affected the life of the man then at the bar, standing on the verge of eternity. In addressing them, he trusted that not one word would escape his lips contrary to that blessed maxim of the English Law, which required that charges of this serious nature should be decided on by the evidence alone. But he would endeavour to state the facts, so that the interests of justice would be protected, and the interest of the prisoner should not be violated. The prisoner, it appeared, was a foundling: his birth-place and parents were alike unknown, as he had been left, while an infant, at the door of a farm-house called Sollywell, from whence he derived the name he was now known by. He moved in one of the humblest paths of life, and some years ago he married the unfortunate deceased. They lived together in a hovel in St. Briavels of the most miserable description: they were without furniture of any kind, with only a bed of straw, and without a door to their wretched abode. The deceased appeared to have submitted to the privation which Providence had placed around her path, with the greatest patience and resignation, and scarcely to have made any complaint at the cruel usage she received from the prisoner. On the evening of Saturday, 23rd May, the deceased went out to meet the prisoner, whose return home she had been expecting. She went along the tram-road, and shortly after cries of "Murder!" were heard; and a girl, who was passing along the road, saw the deceased on the ground, and the prisoner kicking her in the most brutal manner. He desired her to get up; she replied she was unable: he then kicked her again; and the girl being too much frightened to interfere, went on as fast as she could, till she met a man, whom she sent to the woman's assistance. The man found the prisoner still beating his wife; he pushed the prisoner from her, and asked him if he was going to murder the woman. The prisoner replied, she was his wife, and he had a right to do as he had a mind with her. The next day she was seen laying on her miserable bed of straw, in a state of great

pain and weakness; she was dreadfully bruised, and unable to rise. A kind neighbour had gone to her assistance, but the prisoner was displeased at it, and threatened, if she came there again, he would serve her the same. On Monday, the 25th, the poor woman died; and the neighbour who had evinced so much kindness for her, removed the body to her own cottage where she performed the last offices for it. The Jury would hear the circumstances detailed by the different witnesses to this unfortunate transaction, and from the Medical Gentlemen who had opened the body of the deceased. If they thought the evidence was sufficient to establish the charge against the prisoner, it would be their duty, by their verdict, and by his example, to hold out a warning to the bad passions of mankind.

Mary Ann Meredith said, I live at Cinderford. I know the prisoner. On Saturday night, 23rd May, about half-past nine o'clock, I had a basket of coals on my head; I was going along the tram-road. I heard a noise; I heard the prisoner's wife crying "Murder!" Her husband was with her on the side of the tram-road. She was sitting down. I saw the prisoner kick her very hard; she begged him not to kick her any more. The prisoner said, "D—n thee eyes, if thou does not get up I shall give thee some more of it". She said she could not get up; he then kicked her again two or three more times. I was very much frightened, and went by as hard as I could. I said nothing to him, because I was so much frightened. He was more than five minutes kicking her from the first time I heard the cry of murder. After I passed by, I looked back, and saw the prisoner kick her again. I met Llewellyn Reece, and told him what I had seen, and he ran as fast as he could towards where I had left the prisoner and his wife. When I had left my coals at home, I returned to the place, and found the prisoner and his wife and Reece still there. The prisoner was talking to Reece; his wife was then standing up; and the prisoner and his wife then went away down the road together. She walked very slowly; there was a hole in her arm all over blood, large enough for me to put my finger in. – By the Court: I did not hear the prisoner's wife abuse him before the cry of murder. I saw the hole in her arm; while her husband was talking to Reece, she said he had done it. The prisoner had great nailed shoes on; he seemed to be sober. I did not hear any quarrelling about her not going for money or bread.

Llewellyn Reece said, he lived about half a mile from the prisoner's hovel. On the evening of the 23rd May, he was spoken to by Mary Ann Meredith. In consequence of what she said, he ran towards the place she mentioned; as he went towards that place he heard cries of "Murder! Murder!" It was a female voice. When he got to the spot where the cries of

murder came from, he saw the prisoner and his wife on the ground; he had heard the sound of heavy blows before. The woman was down at length on the ground. He saw the prisoner hit her two or three times, stooping over her; this might be about ten minutes after he left Mary Ann Meredith. He pushed the prisoner off, till he fell to the ground, and said, "What be at?" or "What be doing; be you murdering the woman?". The prisoner said, "No, I am not; I have a right to do as I have a mind with her, she is my own wife". The woman got up as soon as witness pushed him off; she seemed to be very poorly and weak. Witness did not see her face, as he retreated back as the prisoner wanted to fight him. Witness asked him what he had beat her for; he said because *her* had come and abused him when he was having some drink. She said, "No, William, I never did in my life, only telling you for your good". He did not appear to be drunk, but he had had some drink. Witness begged him not to beat her any more, and he promised he would not. Witness then turned away and left them. Cross-examined: She seemed very poorly and very weak. The prisoner did not appear to be drunk or tipsey; there was a child with her sitting down on the ground.

Joseph Tingle, a miserable-looking boy, 14 years of age, said he had never been to school, but he had learnt the Lord's Prayer, and knew he should go to hell if he spoke falsely. He knew the prisoner at the bar, and the house the prisoner and his wife lived in. He was near the prisoner's house on the night of 23rd May, and saw the prisoner and his wife come over the bridge; she was walking lame. The prisoner was, he believed, carrying the child; his wife was crying, and complaining of a pain in her side. The prisoner said if she did not hold her tongue, he would give her more. She said, "William, you have no need to beat me more; I shall not want more in this world". They then went into their own cottage. That was on the Saturday night. On the Sunday evening, witness was in their cottage. The prisoner and their child were there, and his wife was lying on the bed. The prisoner was then sitting down, not on a chair, as they had no chairs. The bed was hay and *foy*, on the floor of the cottage. The prisoner went towards the bed; his wife was then sitting up; she put on her shoes, and the prisoner tied them. I saw her get up off the bed and sit on a stone. The prisoner took hold of her arm, and assisted her to get off the bed, and sit on the stone; while she was sitting on the stone, she complained of her side. The prisoner said she made more of it than what it was; he d—d her eyes.

Sophia Bishop said, the hovel in which prisoner lived was without a

door, and that the prisoner had no furniture of any description; his wife and he slept on a straw bed, and they had a kind of sheet and coverlid. I was near their garden, about 30 yards from their hovel, on the Friday week before the prisoner's wife died. The prisoner was digging; his wife was by. I heard him say to her, "Go thee hence", meaning for her to leave the garden. She said, she dared not say her soul was her own. He then left off digging, and went up to her, and struck her with his fist on the side of her head; he struck her several blows on the head; she did nothing but cry. There was a wall separating the garden from some other place. The prisoner tried to take her up in his arms, seeming as if he was going to throw her over the wall; she struggled against it, and got away from him. I saw her after that on the bed, her eyes were very badly swelled and black, and she complained of her loins. I saw her husband in the course of the day; he said to me, "*Keep thee hence before thee haul'st it on her again*". I went away in consequence. On the Monday morning I heard of her death. I went to the hovel and found she was dead. Ann Parry took the body back to her own cottage. I saw the body; there were marks on her loins and back, and on her arms a scratch, and on her chin also.

Ann Parry knows the prisoner, and went to his cottage on Sunday, 24th May, between eleven and twelve o'clock. The prisoner's wife and her child were there; the woman was lying down on the ground on some sort of a bed; there was a sheet, a blanket and a coverlid on it. She was undressed; I did not observe her person particularly, as I was so badly frightened. She spoke to me, and I examined her chin; there was a bruise on it, and both her eyes were very black. I only stopped about two minutes; I went away to make her a drop of tea. I saw the prisoner as I was going away; he said to me, "You had better stop from there, or I'll be d—d if I don't serve you the same". I did not go back again, as I was afraid. I sent her some tea and a little bread and butter by a child. Next morning I went to the prisoner's cottage about ten o'clock. I found the prisoner's wife lying dead upon the bed, and the little child; the body was warm. The prisoner was not there. I took the body to my own house, where the inquest was held.

Mr. Jos. Abell, surgeon, said, I examined the body of the deceased, on Tuesday, 26th May. Mr. Phillips assisted me. The eyes were very much swollen and black; there was a bruise on the chin, and on opening the head I found a portion of extravasated blood on the eye-brows and on each temple; those appearances corresponded with the external injuries. I examined the brain, and found some extravasated blood there; the head did not appear otherwise diseased. I then examined the back and loins;

there was a general discolouration from the neck to the knees; that would be produced by the settling of the blood after death. The lungs were loaded with blood in a state of congestion. I found the seventh rib broken; the lungs had adhered to the ribs, the adhesion appeared of recent formation; the bowels were quite empty. The woman appeared to have been naturally a healthy subject. I consider her death was occasioned by the extreme violence. The rib was not merely broken but smashed.

Mr. Charles Taylor Phillips, surgeon, residing at Newnham, assisted Mr. Abell in the internal and external examination of the deceased. He had heard the examination of the last witness, and entirely concurred in the facts stated by him.

The evidence of this witness closed the case for the prosecution; and the prisoner being called on for his defence, handed in the following statement, which was read by the Officer of the Court:

"My Lord and Gentlemen of the Jury. On the day this unfortunate affair happened, my wife and myself were digging for Mr. White, of Cinderfoot. About twelve o'clock my wife went home. I went from there to Mr. Guest's to take some more work, but did not agree then; I was to call on the morrow, but did not go, it being Sunday. I came back to Mr. White's, of Cinderfoot, to receive the money for the work I had done. I received a note for 10s. to go to the shop, and have what I wanted to that amount. I bought a peck of flour, some tea and sugar, an apron for my wife, a frock for the child, and a piece of bacon; altogether to the amount of 8s. and received 2s. in silver. I brought those things from the shop, and left them at a house where I used to lodge some time before. I went back to Mr. White, of Cinderfoot, as I had some things to take from there for another person. Mr. White had been giving his men some beer, and there being one or two in company I knew, I staid and drank with them; I staid about two hours. I then went and fetched my things; and my wife met me, and began to abuse me for staying so long. I told her not to be angry, as I had not spent any of the money besides what I paid for the things she told me to buy. I offered her the rest of the money to go and buy some bread, but she would not go. We then went towards home; we were quarrelling. After we had walked together about a quarter of a mile, we came to very angry words. She struck me, and threw several pieces of coal at me. She put the child down in the road which she was carrying. I struck her with my fist two or three times. She cried out murder. I did not strike her until she had struck me several times. I struck her with nothing but my fist. There was a man in the road, who came and pushed me; I told him to go about his

business, as it was no difference to him. We then went home. My wife carried the peck of flour, and the other articles; I carried the child. We did not quarrel afterwards. We had a quarter of a mile to go. On the next day (Sunday) she complained of a pain under the left breast; there was no mark; she was very subject to a pain in the breast and stomach. She got up in the morning and went about her work; she did not go to bed until her usual time in the evening. On the same evening, a man of the name of John Parry, that lived close by us, came and sat with us in the cabin; we lived in a collier's cabin. He staid about two hours; my wife did not complain afterwards. The next morning (Monday), I got up about six o'clock; my wife advised me to go and take the digging of Mr. Guest, and she would get up and bake the flour, as I might have some bread to take to my work. A little girl, the daughter of Joseph Tingle, used to come and take care of the child; she had been there the morning I left, to go and take the work. After I had been at Mr. Guest's about an hour, five men came and told me I was their prisoner, as my wife was dead. I told them I did not believe it, as she was well when I left her an hour and a half before. I begged of them to let me go down with them and see; but they would not, and dragged me off to Justice Meeting; when the Magistrate committed me to Gloucester Prison. I did not believe my wife was dead at the time I was committed. My Lord, I solemnly declare my wife appeared to me to be in good health when I left her. I have not had the means to bring the girl forward that I left in the cabin with my wife, or the man that was with us the evening before. I hope they are here, for they can testify that my wife did not complain of any thing the matter with her. My Lord, this is nothing but the truth. My wife and self lived very comfortable together. We had been married five years, and had two children, they were both alive at the time this melancholy affair happened. I am a friendless man, having no relation of my own family living. I declare to God, I never intended to be the death of my unfortunate wife. I hope, my Lord, my life will be spared, for I am innocent of the charge of wilful murder".

Mr. Sergeant Taddy then recapitulated the evidence to the Jury, and told them that, in order to arrive at a proper conclusion in this case, it would be their duty to consider whether the acts of violence which had been detailed to them were the result of any provocation by the deceased – whether she had struck the first blow, as the prisoner alleged – whether she had struck him at all – whether her death was occasioned by that brutal and ferocious violence of the prisoner, which would amount to that degree of malice necessary to constitute the crime of murder. If they were

of opinion that the death of the unfortunate woman had been occasioned by the brutal and ferocious violence of the prisoner, unprovoked by any conduct of hers, it would be their duty to find him guilty of murder; but if they entertained any doubt with regard to the provocation the prisoner received, it was equally their duty to give him the benefit of that doubt, and find him guilty of manslaughter.

The Jury, after considering a short time, found the prisoner *Guilty of Murder*.

Mr. Sergeant Taddy then put on the black cap; and proclamation of silence having been made, his Lordship said, "William Salewell, you have been convicted by a most attentive, and, as far as I could judge, a most merciful Jury, of the crime of the wilful murder of your wife! She was, it has appeared, a most kind and affectionate wife to you! The only instance of her making any complaint against you, was when she remonstrated with you against indulging in drunkenness. When attacked by you, she appears to have made scarcely any resistance. She was one of that sex that was formed for, and intrusted to, our protection! By the sacred obligation which you entered into with her, it was your bounden duty to have loved, cherished, and protected her. You were connected to her by the dearest ties; but you have broken not only thro' those ties, but thro' the common ties of humanity, the sympathies of our nature, by the brutal and ferocious violence with which you destroyed her. It is my painful duty to tell you that there is no hope of mercy for you in this world; but to the Almighty every thing is possible. Let me implore you, as you value your salvation, during the short time you have to remain here, to apply yourself to prayer and penitence; to humble yourself at the Throne of Mercy, and to endeavour, by sincere contrition, thro' the merits of your Saviour, to appease the wrath of your Creator, before whom you must shortly appear. It only remains for me now to pronounce upon you the awful sentence of the law, which is – that you, William Salewell, be taken from hence to the place from whence you came, and from thence, on Saturday next, to the place of execution, and be there hanged by the neck until you are dead, and that your body be then delivered over to be dissected; and may the Lord have mercy upon your soul!"

The prisoner uttered some entreaty, but it was scarcely audible, and he was immediately removed from the dock.

His Lordship was considerably affected while passing sentence, and during the summing up to the Jury.

From the Gloucester Journal, 12 September 1829:

EXECUTIONS – *William Salewell*, alias *Sully*, whose trial for the murder of his wife was detailed in our last, suffered the awful penalty of the law, on the New Lodge, in front of our County Gaol, on Saturday last. The earnest exhortations of the Rev. Chaplain to this unhappy man, both before and after trial, seemed to have aroused him to a proper sense of his miserable state. Subsequently to his condemnation, he admitted without hesitation that he inflicted the blows which occasioned her death, but constantly asserted that it never was his intention to murder her. He was very ignorant and illiterate, and had evidently a great load of guilt upon his conscience; indeed he acknowledged having transgressed the principal commandments of his Maker, dating his commencement in the career of crime from the practice of poaching; but we know not the extent of his disclosures. On the morning of execution he paid great attention to the performance of divine service, and at its conclusion took leave of his fellow-prisoners, with a warning by which many of them were sensibly affected. After a short interval he was conducted to the fatal scaffold, which he approached with tolerable firmness. When tied up, he addressed the assembled multitude at considerable length; acknowledging that he was the cause of his wife's death, and attributing the bad understanding that subsisted between them to the officious and meddling interference of their neighbours. He particularly cautioned his hearers against the indulgence of passion when in liquor, which had led him to his present unhappy state, and hoped that some care would be taken of his unfortunate child. When he had concluded his address, the signal was given, and the fatal bolt being withdrawn, his sufferings in this world were speedily terminated. The concourse of spectators was immense.

From the Gloucester Journal, 5 September 1829:

Thos. Ball, a very respectable man, aged 46, was indicted, charged with assaulting Margaret Edwards, the wife of John Edwards. – Margaret Edwards, a coarse looking woman, about 40, said she was the wife of John Edwards, and went, on 13th July, to the prisoner's house, to sell needles and cotton. The prisoner declined buying any thing of her, but asked her if she would take a cup of cider. She said she would. The prisoner then brought some cider in a quart cup; he drank first, passed the cup to her, and she drank his health. She was going away, when he called her back,

and said he wanted a pennyworth of needles. The witness went to give them to him, and the prisoner laid hold of her hand, and pulled her into his carpenter's shop, and locked the door. He then proceeded to take liberties with her; and though she called out twice, and resisted as much as she could, he effected his intentions. He then went away, and locked the door on her in the shop, and kept her there about an hour, and would not let her out till she promised to say nothing about it; and he told her, if she made any disturbance, he would have her severely punished. – Cross-examined: She did not tell the Magistrate that she had made that promise, or that he had locked her up for an hour.

Mr. Sergeant Taddy said that, on this evidence, he thought the Jury could not satisfactorily convict the prisoner, and he would therefore advise them to acquit him. – Verdict – *Not Guilty.*

Peter Megget and *Robert Evans* were indicted for having on the night of Sunday the 24th or early in the morning of the 25th May last, burglariously entered the dwelling-house of Thomas Hatton, of Coleford, and stolen therefrom a large quantity of drapery and mercery goods.

Mr. Curwood conducted the prosecution; Mr. Watson the defence.

Thomas Hatton, the prosecutor, said that he kept a draper's shop at Coleford. On the evening of the 24th May, the house and shop were secured in the usual manner, but on opening the door next morning, he saw that part of the shutter had been taken out, and a quantity of goods to the value of 100*l.* had been taken away.

Thos. Hawkins saw the prisoners together near Coleford, on Saturday, with a hawker's caravan. He did not see them again till the following Tuesday; they were then together, and had the caravan standing by the side of the road; Megget's name was on it.

George Williams said he apprehended Megget, and searched him; he had in his pocket a phosphorus box, two pieces of ribbon, and his licence as a hawker. – Cross-examined: I know Megget was a hawker, and that his name was on the cart. The other prisoner had part of a centre-bit concealed in his sleeve.

John Marsh, a police officer of Gloucester, searched the prisoner's caravan, and found in it a dark lanthorn, and the throw of a centre-bit, to which the bit produced by the last witness fitted. The witness also produced several articles of drapery which he had found in the caravan, and which the prosecutor claimed to be his. – Cross-examined: Has known Megget for some years, and that he has travelled the country as a hawker with flannel. He matched the centre-bit with the holes in the

prosecutor's shutters, and it fitted exactly.

John Hatton, the prosecutor's son, proved that the prisoners sent for his father. The prisoner Evans asked if he would save them, and have mercy on them, as there was nobody in Coleford concerned with them. Witness then identified the different articles found in the caravan, and on the prisoners, and stated that they were all his father's property. – Cross-examined: Heard that another man had absconded. His father did not employ the prisoner to carry the goods to Gloucester.

The prisoner Megget said he had purchased the goods of a man as *remnants*, as he dealt in those articles.

Mr. Watson then called two witnesses, who gave him a good character.

The Jury having found the prisoners *Guilty*, Mr. Sergeant Taddy ordered sentence of death to be recorded.

Wm. Cole, aged 20, was indicted for stealing a black mare, the property of Mrs. Ann Scott, and *George Gabb*, a respectable looking young man, aged 23, was charged with aiding, abetting, and counselling the said William Cole to commit the said robbery.

Mr. Justice conducted the prosecution.

Mrs. Scott, the prosecutrix (who appeared in bad health, and was accomodated with a seat), said, I am a widow, residing about two miles from Chepstow. On 20th Aug. last, I had a black mare, and saw it turned into a field; the next day it was gone, and I did not see it again till the 22nd, when I saw it at Lidney, and the prisoner Cole was in custody. Cole had been in my service, and knew I had the mare and a colt.

Matthew Stevens lives at Coleford, and was called up between one and two o'clock in the morning of the 22nd and saw the prisoner Cole with a black mare; she had one halter on and another round her neck. He came from the Chepstow road, and said he had brought her from Lidney. Mrs. Scott afterwards saw the mare at Lidney, and claimed her as her property.

George Harris said, that Coleford was about 14 miles from where Mrs Scott lived. I was called up about two o'clock in the morning; and Cole, who was on a black mare, was given into my custody. The mare was afterwards claimed by Mrs. Scott.

Mr. Stevens, a sadler at Coleford, sold two halters to Geo. Gabb, on Friday, the 21st, and received 1*s.*6*d.* for them. Early on Saturday morning, he was called up and sent to a stable to look at a black mare, and found the halters he had sold to Gabb upon her. Saw Gabb twice, as he came back after buying the halters, to change one which he complained of.

Mr. Wm. Watkins saw the two prisoners at the Plume of Feathers; they asked if they could sleep there the same as the night before? The defendant said they might. After that, they said they should go to Edmond's, at the Royal Oak, and have some beer, then come back and go to bed. Between one and two in the morning, witness was passing the Feathers again, and saw George Gabb in the yard; witness took him into custody; he was dressed as he now is. Witness had been on the look-out from nine o'clock. While witness had Gabb in custody, Wm. Cole was taken on the black mare.

Richard Hawkins, a servant to Mr. White, of Coleford, was put to watch a field on the night of Friday, 21st August. He was in a shed near the field about eight o'clock; and then at eleven, when he got there the second time, there were two men lying down in it. Witness called some other people to his assistance, and the two men got up; one of them, Reuben Owen, ran away; the other was George Gabb.

The prisoners being called on for their defence, George Gabb protested his innocence, and entered into a very long minute detail of the circumstances. He said he had been asked by Reuben Owen to buy the halters for him, as he wanted them to take a horse. After leaving the Plume of Feathers, he met Reuben Owen in the street, and they went and had some beer together. He then wanted Owen to return with him and go to bed; they left the house for that purpose, and when they came out Owen complained of being ill, and they went and stood over a gate for some time. They then went into the shed, and Owen lay down upon some straw there, and fell asleep. He (Gabb) did not like to leave him, and sat down by his side, and fell asleep also. He was awakened by the men coming into the shed, and Owen then got up and ran away. He was knocked down by a blow from a stick, and was much beaten, and was then taken into custody. The prisoner then asked some questions of the witnesses for the prosecutor, to shew that he had not made any resistance, and said that after he was in custody Cole was taken.

Cole said, he had been employed by a person of the name of Stokes to take the mare to some place where he was to meet him; and protested that Gabb was quite innocent of the charge against him.

Mr. Sergeant Taddy summed up the evidence, and the Jury found Wm. Cole *guilty*, George Gabb *not guilty*.

Mr. Sergeant Taddy said that sentence of death must be recorded against Cole, and cautioned Gabb to be very careful of his conduct in future.

CIVIL SIDE

Nicholls v. *Storer* – This was an action brought to recover the sum of 24*l.* being the amount due by the defendant for goods sold and delivered. Mr. Taunton said that the plaintiff was a cooper, and the defendant a publican, and he should prove that the goods were delivered; and Mr. Phillpotts, for the defendant, said he should prove that the plaintiff had agreed to accept 4*s.*6*d.* in the pound, in common with the defendant's other creditors, and that he had actually been paid to that amount. He then called

Joseph Pope, a respectable looking man, about forty years of age, who, on entering the box, exclaimed, "Here I am – Joseph Pope".

What are you, Mr. Pope? I am an auctioneer, when at Bristol; here I am a witness. – Did you not assist in compromising with the creditors of the defendant? How could I refuse it, when he was in distress? "Joseph", says he – that is, to me, "Joseph", says he, "it is all up". "Well", says I, "how up? I suppose you are dished". (Here the witness, as he proceeded, kept tapping the point of his fore-finger into the palm of his hand). "My Lord, you see, dished in our country means done up – clean done – all up".

The risible faculties of the whole Court, which from the time he entered the box were in a state of excitation, were now giving way to uncontrolled, and the whole Court was convulsed with laughter.

Did you apply to Hopkins to sign the agreement? You shall hear? *(A laugh).* "Storer", says I, "avoid the law – have nothing to do with the law. *(Much laughter).* I will endeavour to settle this business for you". – Mr. Baron Vaughan: But this is no answer to the question. – My Lord, I will answer every thing; I will tell every thing like an honest upright appraiser, as I am. *(Laughter).* Suppose now, Sir, you were in distress, and you came to me and say, "Joseph, my friend, Joseph, it's all up". *(Immense laughter).* – You are not answering the question. Did you tell Hopkins that it was all up with Storer? Certainly I did. – Were there not two casks of beer missing which had been taken to Mrs. Williams's? I am no drayman. *(A laugh.)* Two casks were found absent, as we say in our part of the country. *(A laugh.)* I heard that they were found at the Swan Inn. – Does not Mrs. Williams keep the Swan Inn? She does. I beg your pardon, no! the Swan Inn keeps her. *(Great laughter.)* – Mr. Baron Vaughan: Sir, we wish for your answers, and not for your wit. I beg your Lordship's pardon, but I wish to be correct. – Now, Mr. Pope, tell me if you remember anything about the payment of seven sovereigns to Mr. Hopkins? (After a pause, and shaking his head) Ah, Sir, that's a nice question. *(A laugh.)* (After a long pause) Must I speak the truth about this matter? *(Great laughter.)* Well, then,

I will tell the whole affair candidly, like an honest appraiser as I am. *(A laugh.)* I went to Hopkins, and I said, "Hopkins, you ought to sign this agreement, because it will be of double use to you, as you can afterwards serve both Storer and Mrs. Williams again". Mr. Hopkins, knowing me, and feeling my pulse, intimated that it would be right to have something in hand. I said, I will give you seven sovereigns if you will sign the agreement. And, good God, my Lord, if you were in distress, and came to me as a friend, could I do less than endeavour to bring you thro' it? *(Laughter.)* I will give you seven sovereigns, says I. "Dab, says Daniel", cried he, and the thing was done in a moment.

A paper was here handed to the witness, and he was asked if he had ever seen it before, and he replied in the affirmative.

Mr. Phillpotts: Did not the plaintiff sign this agreement? Yes, they all signed it at my auction-rooms, Baldwin-street, Bristol.

Another witness was called, who proved that the defendant owed him 24*l.* and gave him 16*l.* in order to induce him to sign the agreement, which he did, and he afterwards received his dividends, so that he got 20*l.* out of his 24*l.*

When this evidence was given, Mr. Phillpotts said he must submit to a verdict – Mr. Baron Vaughan said it was clear that the agreement was fraudulent, and the defendant was therefore liable.

Verdict for the plaintiff for the full amount of his demand.

Clifton, as it looked at the time Lady Bantry suffered such a rude awakening in her bedroom in the small hours.

Notes in the text:

1. The writer will not insult readers below the age of, say, 35 by assuming that they need to be told about the denominations of pounds, shillings and pence which went out of use in the 1970s, other than to point out that, rather earlier than that, *l* (for *librae*) was used instead of the £ symbol.

2. Jalap was a medicinal drug in use at the time. It had an acrid and nauseous taste. Named after Xalapa, in Spain, where it was discovered.

3. i.e he asked for the jury to be increased to the full number. From the Latin *tales de circumstantibus*.

4. Edward Law (1750-1818) was appointed Attorney General in 1801. In the following year he was created 1st Baron Ellenborough and became Lord Chief Justice.

5. 'Truck': payment in kind, *in lieu* of money.

6. Equivalent to about £28,028.89 using the retail price index, today. (or £314,400.00 using average earnings.)

7. 'Quist' is dialect for wood-pigeon.

8. The name of the other person was suppressed, lest it should criminate the other prisoner. *(This footnote appeared in the original report)*.

POSTSCRIPT

With the ending of the last trial on the calendar of the Summer Assize of 1829, the courts in Gloucester's Shire Hall have for the time being fallen silent. The Judges, their duty done, have departed from the city, to go about their next business; the last eloquent and persuasive arguments have been put by Learned Counsel; the last witness has given his halting answers to their peremptory questions; the jurers have delivered their final verdict and have returned thankfully to their more usual occupations.

We too have left the courts where, off and on, we have been sitting in the public seats, while, outside, a decade passed by. There, with a sprinkling of the citizens of Gloucestershire, who were either personally concerned or who had leisure to indulge their curiosity, we have been able, thanks to the pen of an anonymous newspaper reporter of long ago, to watch and listen as a number of the more absorbing dramas have unfolded before us, getting as we did so some idea of how English justice was administered nearly two centuries ago.. At the end of each criminal trial, we have been repeatedly reminded of how much harsher were the rewards for misdemeanours in those days. Regrettably, in that connection, we have also from time to time allowed ourselves to join the enthralled multitude standing in front of Gloucester Gaol, as some unfortunate devil, judged to be deserving of the harshest of those rewards, has been escorted to the scaffold and there launched into eternity.

The central figures in these fearsome tragedies were members of a motley cast: the enigmatic Rebecca Worlock, poisoner of her husband; those two pairs of brothers and inveterate law-breakers, the Dyers and the Pinnells; the pathetic Salewell – pathetic, but a brutal wife-beater; Barrett and Oliffe, the horse-thieves, along with Sparrow, who stole no more than a sheep; and the youthful trio of Ray, Jones and Leach, whose

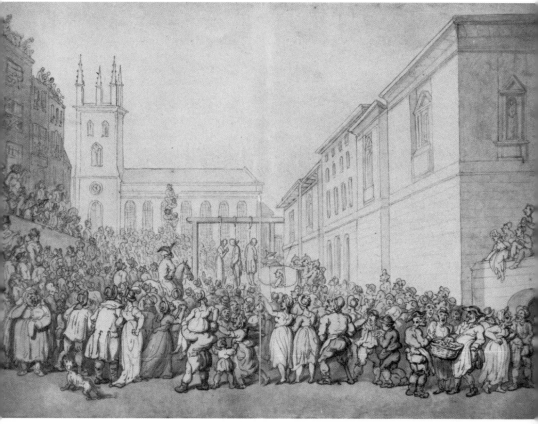

The public execution portrayed here took place at Newgate. The crowd before Gloucester Gaol on similar occasions was apparently every bit as dense and the atmosphere every bit as festive.

low natures were firstly revealed by their callous maltreatment of their aged victims and then confirmed by their craven reactions at the time of their sentencing.

Of the fates of these few we are all too well aware, but apart from these few, the remainder vanish from our sight the moment they are escorted from the courtroom. We know only that their destination lies either in one of the local Houses of Correction, or for many, the more serious cases, on the other side of the world. Some of the latter, like Simon Hickey, who had made off with Lady Bantry's silver, had also been nominated for the hangman's rope, but, through the King's Mercy, saw their death sentences converted into the lesser punishment. Concerning his subsequent adventures, and those of all the other 'transports', as they are conducted from the court, we only know that they are 'bound for Botany Bay'; further than that, we can in these pages do little more

Botany Bay.

than speculate. It is certain that, once arrived, they faced a harsh life: few privileges, strict discipline, poor food and hard work, the latter often in chain gangs, engaged in road-making or other heavy labour. One can only wonder how young Daniel Pennington, to take a particular example and who was less a villain than the naive victim of an evil father, as well as being, we may take it, quite unused to enforced manual toil of that kind, fared under such conditions, amongst companions who were both rough and uncouth.

Later on, we may perhaps glimpse the possibility of a better future for at least some of them. The ones serving lesser sentences, the seven-year men, had the option, once their term was finished, of returning to this country, but many no doubt decided to spend the rest of their days in Australia and seize what opportunities the new and empty country might have to offer. These involuntary colonists will also have included some of the 'lifers' – those who, in return for good behaviour, were eventually given a Conditional Pardon – the so-called 'ticket-of-leave' men.

It should be added that there was in fact a third category of 'free men', composed of the small number of convicts who contrived to escape their chains. For these desperadoes, the only choice consisted of outlawry and

a precarious refuge in the 'outback', existing as 'bushrangers' and keeping themselves alive by relapsing into theft and sometimes murder – the earliest examples of that species of whom, much later on, Ned Kelly was to provide the most famous, or rather, infamous example.

However, most ex-convicts will, we trust, have decided to 'go straight' and find useful employment in the new land, some of them even finding better fortune than they had in the old. Indeed, it is not to be excluded that, having survived their early toils and privations, a few managed to convert initial apparent misfortune into later prosperity, as the early settlements grew into a real Colony.

As for the other participants in the Assize cases – the 'respectable' litigants in the civil actions - one might also, with equal curiosity, but equal difficulty, speculate on the later fortunes of some of these. Here we are tempted, alas, to focus our interest on the young – and not-so-young – ladies whose disturbed hearts were the source of some of the disputes. Did Miss King of Dursley recover her equilibrium and, as a result, did her business return to its former prosperity? How fared the estranged wife of Mr Waterhouse and her babe, in whose veins the blood of the Berkeleys must be assumed to have flowed? Did the alliance between the young Mr Birket and the somewhat older Mrs Wallis, who absconded to Leamington in the former's carriage, endure and prosper, in the face of the social ostracism which, it is to be feared, they are likely to have suffered?

Regrettably, all these speculations lie outside our vision, restricted as it is to that enjoyed by our informant in the *Gloucester Journal*, so that, as we leave the empty courtroom, we can in this present account only wish the law-abiding citizens well, while hoping that, for the other, less honestly inclined ones, their chastening experiences of the power of the law will have persuaded them to follow more virtuous paths during their remaining days.